CIRCLES OF TRADITION
Folk Arts in Minnesota

CIRCLES OF TRADITION
Folk Arts in Minnesota

With essays by

Willard B. Moore
Marion J. Nelson
Colleen J. Sheehy
Thomas Vennum, Jr.
Johannes Riedel
M. Catherine Daly

Published for the University of Minnesota Art Museum by the
Minnesota Historical Society Press, St. Paul, 1989

MINNESOTA HISTORICAL SOCIETY PRESS, ST. PAUL, 55101 for the
UNIVERSITY OF MINNESOTA ART MUSEUM, MINNEAPOLIS, 55455

Manufactured in United States of America
10 9 8 7 6 5 4 3 2 1

International Standard Book Number:
0-87351-239-1

Library of Congress Cataloging-in-Publication Data

Circles of Tradition.

 Published in conjunction with an exhibition held at the University of Minnesota
Art Museum.
 Catalog : p.
 Bibliography : p.
 Includes index.
 1. Folk art—Minnesota—Exhibitions. 2. Ethnic art—Minnesota—Exhibitions.
I. Moore, Willard B. (Willard Burgess), 1931- . II. University of Minnesota.
University Art Museum.
NK835.M6C5 1989 745'.09776'0740176 88-37753
ISBN 0-87351-239-1 (alk. paper)

This publication is supported by grants from the National Endowment for the
Humanities, Washington, D.C., a federal agency; The L. J. Skaggs and Mary C. Skaggs
Foundation, Oakland, California; The Saint Paul Foundation, St. Paul, Minnesota; and
The F. R. Bigelow Foundation, St. Paul, Minnesota. The publication of this catalog is
in conjunction with an exhibition of the same name in 1989 by the University of
Minnesota Art Museum.

This publication is printed on a coated paper manufactured on an acid-free base to
ensure its long life.

Contents

Foreword / vii

Acknowledgments / xi

Circles of Tradition: Toward an Interpretation of Minnesota Folk Art
Willard B. Moore / 1

Folk Art in Minnesota and the Case of the Norwegian American
Marion J. Nelson / 24

Giant Mosquitoes, Eelpout Displays, Pink Flamingos: Some
Overlooked and Unexpected Minnesota Folk Arts
Colleen J. Sheehy / 45

Ojibway Drum Decor: Sources and Variations of Ritual Design
Thomas Vennum, Jr. / 60

Nicolás Castillo and the Mexican-American Corrido Tradition
Johannes Riedel / 71

Anna Mizens, Latvian Mitten Knitter
M. Catherine Daly / 80

The Catalog / 89
Color Plates / 89
Integrated Traditions / 105
Perceived Traditions / 125
Celebrated Traditions / 141

The Minnesota Folk Arts Survey / 148

Selected Bibliography / 156

Index / 159

Foreword

A PUBLICATION and exhibition of Minnesota folk art has been a goal of the University Art Museum since at least 1976. During that year's bicentennial celebration of the United States, the Art Museum, then called the University Gallery, mounted the most ambitious project in its almost fifty-year history—A Bicentennial Exhibition of Minnesota Art and Architecture. The exhibition included more than 650 objects and represented several firsts for Minnesota. We researched and published, with the University of Minnesota Press, the first comprehensive guide to architecture in Minnesota and the first history of painting and sculpture in the state. The bicentennial exhibition toured the state after it closed in the Twin Cities, and the positive response that it received prompted the Museum to found Minnesota's first ongoing statewide traveling art exhibition service. That program now serves 150,000 people outside the metropolitan area each year. This book, *Circles of Tradition: Folk Arts in Minnesota,* and the exhibition of the same name represent another first—the first comprehensive presentation of Minnesota's traditional arts anywhere. The exhibition will also tour statewide after its Twin Cities showing.

Circles of Tradition grew directly out of our bicentennial project. Shortly after the anniversary year ended, I realized that our research and presentation had slighted one very important area of artistic creativity in Minnesota. While the bicentennial art exhibition had included some naive painting and a few Ojibway pieces, it had, by and large, ignored the traditional arts and focused with an art historian's bias on what is considered "high" art. We did not make a conscious decision to leave out traditional arts; in retrospect, the omission seems more a result of our own ignorance. In the 1970s when we started our bicentennial research, many art historians and traditional art museums were simply not aware of the complexities or the richness of the traditional arts. As a university museum, however, we see our mission as including those arts that may not be in the mainstream, and so as soon as our always-stretched resources would allow, the Museum started to make plans toward a survey and presentation of the traditional arts in Minnesota.

In 1979 we received funding from the research division of the National Endowment for the Humanities to plan and implement a national symposium on the topic of presenting the traditional arts in a museum setting, to be cosponsored by the Minnesota Historical Society's Center for the Study of Minnesota Folklife in 1980. In 1984, with a grant from the National Endowment for the Arts Folk Art Program, the Museum began the first-ever comprehensive survey of the traditional arts in Minnesota. Dr. Willard B. Moore, who holds

a Ph.D. in folklore and was the associate director of the Minnesota Historical Society's folklife center, came on our staff to conduct this survey of both contemporary and historical material. After about two years and thousands of miles, Bill Moore probably now knows as much about small-town Minnesota restaurants and truck stops as he does about Minnesota folk art. His successful survey is the foundation for this book and the exhibition that accompanies it. While these can feature only a small number of the people and objects that Bill's survey recorded, at the back of this book all the artists and collections he found are listed. Though it is hard for me to imagine that Bill missed anyone in his travels, I suspect that for every person he interviewed, there are at least three he did not find. We hope this book will encourage those people to come forward to be recognized.

The Museum started this work with somewhat vague ideas about the outcome. We knew that we wanted to present some very special people as well as things that were made in Minnesota, but we wanted to approach Minnesota's traditional arts with an open mind, without any preconceived theories to prove or disprove. We did realize when the research began that we would probably conclude that Minnesota's was not a unique situation. We knew that using the state's borders as our limits for the survey was somewhat artificial and that what we found might be valid for a larger region, but we also realized that limiting our research to Minnesota might help dispel some erroneous ideas about the state. Minnesota has the reputation of being a homogeneous enclave of Scandinavian Americans. While it is true that those groups are present in large numbers, we hoped that a survey would reveal much more diversity. And, indeed, Bill discovered that there is much, much more than rosemaling in Minnesota. While this has always been true, it is especially so after an influx of Southeast Asian immigrants

to Minnesota in the last ten years. And, after realizing the diversity of the traditional arts in Minnesota, we believed that the state *could* serve as a microcosm for developing new ways of looking at the traditional arts that were valid generally.

As Bill Moore began to study the information he collected in his survey, he began to develop ideas about "circles of tradition" that were exciting to our staff. We liked Bill's ideas about broadening the definition of folk art: about including people and things that did not seem to fit into neat ethnic packages, and about looking at how the artist and his or her community felt about the things the artist created and not just at how the object fit into some predetermined, formal definition of folk aesthetics. The model of circles of tradition allows us to consider seriously many things that I had always felt were folk art, even though they might not fit more rigid academic definitions. The circles of tradition encompass not only the most traditional-looking objects and people who follow the strictest rules in making them, but also people who have strayed far from the "folk" fold and those whose activity did not originate in any ethnic tradition. Yet the circles offer an organizing structure and a way of looking at objects that makes them more meaningful to both the scholar and the general public.

The National Endowment for the Humanities agreed that this presentation of Minnesota's traditional arts through circles of tradition had both scholarly importance and popular appeal and funded the implementation of the exhibition and this publication with a generous grant. We are grateful for not only the NEH's confidence in our project, but also the assistance of its staff. Sally Yerkovitch, formerly at the NEH, Suzi Jones, NEH program officer, and Marsha Semmel, head of the NEH Museum Program, were particularly helpful, as was Bess Hawes, head of the National Endowment for the Arts Folk Art

Program. Jillian Steiner Sandrock of the L. J. Skaggs and Mary C. Skaggs Foundation in Oakland, California, also a folk art enthusiast, helped with a grant from that foundation, and the Saint Paul Foundation and the F. R. Bigelow Foundation of St. Paul also provided funding. Campbell-Mithun advertising agency in Minneapolis provided pro-bono services for the exhibition.

Bill Moore explains his concepts in this volume's keynote essay, ''Circles of Tradition: Toward an Interpretation of Minnesota Folk Art.'' He also selected the topics and writers for the other essays to complement and enlarge upon his ideas about Minnesota folk art. A list of others who contributed in vital ways to this book is too long to include in this introduction. It must suffice to say that the Museum staff, particularly Susan Brown, associate director; Cindy Collins, registrar; and special exhibition coordinators Carol Smith, Karen Rigdon, and Diane Redfern Ross were particularly important to this publication. In addition, we were honored by the opportunity to work with the Minnesota Historical Society Press staff, especially Anne R. Kaplan, editor, Ann Regan, managing editor, Jean Brookins, assistant director for publications and research, and Alan Ominsky, production supervisor, all of whom helped us shape this book. Lois Stanfield takes the credit for the design of the book and Tim Rummelhoff, formerly of the University's Biomedical Graphics Department, was its photographer, except where otherwise noted. I would like also to acknowledge the support of the Minnesota Historical Society's director, Nina Archabal, who has a particular stake in the exhibition because she was on the staff of the University Art Museum at the time of the bicentennial exhibition and founded the traveling exhibition service that grew out of that exhibition. It seems only fitting that she also be involved in its other outgrowth—*Circles of Tradition.*

Circles of Tradition explores ideas that we believe will break new ground among scholars and enlighten the general reader. It also presents works of art that are serious, witty, beautiful, and whimsical—and sometimes all of those things at the same time. It's our tribute to the wonderful creativity of the people of Minnesota.

Lyndel King
Director
University of Minnesota Art Museum

Acknowledgments

FIRST and foremost, I wish to thank all the Minnesotans who graciously gave their time and energy to this survey. Without exception, they were eager to see Minnesota's traditions put before the general public and to help future scholars better understand what they do and the meanings inherent in their works.

Beyond this I wish to mention certain individuals who contributed to the project. There is no way to express my thanks to my colleague Alec Bond, who passed away in October 1985, except to remind his family and all Minnesotans of his special contributions, not only to this exhibition but to folk cultural studies in general. My special thanks, also, to Shirley I. Morton for the many ways she nourished this project. Her seemingly endless list of resources was willingly given to the research, and her insight and wisdom brought clarity to the formation of the concept of circles of tradition. For her patience and fortitude, her insightful editorial questioning based on a sound background in folklore studies, I thank my friend, colleague, and editor Anne R. Kaplan. I am perhaps most grateful for the help of Carol Smith, Karen Rigdon, and Diane Redfern Ross, exhibit coordinators who managed to bring together an unusually complex exhibit, despite my periodic oversights and deficiencies.

Others who contributed enormously to the overall project include Janet Benson, Mengkruy Ung, and Lar Mundstock, who served as liaison with the Cambodian communities of Minnesota; Jeanne L. Blake, who always found time to provide English-Hmong translations and good advice about the Hmong community and its arts; John Berquist, who pioneered much of the study of folk art in Minnesota; Helen Carciofini, who spent many hours introducing me to Minnesotans whose cultural origins lay in the Near and Middle East; Marilyn Chiat, whose expertise on traditional Jewish culture and arts was always at hand; Ormond Loomis, whose research on Minnesota's iron ranges in 1978 contributed to our early understanding of that region's material culture; Janet K. Meany, whose untiring research on weaving and loom construction among ethnic Minnesotans has already begun to enrich the study of our state's folk arts; my colleague and friend Phil Nusbaum, who serves Minnesotans as the folk arts program associate at the Minnesota State Arts Board and whose expertise in folk music allowed the exhibition to include the performance of folk music and oral traditions; Steve Ohrn, historic sites manager at the State Historical Society of Iowa, who knows much about Minnesota and constantly sought to keep us on track; Banlang Phommasouvanh, who was always willing to provide leads to and interpretations of traditional Lao culture and arts; and Sonja Peterson of the West Central Regional Arts

Council, whom I met on my first field trip and whose leads to folk artists always paid off. The University Art Museum staff was, of course, instrumental in this project, especially Cindy Frye Collins, William Lampe, and Colleen Sheehy. And without the talents and good judgment of Susan Brown and Lyndel King the exhibit would not have been realized.

For making me welcome in their homes, lending their special expertise to the survey, and helping me to contact others in their communities, I wish to thank Carolyn Abbott, Virgil Benoit, Kathy Bond, Jack and Nancy Bratrud, Robert Duenes, Eugene and Rosemary Goodsky, James and Karen Gray, Mr. and Mrs. Albert Harder and Maryann Harder, Gladys Holmes, Karen Jenson, Ann Kmit, Margo Mackay and Harry Van Ornum, Wad and Caroline Miller, Vera Mandybur, Georgia Rosendahl, Sister Anita Smisek, Jean Stimac, and Tran Xuan Thoi (Tom Tran).

Others who have helped throughout the survey and the exhibition include Fadia Abul-hajj, Tuula Airhola of the Pohjanman Museum in Vaasa, Finland, Gretchen Anderson, Lena Andersson-Palmqvist of the Nordiska Museet in Stockholm, Sweden, John E. Andrys, Joyce Aufderheide, Michael and Suzanne Baizerman, Floyd Ballinger, Jesse Bethke, Clarence W. Blue, the Blue Earth County Historical Society, Jean Bollig of the Agricultural Extension Service, University of Minnesota, Pam Brunfelt, Reginald Buckner, the Cambodian Buddhist Society of Minnesota, Carlton County Historical Society, Siu Lin Chong, Clay County Historical Society, Cokato County Museum and Historical Society, Richard Cooney, Country Comfort Antiques, Randy Croce, Gerald Czulewicz, Liv Dahl of the Sons of Norway, William James Davis, Joan Demeules, David Ebnet of the Stearns County Heritage Center, the Eclectic Company, Mrs. Jeffrey Eide, Noland A. Eidsmoe, Nancy Ellison, Gertrude Esteros, Faith Lutheran Church of Madison, Arthur Geffen, Dennis Gelpe, Larry Goga, the Goldstein Gallery, the Goodhue County Historical Society, Evelyn Hagen of the creative activity division of the Minnesota State Fair, Molly Harris, Ida Haukos, Heart of the Beast Mask and Puppet Theater, Kris Heim, Darrell D. Henning, Plia Her, Hmong Handwork, Susan Ho, Judy Hohman, Penny Hunt, the Immigration History Research Center of the University of Minnesota, the Iron Range Historical Society, Noah Ismail, Bruce and Cheryl Iverson, Marianne Jameson, Michael Karni, Matti Kaups, Helen Kelley, Dennis Kelly of the Midwest Arts Alliance, Bill Klinger, Timothy Kloberdanz, Marion Kohlmeyer, Ruben Kolsrud, Peggy Korsmo-Kennon, Emma Jean Kyd, Cheryl Larson, Gustaf Larson, LeRoy Larson, Harlan Lidke, Brad Linder, Muas Lis, Carl Madsen, Minnesota Quilters, Inc., Bill Morgan, Mountain Lake Heritage Museum, Pauline Mueller, Darrel Nickolson, Marc Norberg, Alice Nussbaum, the Otter Tail County Historical Society, Corrine Pearson, Susan Peters, Fred Peterson, Harvey L. Peterson, Pilgrim Baptist Church, St. Paul, Addie Pittlekow, the Polish Museum, Winona, Red Wing Arts Association, Les Ristenen, Farooque Rizway, St. Catherine Ukrainian Church, Minneapolis, Edwin Saari, Marylou Schmitz, Barbara Schraer, the Science Museum of Minnesota, Maria Silva, Cliff Sloane, Jeannie M. Spears, Caecilie Stang of the Norwegian Emigrant Museum in Hamar, Norway, Kathy Stokker, Father William J. Straka, Joseph Svoboda, Greta Swenson, Tesfai Tekle, Phil Thompson, Inna Turchman, Mrs. Dennis Ueke, Sy Vang, Vesterheim, the Norwegian-American Museum in Decorah, Iowa, Nicholas Vrooman, Nancy B. Walters, the Weavers Guild of Minnesota, James West, Helen White, Cecil Winegarner, Pa Sen Yang, Sharon Zweigbaum.

Willard B. Moore
Special Curator for Folk Art

Circles of Tradition:
Toward an Interpretation of Minnesota Folk Art

WILLARD B. MOORE

IN REFLECTING upon his twenty years studying folk art, Michael Owen Jones commented: "I am . . . convinced that a craving for tradition and an aesthetic impulse inform our lives. Familiarity vies with novelty for our attention and appreciation. And even the most prosaic of utilitarian forms can be, and often are, imbued with aesthetic value."[1]

Jones's linking of aesthetic expression with tradition reminds us that tradition continues to be important despite recent scholarly arguments that the term is no longer valid and should be replaced with alternatives when assessing folk art. A *sense of tradition* is the organizing feature of our approach to interpreting Minnesota's folk arts.

The term *folk art* today has wide recognition but is a troublesome one, born out of nineteenth-century Romanticism's attempt to crystallize a nationalistic spirit.[2] The Romantic movement drew upon peasant life as the wellspring of beauty and truth and as a vitalizing, cohesive image for the times. Today the term *folk art* is perpetuated mainly by funding agencies, ethnic organizations, and commercial enterprise for approximately the same reasons. As a popularized concept, it does little to help scholars or the people who create art to understand that all arts are part of a seamless fabric of perception and expression that we call culture.

Culture is not static but is ever changing and dynamic in its relationship to individuals and society. Within the various contexts of culture and its social institutions, artists may identify with one or another stratum of society and any one of many traditions. They may react against or accept community affiliation and a sense of their community's or region's history, according to their perception of their own identity. Underlying these complex social choices is the apprehension that the term *folk,* with its original connotations of "peasant" or "crude," may demean their craft and distance artists from their other roles and identities in the public's view.

If *folk art* is a troublesome term, so, too, is *tradition*. It has always been part of the basic definition of folk art, but it has become controversial in recent decades because of our more sophisticated understanding of culture and culture change. Tradition generally connotes past-oriented, static forms or the seemingly endless perpetuation of molded behavior, a notion contrary to the belief that culture is dynamic. Scholars' principal objections to the term are based on the view that a sense of tradition cannot be found in, for example, newly created forms which they sense should be classified as folk art. This dilemma raises the point, then, that there must be an alternative approach to this art. If the term *folk* is passé or

unreliable, and if tradition's emphasis on long-standing behavior seems inadequate, then how do we describe and analyze art that often reflects community or cultural values, is passed on outside the academy but in a structured way, and is conservative yet subject to change?[3]

The American scholarly community continues to refine its understanding of this aesthetic activity that spans three centuries and the entire nation. Arguments have been made to jettison tradition and think in terms of technique of expression in particular social contexts and within a single reference group; studying the copy-machine folklore circulated by office workers is a prime example. Others would diminish the role of tradition and substitute *style,* thereby shifting the emphases to the synthesis of individual innovation and cultural norms. This is a workable idea in that it accounts for variation of an individual's work within the acceptable frame of cultural guidelines.[4] Still other scholars have countered these arguments by positing tradition not as a determinant of all folk expression but as a baseline or precedent to which artists may react, positively or negatively, and thereby participate in the actualization of tradition.

In 1982 anthropologist M. Estellie Smith provided another view of tradition as she sought to clarify the binary model of tradition *vs* change (or change/no change) with which scholars grappled when studying sociocultural groups. Smith determined that *continuity* was a better term to describe how members of a socioculture depend upon elements both traditional and innovative as they attempt to reaffirm their identities while undergoing change. She concluded that "Continuity is that synthesis within which tradition is persistent viability through adaptation and change is the novel manifestation of a durable identity."[5]

"Participation in tradition," suggested by folklorist Kay L. Cothran, is another approach, one that brings us to the edge of the concept of circles of tradition. Focusing on participation shifts the scholar's emphasis from a product or art form to "an environment and a set of techniques of human social activity that can change the environment or perpetuate it." Participation goes on at a deep level; it is not adopted or abandoned quickly, and it does not necessarily entail approval of tradition. If a third-generation quilt maker, for example, decides *not* to continue that work and, further, refuses even to discuss it, her behavior is a message about quilting that is as meaningful as a more positive response might be. As scholars who studied contemporary folk legends also found, negative response does not diminish expression; it merely reveals another view.[6]

Finally, scholars of the traditional arts have turned their attention to the relationship of context and artists' roles in their communities. In a fascinating discussion with his colleague Roger L. Welsch, Warren E. Roberts proposed two categories for folk artists. Artists whose work mirrors the tastes and aspirations of the culture and is part of everyday life fit the "Medieval" model of the folk artist, for this was the general relationship in the Middle Ages. And artists who are set apart, perhaps even alienated, from society, who are often responsible for the introduction of new ideas and symbols, and who create works of little appeal to their neighbors fit the "Romantic" model.[7] In Minnesota, both models can be found, though the latter is more prevalent. The question, however, should not be either/or, and the answer should come from examining the results of comprehensive fieldwork and deciding on a case-by-case basis.

Clearly, this search for a holistic understanding of tradition in folk art has gone well beyond analyzing an object's form and function. It has been accompanied by a search for

meaning that focuses upon the artists' intentions and the symbolic weight that a community attaches to or derives from their art. Other elements need also be observed and assessed as one studies folk arts in the modern world: materials, processes and techniques of production, and the modes of communication with novices, other artists, or the community. One or more of these elements—form, function, meaning, materials, and so forth—may change. Artists and their work may remain traditional as long as they continue to tap some element of tradition in their efforts toward aesthetic expression.

IT IS OUR CONCLUSION that Jones's observation is correct and that the aesthetic impulse, indeed, abides within us. At times we create or select our material worlds in accordance with styles that one could hardly call traditional. We listen to wide ranges of music from popular to classical, and we dress ourselves and furnish our homes largely through the convenience of mass-produced or custom-designed materials. We are most of the time unlike pretechnological and preliterate societies whose communication pattern is face-to-face and whose cultures are integrated, not only with temporal things but with the spirit world of ancestors and the cosmos as well. Under what conditions, then, does tradition become important to modern Minnesotans and, indeed, to all Americans?

The answer seems to lie within time frames. There are times when, in Jones's words, "we crave tradition." We perform traditional rituals, select traditional designs, eat traditional foods, or yearn for traditional tunes. The times when we behave in this way vary from one individual to another, depending on many circumstances, one of which is the nature of the community in which we live. If, for instance, we are members of an Old Order Amish community in southeast Minnesota, we will follow tradition more intensely than if we are a member of the faculty at a local university. The Amish sense of tradition lies integrated with the community and based largely upon spiritual beliefs that are shared by that community and interpreted and overseen by its elders. Costume, vehicles for transportation, language, quilt designs, and even styles of housekeeping and yard care may be subtly varied, but all lie strictly within tradition. Moreover, there is little discrepancy between private and public expression. The professor, on the other hand, may have separate public and private senses of identity. As a scholar, she may wish to be viewed as "modern" and "on the cutting edge." Yet she will, at certain specific times, act traditionally by observing time-honored academic customs such as participating in graduation ceremonies and decorating her office door with clippings, cartoons, and other images and messages that assert her intellectual position on certain issues and reduce anonymity in the academic community. In her private life she may more intensely seek the traditional by celebrating a religious holiday, for example, or planning the details of a family wedding or funeral, teaching her son to build a snowman, or building a sauna at her northern Minnesota lakeside cabin.

Clearly, we all have access, more or less, to the aesthetic impulse within a framework of tradition. Questions to guide our inquiry, then, are: What traditions exist in Minnesota? How can we interpret the artist's sense of tradition? Under what conditions do people readily turn to tradition as a means of expression? Our exhibition, Circles of Tradition: Folk Arts in Minnesota, attempts to answer these questions through analyses of *tradition,* a term still useful, if not indispensable, to folk art study.

CIRCLES OF TRADITION

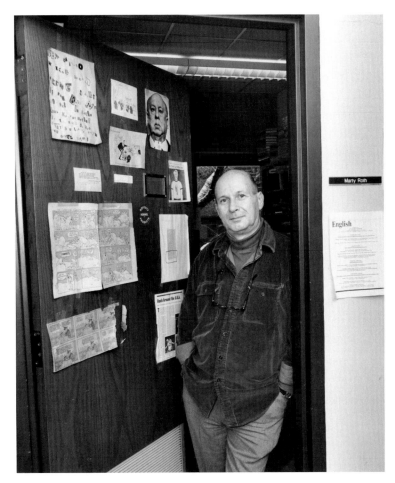

Professor Marty Roth's door, University of Minnesota, 1988, conveys to his students and colleagues his interest in literature, popular culture, film, and young people, as well as the need to raise the political consciousness of his department.

Our model for folk arts analysis is represented by three concentric circles.[8] The innermost circle is called *Integrated Traditions,* and within it lie the art forms, techniques, materials, and symbolic meanings that are most fully interwoven with the rest of community life. What changes they experience are organic and highly integrated with the rest of that culture. Artists' aesthetics tend to be culture based and shared by other members of the community, whether they are also practicing artists or simply people who admire and utilize the work. The arts themselves tend to be characterized by conservatism; Hmong costume and other aspects of their material culture serve as excellent examples. For the Hmong especially, form itself and sometimes technique are integral to function and meaning.

Many of the objects in this circle express a group's sense of spiritual community; a random sampling includes handmade Jewish *dreidels* (tops), Ojibway ribbon shirts, Hmong funeral costumes, Roman Catholic family grottoes, and Palestinian Easter pastries (Cat. nos. 20, 36, 61). Each of these artifacts has a traditional form, but more important, behind each is a history denoting its symbolic importance or meaning. Meaning is *never* taken for granted in an integrated community. For this reason the principal emphasis in our interpretation of this circle is on *meaning.*

The second circle of the model is called *Perceived Traditions.* Our survey, in looking at aesthetic traditions in both historic and contemporary times, documented forms, production techniques, their associated meanings, and creative roles that were not totally integrated with community life but were considered or *perceived* as traditional by some individuals. Often traditions have been transformed in the

context of twentieth-century American life so that they bear diminished resemblance in form, technique, or function to the original practice. Their significance lies in the maker's firm belief and commitment to the object and its meaning as a dynamic extension of an older tradition. Many Minnesotans, for example, practice perceived traditions as a means of proclaiming their ethnic affiliation. Examples include the highly revised traditions of Polish *wycinanki* (paper cutting). Once created only during Lent to decorate peasant homes, these intricate images are now made and displayed year-round, as well as in their original context as a deeply meaningful aspect of Easter celebrations.

Another type of artist in Minnesota are those who have actually found artistic roles that have come to be perceived as traditional—as have the arts and techniques themselves. Personal or social conditions—such as life changes, social and political change, and displacement, as in the case of refugees—often generate these new roles. For example, Melvin Hall, a retired farmer from Lanesboro, explained: "Farmers work hard all their lives and when they retire they are allowed to be artistic." This statement reveals a great deal about perceived roles in Minnesota and how they may be defined by gender or by historic, social, and age-related imperatives. Hall could not have created his imaginative yard ornaments during the prime of his life when the main concern was raising food for his family, but later his art became a part of the way he spent his time and related to his peers, also retired farmers (Cat. no. 65). His productions were therapeutic, recognized as appropriate and, most important, as aesthetically pleasing by his community.

The nature of tradition in this circle enables individuals to form natural, social, and aesthetic connections with art. It is this *function*—whether interpreted as an object's use or

how an aesthetic role helps individuals define their place in society—that is the primary characteristic of the perceived circle.

The outermost circle in the model, *Celebrated Traditions,* allows us to interpret forms frequently dubbed "not authentic" in other studies and consequently ignored as folk or traditional art. This circle contains the work of artists who, for personal and aesthetic reasons, choose to create objects not necessarily related to their own heritage or social roles. While these objects and the techniques required to make them are rooted in tradition, it is a tradition of other times, places, and social conditions. Through the celebrated traditions, Minnesotans have enriched the state's arts with revivals of traditions that their predecessors had little time to pursue. In some instances, artists have sought forms from other regions of the country, such as Upland South dulcimers and New England fireboards. Other people have experimented with historic genres and created fresh forms with new meanings, as in the early twentieth-century cement figures by Carl E. Peterson (Cat. no. 105) and the more recent whirligigs by Dean Lucker and Ann Wood (see cover).

In this circle, the emphasis is upon *form.* Artists who pursue the traditional arts in this manner are characterized by a self-consciousness that is less apparent in the first two circles. For example, teachers of "folk arts" and those who have adopted certain forms for personal and professional reasons approach the task as outsiders, lacking the cognitive and affective orientation of the original culture. The less skilled may, therefore, cautiously restrain their creativity as they strive to "follow the rules" for a given form or process. And ironically, they are often more constrained by these rules of form and process (and in a way that may be aesthetically detrimental to their products) than are the artists in the

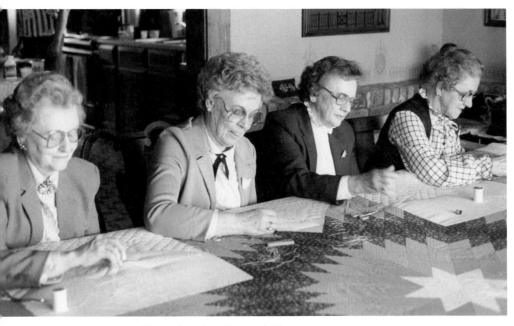

Norwegian-American neighbors (left to right) Ruth Torstenson, Aletrice Neraason, Selma Torstenson, and Thora Trelstad, quilting at the home of Sharlene Jorgenson, Montevideo, 1985. (Photograph by Willard B. Moore)

integrated circle, whose traditions inspired such celebration.

Many artists who do rosemaling (rose painting), derived from one of the nineteenth-century Norwegian regional styles, fall into this category. They may have no connection whatsoever with Norwegian ethnic or immigrant culture but find the form pleasing and the creative act fulfilling. As with all revivals of what was once a traditional art in a natural context, modern Minnesota rosemalers are challenged to acquire a naturalness of creativity that is artificial in their culture.[9]

Circles of tradition is a useful analytical model precisely because it is comprehensive and does not isolate forms from their behavioral and aesthetic contexts or artists from their intentions. Quilting in Minnesota serves as a clear example. While quilting per se is generally accepted as a traditional or "folk" art, it is traditional in the sense of the integrated circle only when the quilter's intentions are largely concerned with reusing scraps of material to create an object that reflects both frugality and artistry. On the other hand, many women take up quilting as a social and aesthetic activity *perceived* as appropriate by the community in which they reside. Others pursue it as a kind of therapy that nourishes and stimulates, often engaging them far into the night. Farm women find both solitary and social enjoyment in quilting, and older women often take up the craft, especially in retirement years, even though they may have had little hands-on experience in their youth. By contrast, hundreds of Minnesotans extend quilt making into the realm of celebrated tradition. Their motivations include creating heirlooms, providing interior decoration, or entering arts competition at the local, regional, or national level. A very few are commissioned to create quilts as a means of fund raising for special community events. Many, though not all, of the quilters in the celebrated circle are affluent enough to purchase costly material specifically for the quilt. In these cases, the form and process of traditional quilting are maintained while the original function and meaning have been altered. Yet women from all three circles may quilt side by side at church on a weekly basis.

CONTEXTS OF TRADITION

In searching through the circles of tradition for form, function, and, most of all, meaning, it is important to remember that art, like language, conveys little by itself. Its meaning is always a part of the context from which it issues— the speaker's or artist's intentions, the audience's response, and the conditions under which these elements interact. One who uses circles of tradition as a model for analyzing and grouping disparate materials will see any number of possibilities in the artifacts themselves, in the artists' behaviors, and in the contexts of each. One could, for example, organize the artifacts by materials (wood, metal, fibers), by the artists' gender or ethnic group, or by processes (carving, weaving, decoration of a surface). Contexts—often social, political, and cultural situations, sometimes spatial and temporal dimensions, and frequently personal imperatives—are another meaningful possibility, principally because they have less to do with form and more to do with meanings.

Typically, the traditional arts are exhibited as representative of one specific social or cultural group or a single regional population. In an exhibition of the traditional arts of an entire state, however, a sampling that follows strict ethnic, regional, or idiosyncratic lines would only perpetuate the notion that these arts are isolated phenomena of "the folk." Such a fragmented view would defeat our intention to be both comprehensive and comparative. More importantly, it would hinder the attempt to interpret more accurately objects that seem to be similar though from different cultures, or that, like the quilts, have been placed in two or more circles, based on their contexts.

Given the three circles as analytical categories, any number of interpretive contexts may be found. The art forms documented in our survey fell quite naturally into four areas: work, play, and survival in a northern land; expressions of spiritual community; adjustments to change through the traditional arts; and continuity and variation in traditional arts. Each of these is a context in which people, for various reasons, turned to a sense of tradition as a source of aesthetic expression.

Work, Play, and Survival in a Northern Land

These artifacts are mainly, though not exclusively, utilitarian.[10] Traditional arts and craft items have frequently been part of the male work environment, as tools for hunting, fishing, farming, mining, and traversing the landscape. They are even more frequently found in the home where women carry on traditional tasks. Occasionally such gender roles may be reversed, as demonstrated by the artistic vegetable canning of Thomas O'Keefe (Cat. no. 2). Urban settings also give rise to traditional art, such as the work of veteran saddlemaker Gerald Schatzlein, Minneapolis, and the piñatas of Nancy Muñoz Bernier, St. Paul. There is also a fair representation from the children's world of ephemera and handmade toys, historic and contemporary.

Work, whether in the home, on the farm, or in the marketplace, draws more upon a sense of tradition than is usually acknowledged, and this sense of tradition is manifested in stories and special language, superstitions, costume and custom, and ritual.[11] Alexander Rennie, Minneapolis, for example, is a fourth-generation stone cutter and carver, the last in his family. Though he no longer carves exclusively with a mallet and chisel and his work usually adorns office buildings or suburban homes, he considers himself a traditional

Simplified 1040

Latest Revision for:

1040 Federal Income Tax Form 19**82**
Department of the Internal Revenue Service 07

▓**Part 1**▓ Income .Your Social Security Number

1. How much money did
 you make last year?..►

2. Send it in...►

Copy-machine folklore posted
anonymously in a janitor's
closet, Northrop Memorial
Auditorium, Minneapolis, 1986

stoneworker (Cat. no. 40). When Rennie entered the field in the 1920s he heard tales of earlier years, of apprentices whose mistakes could be righted only by a ritual. During a ceremony, the badly cut stone was buried while a circle of elders took a switch to the erring apprentice.[12]

Few such traditional initiations and lineages exist for Minnesotans entering today's world of work. On-the-job traditions, however, are well known and often reveal themselves in visual forms. In the 1950s, as a youthful employee at an eastern newspaper, I observed pressroom workers wearing folded paper hats, which they constructed anew each day from newsprint. Today, though presses are electronic and pressmen no longer need to protect themselves from dripping grease, the traditional square hats are still made as a symbol of occupational identity (Cat. no. 94).[13]

Wherever the workers' environment is impersonal and they view their relationship to the product as anonymous, there develops the practice of using company tools and materials to make things for themselves or to engage in some in-group communication with colleagues, thereby off-setting their lack of voice in the shop. The most ubiquitous example is the copy-machine folklore and images found in many modern offices. Traditional stories from Minnesota's iron ranges describe workers' garages stocked with sophisticated shop equipment, fishing gear, even customized cars, all made in small pieces during solitary moments on company time.[14] *Lunch-time pieces* is the term applied to such ceramic works made in the nineteenth century, and while some were meant to be throw-aways devoid of symbolic import or useful items for the home, others like "The Pullman Porter" reflected the bigotry of another era (Cat. no. 60).

Workers of all types reinforce their identity on the job and at home by decorating their gear and their surroundings. Good examples of this impulse are the mailboxes that project occupational specialties (Cat. no. 43). In cases where the maker's identity is no longer known, however, we must try to discern the impetus for the aesthetic impulse from the artifacts themselves. Who can tell us why a Norwegian immigrant farmer in Otter Tail County incised his homemade skis with

the traditional acanthus design (Cat. no. 38), when his requirements appeared to be merely crossing the fields or traversing a wood on his way to work or sociability?

Some traditional occupations and skills demand the production of equally traditional tools. Vu Yang, a Hmong refugee, immigrated to Minnesota in 1978 and works as a bilingual counselor in the Minneapolis public schools. He and the members of his extended family have attempted to reestablish in Minnesota the male blacksmithing tradition of his native Laos. Along with several other implements, his family creates knives (Cat. nos. 52, 85) for the traditional butchering and food preparation still maintained in Minnesota. These knives provide Hmong refugees with a familiar and efficient tool. At the same time they promote the larger, integrated tradition of Hmong foodways.

Senior citizens, usually with an eye to their descendants, have created much occupationally related art. Ex-loggers Pete Trygg and Milo Stillwell, for example, constructed in minute detail a model of an early twentieth-century lumber camp (Cat. no. 88) in order to pass on to future generations a sense of the occupation to which they devoted their lives.

Cultural geographers and folk arts scholars have joined in their study of culture as a normative phenomenon, as man's "cognitive and psychological adaptations to his social and ecological environments." The pervasive midwestern tradition of yard decoration, creating what humanities scholar Fred E. H. Schroeder has called "the democratic garden," is particularly prevalent in rural areas. It is a good example of the normative influence exerted by social and cultural forces. Yard ornamentation, composed of found, homemade, or purchased objects arranged in a manner aesthetically pleasing by local standards, serves as a personalized yet socially acceptable way of managing the appearance of the landscape. The ornaments

themselves may include whirligigs, semirealistic animals and birds, human figures, and abstractions of plant life. Such rural yards establish a middle ground between the natural and virtually unadorned fields and the house, a prime cultural artifact. They clearly display their creators' uneasiness with unused exterior space. The entire phenomenon, closely examined, reveals the artists' deep-seated views about their place on the natural landscape in the plains region.

Two excellent examples are the yard ornaments of retired farmers Melvin Hall and Truman Austin of Lanesboro. As close friends, they probably saw and even replicated some of the same things, although their styles differ. Hall's "Flowers" are clearly similar to Austin's, but Austin's large ornament with wrenches and wheel is unique and unparalleled, as far as we know, in anyone's work. With personal identities so tightly enmeshed in farm work, these artists, once retired, continued to respond to life through familiar tools and materials. To some observers, however, these activities of elder Minnesotans seem more like play than work, and the artists themselves frequently testify that they are "just passing the time" or "fooling around."

PLAY itself is one of the oldest and most stable activities open to scholarly examination. Children's and adults' games are often ancient patterns with obscure origins. To understand them, scholars have initiated a variety of approaches, essentially categorizing play activities as competition or mimicry. Folklorists interested in formal analysis, for example, have successfully compared games to folktales, imitation of social roles, or rituals. Behavioral analysts have concluded that game activity teaches culturally desirable skills such as planning and experimentation, physical skill and dexterity, strategy making, and dealing with chance.[15]

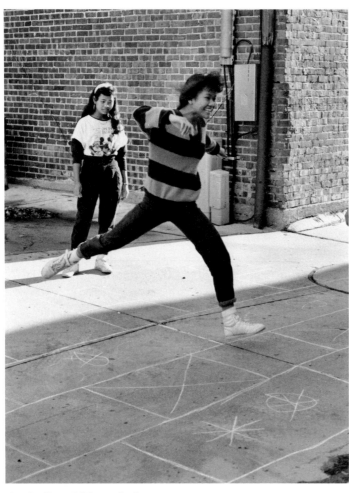

Cambodian children playing
muk, *their own traditional form*
of hopscotch, Faribault, 1988;
the pattern on the ground
designates special areas
metaphorically expressed as, for
example, heaven and hell.

Some adult games, however, can be interpreted as exercises in social control as well as mimicry and sheer fun. In Minnesota and adjacent states, the old tradition of Julebukking or "Christmas Fools" still thrives wherever Norwegian communities exist in farming areas. Their identities concealed by costumes, Julebukkers attempt to fool and sometimes torment their neighbors during boisterous evening visits. Julebukking is also a way of expressing ethnic identity and initiating newcomers to an area.[16]

Minnesotans have tended to preserve playthings as mementoes and evidence that newer is not always better. Preschool teacher Shirley Morton, Minneapolis, still owns the soldier doll, a carefully rendered depiction of her father in uniform, sewn by her mother in 1944 when Sgt. Morton was serving in the Army Air Corps in England. For girls, playing dolls was like playing soldier for boys, a mimicry of adult roles for better or for worse. As for the maker, she drew upon traditional skills in sewing and quilting and a traditional attitude of self-sufficiency to "make do" in a time when a less personal, manufactured doll would not have been meaningful.

Other playthings are ephemeral; often they are seasonal objects, re-created year after year. No form is more traditional than the snowman, learned from older siblings, playmates, or parents. The custom of carving jack-o'-lanterns at Halloween, also first learned from an older person, was brought to the United States by the Catholic immigrants of the seventeenth century, gaining widespread popularity in the mid-nineteenth century.[17] Present-day jack-o'-lanterns may continue the traditional leering or grimacing visage of dangerous spirits, or they may display such innovations as peace signs or abstract designs. Equally important as the object's form are the ways in which making snowmen and carving pumpkins are perpetuated through the interaction of family or community

members, whether for competition or merely for the act of community.

Some toys, such as a Jewish *dreidel* (Cat. no. 61), have a distinct place in a cultural celebration. *Dreidels* may be made of any material but must carry the specific Hebrew letters, נ ה ג ש, the first letters of the Hebrew words for "a great miracle happened there," a reference to the Hanukkah story. Children in Jewish families spin the *dreidel* during Hanukkah and may sing a variant of the following song:

> I had a little dreidel,
> I made it out of clay,
> And when it's dry and ready,
> Oh, dreidel we will play.
>
> Oh, dreidel, dreidel, dreidel,
> I made you out of clay,
> And when you're dry and ready,
> Oh, dreidel we will play.[18]

While Hanukkah is a religious holiday, playing *dreidel* is seen as a secular activity.

Survival in Minnesota has much to do with terrain and climate. Traditional implements that enable survival include fishing lures, duck decoys, snowshoes, tools for hunting and gathering food, and Old World devices deemed reliable in a new environment. For example, John Juhala, born in Biwabik in 1904, remembers using a *potkukelkka* (Cat. no. 41) or Finnish kick sled as a means of getting across the crusted deep snow of fields and roads for trips to the grocery store or to pick up his date for a Saturday night dance at the local Finnish hall.

The vast majority of artifacts for work, play, and survival fall under the rubric of integrated traditions. This grouping tells us that the pieces served immediate functions in everyday life.

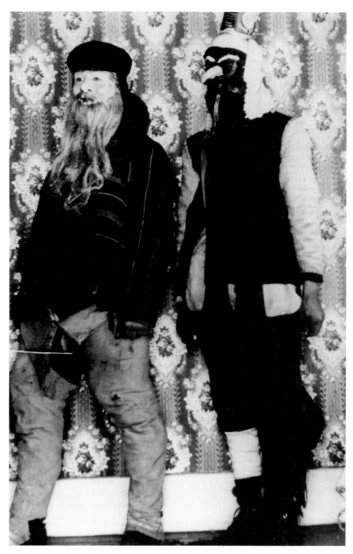

Young men going Julebukking, Madison, 1908. (Photograph courtesy of the Minnesota Historical Society)

Expressions of Spiritual Community

Traditional religious art is one of the most enduring and powerful forms of expression in American history, continuing into contemporary times. It brings into focus the religious foundations of our national life, though often through a regional or sectarian perspective, and it demonstrates the diverse and enduring personal faiths of the American people. All of the objects in this context carry dense symbolic import. And because these objects symbolize and are integrated with ritual, cultural images, and social values, their power lies in their meaning.

Expressions of spiritual community, like secular folk arts, are a result of both cultural or community aesthetic values and the visions of inspired individual artists. The authors of the comprehensive study, *Religious Folk Art in America,* acknowledged that "religious folk art is but a single strand of the cultural fabric that forms the religious life of a folk group" and limited their coverage to items in six categories, including documentation of spiritual events, expression of visionary views, and evangelizing art. Their examples, drawn from the Judeo-Christian traditions, represent a predominance of individualized pieces by artists who had undergone intensive religious experiences in a variety of contexts.[19]

Minnesota expressions, on the other hand, tend to be more participatory and, with few exceptions (for example, John Rein's altar painting, Cat. no. 6), less idiosyncratic. Aside from the highly integrated material culture of the Old Order Amish, Buddhist and animist Southeast Asians, and Minnesota's Indian people, the survey documented a pattern of Minnesotans drawing upon ethnic or other, broader secular traditions to express their spiritual group identity. This expression is usually within the mainstream of religious life, though not necessarily fostered by any organizational or denominational structure. Examples include the needlepoint prayer kneeler from St. Paul's Episcopal Church, Winona, and the Hardanger lace altar cloth from the Madison Lutheran Church. Objects that express spiritual community are almost entirely integrated traditions, and in this pattern we learn something about the nature of the traditional arts in spiritual contexts. Their power and meaning are not necessarily derived from their formal beauty or their monetary value. Their intrinsic value lies in their ability to inspire and perhaps unite a community in a shared belief system.

Many of these arts of spiritual community are associated with religious ritual and ceremony. Cases in point are the ancient Jewish traditions that continue today. One rather commonplace but meaningful tradition is the creation of *kepot,* also called *yarlmulkahs,* the caps once worn only by males and now sometimes worn while praying by women as well as children of both sexes. It is significant that the caps may be valued as works of art as well as ritual objects. Ardis Wexler, for example, entered the ones she made for her son and daughter in the creative arts division of the Minnesota State Fair in 1985 (Cat. no. 57). Her action suggests that the form, at least, is understood by a general public and may be placed in public competition without diminishing its symbolic meaning. While such headwear may be purchased at religious specialty shops, women traditionally knit or crochet them for children and grandchildren, especially at the time of their Bar and Bat Mitzvahs (coming-of-age rituals).[20] Other traditional ritual items include *mizrachs* (Cat. no. 33), ornamental designs that serve as prayer reminders and are attached to the eastern wall of a room in the home, and *mezuzzahs,* scripture containers fastened to the door frames of homes. They are generally created by professional artists according to

community or denominational norms and are acquired from specialty shops or from the artist directly. However, these integrated objects may be created by folk artists, untutored individuals, and even children in Sunday school and serve as meaningfully as professionally rendered items.

The rich textiles of the Hmong refugee community in Minnesota provide an example of a continuing integrated tradition in a ceremonial context.[21] In an essay on tradition and change in Hmong art, Joanne Cubbs explains: "In death, as in early life, the human soul faces great peril. Paj ntaub (literally, 'flowery cloth') assists in the passage from this world to the next."[22] Unlike most of their neighbors in Buddhist Southeast Asia, the Hmong are animists, and their artwork is intricately integrated with their belief system. The elaborate Green Hmong funeral costume, for example, serves a specific function in their traditional religion. Women sew funeral clothing for their husbands, fathers-in-law, and themselves as one of many gestures of respect, reflecting traditional Hmong patrilineal family structure and the place of women therein. These tokens, from simple needlework pieces to entire costumes, some with designs conveying family or lineage cohesiveness and depictions of the deceased's possessions, are buried with the body. They afford special protection during the long journey to the netherworld and ensure a prosperous and fortuitous reincarnation for the deceased.

Frequently, objects of spiritual importance have utilitarian and social functions as well. The best example is found among Old Order Amish communities whose entire world view is imbued with practical, unpretentious modes of behavior. All aspects of material culture are determined by the elders of the community, based on interpretation of their history and holy scripture. For example, women's caps, black for day wear at work and white for worship, are handmade at home according to styles traditional within a particular community, a continuation of the form used in their former homes, perhaps in Ohio, Indiana, or Iowa. Buggy design, too, and even the accoutrements such as lights and windscreens, are subtly tailored to their spiritual beliefs. When an Amishman orders a buggy from a maker in Harmony, Minnesota, he knows that kerosene lanterns will serve as lights and there will be no plastic windscreens because, they feel, if it is cold enough to need a windscreen to protect the driver, then it is too cold to be out with a horse. And yet, only some miles to the northeast in Utica, Amish families drive buggies with windscreens and battery-powered lights. Furthermore, the old requirement in Utica of open courting buggies for the young has recently been relaxed, and youths are now courting in enclosed vehicles that conform in style and size to all others in the community.[23]

Like the Ojibway, who have decorated jingle dresses with cones cut from Copenhagen snuff-can lids and, more lately, soft drink pull-tabs, the Amish place little importance upon material; their emphases are upon process, form, function, and symbolic meaning. The Amish easily adopted cotton-polyester cloth for quilts, plywood and plastic-coated sheeting for buggy roofs, and commercially produced wagon wheels, but they draw the line at buttons or electrically powered tools. Old Order Amish, uncomfortable with the compromises that modern technology places upon life in America, will purchase only handmade straw hats, while their more liberal brethren are content with factory-made hats that are cheaper but less durable.[24]

Basically, groups or communities maintain boundaries through a conscious yet subtle use of forms and styles. Such boundary maintenance is a major concern in many spiritual communities such as the Amish, Jews, the Hmong, and the

Ojibway. The need to be set apart, even from other Amish, synagogue congregations, or tribal groups differing only in subtle ways, is intrinsic in this behavior pattern. When Linda Isham, an Ojibway from Nett Lake, sent her five-year-old son to school for the first time, she made him a special cap: a common blue baseball cap but one with colorful beading and quillwork covering the crown and a small eagle feather attached. "So he will be protected from harm and never forget who he is," she explained.

FOOD is a quintessential example of the fusion of ethnic and religious identities. The metaphors of food *qua* gift, nourishment, and communion are presented in visual form at particular times of the week or year. In most cases form itself is both the major consideration and the major contributor to symbolic meaning. For example, Rose Hanna, St. Paul, is a Palestinian Christian who continues the tradition of making Easter pastries (Cat. no. 36) consisting of two parts: the crown of thorns base and the rounded, sepulchral top, both symbols drawn from Christ's passion at the Passover and crucifixion. The Laotian kau-tum, a sweet rice patty flavored with coconut, sugar, and banana or sometimes mung beans or meat, is wrapped in a banana leaf (Cat. no. 11). Shaped in a pyramidal form resembling both the Buddhist temple spires and the traditional pressed-palms greeting, this cake is a traditional gift to monks, especially on certain festival days such as the anniversary of Buddha's birth or at the New Year.[25]

Beyond form itself, the preparation and consumption of certain traditional foods are also perceived as part of the life of a spiritual community. On the Saturday before Easter, Ukrainian Americans at St. Constantine's Ukrainian Catholic Church in Minneapolis prepare special Easter baskets of meat, dairy products, decorated eggs, bread, and herbs, all arranged in towels embroidered with Ukrainian designs. The basket's contents are blessed by a priest and eventually serve as a communal meal, signaling the advent of the new religious year. Likewise, delicately designed Norwegian pastries, consisting mainly of butter and sugar, are part of the ritual of family gatherings across Minnesota each year as Christmas approaches. These foods unite the faithful through a continued attention to both form and meaning.

The process of preparing some traditional foods may reflect social interaction as well as satisfy specific social obligations. For example, when three generations of women gather in a synagogue kitchen to prepare Hamentaschen (Purim pastries), the older generation is clearly in charge. They are expert in every detail and they orchestrate the action, even though their daughters are perfectly capable of completing the task. In this way traditional art serves to communicate social hierarchy and privilege as elders assert traditional ideas, aesthetic standards, and social norms.

SETTINGS sometimes determine symbolic meaning. Family grottoes, found mainly in predominantly Roman Catholic communities such as the German Americans of Stearns County and the French Canadians of Red Lake Falls, are a good example of spiritual expression purposefully placed in a public setting. These shrines are primarily personal expressions of piety and are assembled in front or side yards as public testimonies that memorialize events in the family's history. In St. Cloud, Edward Winczewski and his family constructed a shrine to the Virgin Mary, including real rosary beads in her hands, to express their thankfulness for two children completing college; to commemorate her father's death, Mary Redick of Brandon converted a storm-struck elm into a colorful shrine to the Virgin Mary (Cat. no. 20).

Finally, the vestments worn today by the Reverend William J. Straka at the Roman Catholic Little Flower Mission on the west shore of Mille Lacs Lake are a prime example of participation in and sharing of tradition. In the 1960s Father Straka's predecessor encouraged his female parishioners, principally Ojibway, to contribute something from their aesthetic traditions to the celebration of the mass. Their choice was to decorate certain items used in the services with traditional quillwork and beadwork. The priest's vestments, a birch-bark ricing basket once used as a collection vessel, and a tabernacle cover all are embellished with designs meaningful to the local Ojibway people, integrating their long-established ceremonial art with their present belief system.

Adjustments to Change through the Traditional Arts

Change is intrinsic to the traditional arts, since culture itself is dynamic and ever changing. Using change as a context for traditional arts allows us to see the ways in which artists deal with change—personal, political, sociocultural, and technological—and the ways in which it has influenced old forms, techniques, and processes or has generated new ones.

Perhaps no culture group has encountered more change than the Hmong people of Laos who became refugees in the United States, France, and other western countries at the conclusion of the Vietnam War in 1975. Largely preliterate, these people had lived as subsistence farmers in the mountains of northern Laos since leaving their original homeland in southwest China hundreds of years ago. While in the refugee camps of eastern Thailand, undergoing the complicated screening before being allowed to emigrate, they began to

meet westerners. Out of this contact grew a new art form, a way of dealing with change.

In the refugee camps the traditional, nonfigurative *paj ntaub* textiles evolved into story cloths depicting a wide variety of semirealistic scenarios from Hmong history and contemporary life (Cat. no. 81). Clearly a part of their refugee experience and perceptions, the story cloths functioned primarily as a source of income, helping meet the costs (including bribes) of getting to their new homes. In Minnesota as Hmong artists competed for acceptance, figures soon became less realistic, supporting Henry Glassie's observation that "folk art is characterized constantly by moves from realism to convention."[26] These cloths, however, still served as visual reminders of the traditional life left behind and as statements to Americans of what trials the Hmong endured in fleeing their homeland.

The original *paj ntaub* textile forms, usually reverse appliqué in geometric designs with cross-stitch embroidery, have been continued in this country, where they are used in a variety of integrated ways: as part of baby carriers and women's costumes and in rituals such as funerals. As Hmong settle in urban and suburban housing, the cloths also find new uses as table coverings and decorative pieces. When Minneapolis school teacher Vu Yang acquired his first personal computer, his mother saw to it that the machine was adequately protected—perhaps from dust and perhaps from spirits—by a piece of her handmade *paj ntaub* (Cat. no. 64).

Perhaps the most traditional aspect of the new art forms is the continuation of the old aesthetic evaluations that Hmong women make of each other's work. As one scholar noted, "strict attention [is paid] to precision sewing and the accurate maintenance of form. Communities rank the seamstresses . . . according to ability. Creative variations of traditional designs

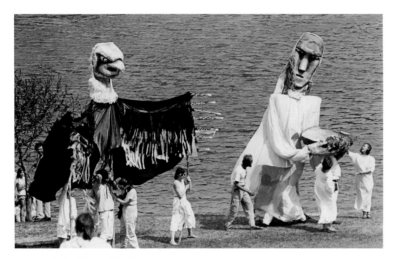

Heart of the Beast Mask and
Puppet Theater, May Day
parade, Minneapolis, 1988

receive praise and recognition."[27] Since the price of story cloths make them prohibitive for the Hmong themselves to buy, more are owned by Americans. In this way they have become pedagogical instruments, teaching Minnesotans some of Hmong contemporary history and folklore. Hmong artists continue documenting their perceptions of life on story cloths, which in turn help reinforce their children's sense of ethnic identity.[28]

SOCIAL CHANGE across America has brought forth individual responses along a wide spectrum of expression. Some are extremely personal, direct, and unsettling visual commentaries on new and threatening social issues. In the tradition of yard ornamentation, William Malwitz, Red Lake Falls, creates

assemblages of handmade and discarded materials (Cat. no. 98). One of his creations resembles an old-fashioned lawn swing, but the hand-carved figures and a sign convey his cranky impatience with feminism: "An Old Rooster's Opinion of a Modern Hen: Just eat and lay eggs."

Karen Jenson's personal change, seen in her art, is dramatic for different reasons. Of Swedish heritage and married to a Danish American, Jenson resided in a Norwegian-American community and found her first artistic expression through rosemaling, a form approved and encouraged by her community and, as she became expert, throughout the Midwest (Cat. no. 108). Later in life, at a time of personal crisis and increasing awareness of her role as a woman, she strove to express herself more in keeping with her own roots. Today, her self-expression through Swedish-style painting, clearly derivative of Dalmålning, integrates her rosemaling skills with social commentary in figurative portrayals of small-town life, personal memories, and biblical scenes (Cat. no. 17). While her Dala-style paintings attract wide attention, she must continue to rely upon her production and teaching of rosemaling as a principal source of income. In many ways, then, Jenson is both a marginal artist, somewhat apart from her community, and an accepted, widely appreciated artist in one specific genre, though not the one of her strongest creative choice. Both Malwitz and Jenson are adjusting to change, in themselves and in their place in society. Clearly, both are concerned with self-image and the social consequences of self-expression in a changing world.

Commentary on political issues is a historic pattern in the arts, and the traditional arts of Minnesota are excellent indicators of both continuity and innovation in this arena of expression. The Heart of the Beast Puppet Theater, Minneapolis, uses giant puppets to interpret controversial

issues such as the refugee sanctuary movement, nuclear disarmament, and the plight of the small family farmer for a wide variety of audiences. One of their principal presentations occurs during the first week in May, marking both May Day and the Mother's Day March for Peace. Similarly, Minnesotans contributed to the Minnesota Peace Ribbon project in 1985 through the traditional arts, responding to the theme "What I Cannot Bear to Think of as Lost Forever in a Nuclear War." Golden Valley tatter Susan E. Mansfield's contribution carried the statement: "This portion of the peace ribbon is made from tatting sewn to a broadcloth backing. I have taught tatting and would hate to see it disappear."

To a large extent, the artistic expression of some minority and radical groups since the 1960s may be interpreted as addressing political issues. Black hairstyles, first worn as a conscious sociopolitical statement in the 1960s, communicate important but ever-changing messages. Gone is the bushy "Afro" of the 1970s. The styles of the 1980s include African "corn row" braids and the dreadlocks of the Caribbean Rastafarians. When, for example, Jewelean Jackson, a black St. Paul dancer and arts advocate, attended the International Conference for Women in Kenya, 1986, she returned with corn rows as well as new resolve about her feminist role in the arts (Cat. no. 74).

Visual protests, however, are not confined to radicals or minorities but may be expressed by relatively mainstream groups. In 1985, when the Local P-9 of the United Food and Commercial Workers Union went out on strike in Austin, workers sanctioned the creation of a protest mural in the vicinity of the meat-packing plant in order to galvanize public opinion. In this effort, they resorted to a medium that has become ubiquitous and traditional, having roots in murals of the Great Depression and, in ethnic arts, even earlier.

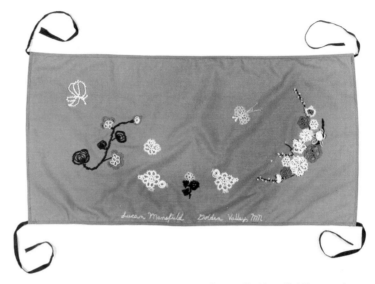

Susan E. Mansfield's tatted contribution to the peace ribbon, Golden Valley, photographed in 1988

Across America in the 1960s there emerged the Mexican-American urban folk tradition of public murals, enlivening the sides of formerly drab buildings. These derive from a precolonial Mexican mural tradition and a later fine art technique of fresco painting, both secular and religious, with strong influences from the realistic regional and narrative

painting styles of early twentieth-century America.[29] Today these murals are part of the visual landscape of the West Side Chicano neighborhood in St. Paul, conveying messages that have to do with cultural traditions and political history. The depiction on Robert Street of a peasant receiving a vision from the Virgin Mary is an excellent example of a visual tradition reinforcing a religious folk legend in the context of Chicano political struggles. It reminds the barrio that its historical roots are both real and powerful.

WITH THE ADVENT of increased leisure time during retirement, easy access to sophisticated labor-saving devices, and improved medical care, older Minnesotans now take the time to pursue those arts they knew from childhood or acquired as skills during their middle years. Though they continue as bearers of tradition within the family, their roles as artists are now more visible at the community center. By continuing to produce something the community recognizes and values, the elderly retain their place in society. Often, the traditional arts they make confer upon them a unique social status in our product-oriented, late-twentieth-century society.

This material requires a special kind of research. It is only after hours of dialogue in kitchens and workshops that one can really sense the complexity of the struggles inherent in later life changes.

Emil Weberg often lay awake at night after his wife died. They'd farmed 42 years near Maynard, MN, before he retired in 1964. Unable to sleep well, he mentally began to recreate haymaking scenes from his youth. These were pleasant memories. Since horse-driven equipment had always fascinated him, Weberg decided to construct scale replicas of three implements—a dump rake, a stacker and a baler.[30]

Weberg worked without photos, producing these replicas from memory, drawing upon his work experience in the early decades of the twentieth century. Making the models helped him face his own life changes, and he now shows them to other elders in nursing homes, creating a supportive sense of their worth as well as his. But he is also concerned that his children and grandchildren have a sense of his life and times, and he will pass on some of that heritage to them through his work.

Another dialogue over three years with Lena Homme, Willmar, revealed how she adapted to retirement from teaching school. As a young girl she was introduced to quilting by her mother. In her later years Homme explored many textile arts but took up quilting seriously as a means of enjoying her own heritage and passing it on to her grandchildren: "I had to have a craft to 'sustain me' in my retirement. I tried many. . . . But the most satisfying was quilting."[31] Weberg's and Homme's stories are not unusual. Hundreds of Minnesotans work through the same pattern for very similar reasons. Many retired farmers carve or construct objects from their pasts in miniature, which may be interpreted as a medium for reviewing and reevaluating life experiences. Some Minnesotans, especially immigrants, transform into art the forms they learned to make as subsistence crafts. Such objects decorate their homes or are given to grandchildren to promote understanding and appreciation of a grandparent's life. While many of the artists claim to be self-taught, they have, in fact, transferred skills from one craft to another: from sewing to quilting or from tractor repair to metal sculpture. Each artist has much to say about his or her life, and because one cannot say it all in detail, the artistic creations speak both cognitively and affectively.

AMONG THE ISSUES in the ongoing debate about change in the traditional arts are the proliferation of new ways to teach form and techniques and the availability of new technology. In the decades following World War II the introduction of new tools and the rapid spread of information through printed and electronic media have wrought great changes in the production of traditional art. Many quilters today, no matter how traditional their sewing techniques, may turn to published sources for guidance. Gladys Raschka and Nancy Raschka-Reeves, Minneapolis, have used computers to develop quilting designs. Halvor Landsverk of Whalan, a regionally known carver of traditional Norwegian *kubbestolar* (chairs made from a single tree trunk), uses power tools to rough out the chairs he otherwise carves by hand. He does not feel that these tools destroy the traditionality of his work and adds that, in his opinion, it is what his grandfather would have done had he access to such machinery.[32]

A more specific issue is how traditional artists perceive power tools as potential equipment. One example concerns the use of the gasoline-powered chain saw by artists who consider themselves traditional. Figure carving in wood and other materials has long been a popular art in Minnesota, beginning at least with pioneer farmers and loggers. Today, this form has been extended by skilled workers who create compelling figures of legendary heroes, beasts, and patriotic symbols. These works are found across the Midwest in farmyards, village parks, and even on suburban lawns. Though part of an older and extensive carving tradition, this is a new art in form, process, and intention. Interpreting this work as traditional art is a complex task. It utilizes a modern power tool, though carvers may refine features with a chisel or even a jackknife. There is no established style in surface treatment; the carvings are often painted in a manner similar to painting on early nineteenth-century folk carvings, yet many people prefer a natural look, leaving the sculptures to weather outdoors. The carvers are generally self-taught, having gained their experience with a chain saw elsewhere, usually cutting logs or trimming trees. They serve their neighbors by turning unsightly tree stumps, victims of storms or disease, into yard sculptures. Through their work, chain-saw carvers create and maintain a set of norms for public art. In Minnesota, these norms include such terms as *practical, natural, realistic,* and *fitting.* This art is not only a reflection of technological change but has become a traditional means to help communities create images of themselves. For example, Spring Grove in southeast Minnesota announces its Norwegianness with a troll-like figure standing at the edge of town. Eventually the carved images themselves come to be perceived as traditional.

Continuity and Variation in Traditional Arts

This is a useful context for examining a variety of significant arts on the spectrum of Minnesota's traditions. It includes those few Old World arts that have been continued in Minnesota with limited contextual changes, and it fosters understanding of innovative variations in otherwise stable arts. Folklorist Henry Glassie explained the ability of traditional artists to make decisions about style and process:

Action within tradition need not be viewed as static replication, and change need not be conceptualized as accidental or as a response to external influences. Variation within tradition may present an evolutionary or degenerative impression, but neither notion accounts for the variety observable in folk objects. The nature of tradition seems to come from an adherence to a

Katri Saari, Finnish-American weaver and traditional artist, Angora, about 1982. (Photograph by John Hanson, courtesy of the Saari family)

traditional base concept—a specific structure of components—and an employment of a traditional set of rules that prescribe a range of additive and subtractive variation. It is in the nature of man to innovate.[33]

This concept allows us to elaborate our notion of how arts that are created through new processes or from totally modern materials can be traditional.

The Minnesota tradition of weaving rag rugs from cloth scraps is well established. Notable as one of the few arts without any particular ethnic association, it is ubiquitous, especially in farming communities.[34] On her farm near Two Harbors, for example, Helga Johnson creates a half-dozen rugs each year, giving some as gifts but putting others to immediate use on her own floors. When one enters her home through the back door, the oldest, most tattered rug is just inside on the porch floor to bear the brunt of muddy shoes. The second rug, lying just ahead, is only somewhat newer, while the newest and brightest ones are in the kitchen proper.

The weaving tradition broadened in the 1960s when plastic, in the form of discarded bread wrappers, became a new scrap for rugs (Cat. no. 45). Rug makers twist the wrappers into long, tight coils and weave them on the loom just as they had done with wool, cotton, or other fabrics. The result is ideal for use in wet areas such as saunas, decks, and porches. The fact that both rags and plastic continue to be recycled into rugs throughout rural and suburban Minnesota shows how a stylistic idea embedded in tradition can be maintained through the flexibility, imagination, and skill of the traditional artist. Rugs made of bread wrappers can usually be interpreted as an integrated tradition. They are more true to the function and meaning of rag rugs than the cloth rugs that imitate older ones more closely in form but pay no attention to the base concept of frugality.

CIRCLES OF TRADITION

Clearly, we all have access, more or less, to the aesthetic impulse within a framework of tradition and in a wide variety of contexts. Indeed, many examples of Minnesota folk art can be interpreted in two or more of the contexts proposed here. Is a chain-saw carver working in a medium and process that is best seen as part of work, play, and survival; is he merely adapting and extending an Old World wood-carving tradition; or is he an example of an artist who perceives the possibilities afforded by technological change? Is Dutch-born Reit Kramer's involvement in the creation of a Norwegian-style Hardanger lace altar cloth in Madison an expression of spiritual community, a variation of crafts she learned in the Netherlands, or her way of adjusting to life in a small Norwegian-American community where her neighbors' aesthetic preferences influence her?

Through our survey and exhibition we learned what traditions exist in Minnesota and under what conditions people most readily turned to them as a means of aesthetic expression. In interviews we determined the artists' degree of affiliation with tradition, from which we built the model of the three concentric circles and four contexts. Our model allows us to accomplish three things. We may inclusively study and comprehend a wider range of art. This range extends from highly derivative or innovative expression that is akin to elite or popular art having little or no linkage to an established, ongoing tradition to the most tightly integrated work that reflects most of the spiritual, social, and aesthetic values of the artist's culture. This approach eschews defining folk art and eliminates unproductive quarrels about the pedigree of "the folk" and the sincerity of their art.

Second, we are now able to discern when and under what conditions Minnesotans are most productive of, for example, integrated forms compared to celebrated ones. We need only examine the four contexts, where we will find that Minnesotans' expressions of spiritual community and the artifacts of work, play, and survival lie mainly in the integrated circle, while the great majority of forms represented in the context of continuity and variation are often individualistic expressions or revivals that belong to the circle of celebrated traditions. And artists facing change are most strongly represented in the perceived circle, creating out of established traditions on the basis of their perceptions of personal identity.

Finally, the model of circles of tradition beckons future scholars to discern and investigate other contexts beyond those described here and to test and improve the model that we have proposed.

Dr. Moore, special curator for folk art at the University of Minnesota Art Museum from 1984–89, has published extensively on folk art, architecture, and material culture. He is a coauthor of The Minnesota Ethnic Food Book *(1986).*

NOTES

1. Michael Owen Jones, *Exploring Folk Art: Twenty Years of Thought on Craft, Work, and Aesthetics* (Ann Arbor: UMI Research Press, 1987), 8.

2. Henry Glassie, "Folk Art," in *Folklore and Folklife: An Introduction,* ed. Richard M. Dorson (University of Chicago Press, 1972), 253–80. See also Jones, *Exploring Folk Art,* 17–18, 80–83.

3. Robert T. Teske, "What is Folk Art?" *El Palacio: Magazine of the Museum of New Mexico* 88 (Winter 1982–83): 34–38.

4. See Henry Glassie's discussion of this concept in "The Variation of Concepts Within Tradition: Barn Building in Otsego County, New York," in *Geoscience and Man,* ed. Bob F. Perkins (Baton Rouge: School of Geoscience, Louisiana State University, 1974), 5:177–235. On style, see Anya P. Royce, *The Anthropology of Dance* (Bloomington: Indiana University Press, 1977), 157–58; for a seminal critique of tradition and the performance of folklore in specific groups, see Dan Ben-Amos, "Toward a Definition of Folklore in Context," *Journal of American Folklore* 84 (January–March 1971), 3–15.

5. M. Estellie Smith, "The Process of Sociocultural Continuity," *Current Anthropology* 23 (April 1982): 135.

6. Kay L. Cothran, "Participation in Tradition," in *Readings in American Folklore,* ed. Jan Harold Brunvand (New York: W. W. Norton and Co., 1979), 446; Linda Dégh, "Symbiosis of Joke and Legend: A Case of Conversational Folklore," in *Readings,* ed. Brunvand, 236–59.

7. Warren E. Roberts, "Investigating the Tree-Stump Tombstone in Indiana," with comments by Roger L. Welsch and Michael Owen Jones, in *American Material Culture and Folklife: A Prologue and Dialogue,* ed. Simon J. Bronner (Ann Arbor: UMI Research Press, 1985), 135–53.

8. Similar schematic graphs are found in the work of anthropologist Mary Douglas, which inspired our initial attempts to pictorialize the model. This concept is somewhat similar to linguist Edward T. Hall's high and low context groups; see his *Beyond Culture* (Garden City, N. Y.: Doubleday, 1977). For an application of Hall's idea to the contexts of folklore, see Barre Toelken, *The Dynamics of Folklore* (Boston: Houghton Mifflin, 1979), 52. For an early attempt to grapple with the place of folk art in a complex society, see Charles Seeger, "The Folkness of the Non-Folk vs. the Non-Folkness of the Folk," in *Folklore and Society: Essays in Honor of Benjamin A. Botkin,* ed. Bruce Jackson (Hatboro, Pa.: Folklore Associates, 1966), 1–9.

9. Those who claim that the art forms and the technique are an intuitive part of their heritage will be found in the perceived circle.

10. For a discussion of the utilitarian in relation to folk arts and crafts, see Glassie, "Folk Art," 253–80.

11. See *Western Folklore* 37 (July 1978), a topical issue devoted to occupational folklife, reprinted as Robert H. Byington, ed., *Working Americans: Contemporary Approaches to Occupational Folklife,* Smithsonian Folklife Studies No. 3, n.d.

12. Rennie was born in Scotland, grew up in Winnipeg, and moved to Minneapolis as a teenager. Bob Ehlert, "A Life Carved in Stone," *Minneapolis Star and Tribune, Sunday Magazine,* Nov. 17, 1985, p. 28–31.

13. Bruce E. Nickerson, "Factory Folklore," in *Handbook of American Folklore,* ed. Richard M. Dorson (Bloomington: Indiana University Press, 1983), 124.

14. I am indebted to Ellen J. Stekert for these entertaining stories. See also Nickerson, "Factory Folklore," 123; Yvonne Lockwood, "The Joy of Labor," *Western Folklore* 43 (July 1984): 202–11.

15. For a comprehensive review of theoretical approaches and sources, see Robert A. Georges, "Recreations and Games," in *Folklore and Folklife,* ed. Dorson, 173–89.

16. Willard B. Moore, "Ritual and Remembrance in Minnesota Folk Celebrations," *Humanities Education* 3 (September 1986): 43–52.

17. Avon Neal, *Ephemeral Folk Figures: Scarecrows, Harvest Figures, and Snowmen* (New York: Clarkson N. Potter, 1969).

18. Lyrics from Laura Savin, St. Paul, 1988.

19. C. Kurt Dewhurst, Marsha MacDowell, and Betty MacDowell, *Religious Folk Art in America: Reflections of Faith* (New York: E. P. Dutton, 1983), ix.

20. Making textiles and tailoring have been traditional Jewish crafts for centuries because Jews were excluded from the other European craft guilds. The textile trade not only allowed them mobility but also was recommended as an honorable profession in

the Talmud, the book of Jewish civil and religious law. These developments did not apply to Middle Eastern Jews. Marilyn Chiat, telephone conversation with the author, Sept. 13, 1988.

21. The Minnesota community is comprised largely of two subgroups: Green Hmong and White Hmong, each speaking a distinct dialect. Each group's name derives from the decoration on its traditional costume.

22. Joanne Cubbs, "Hmong Art: Tradition and Change," in *Hmong Art: Tradition and Change* (Sheboygan, Wis.: John Michael Kohler Arts Center, 1986), 21–29.

23. For documentation of one Old Order Amish community and its material culture, see Willard B. Moore, "A Recent Immigration to the Upper Mississippi River Valley: The Amish of Canton, MN," in *Historic Lifestyles in the Upper Mississippi River Valley,* [ed. John S. Wozniak] (Lanham, Md.: University Press of America, 1983), 347–68. For a study of variation in forms among Amish settlements, see John A. Hostetler, "The Amish Use of Symbols and their Function in Bounding the Community," *Journal of the Royal Anthropological Institute of Great Britain and Ireland* 94 (January–December 1964): 11–22.

24. Moore, "Amish of Canton," 355–56.

25. For more on the state's foodways, see Anne R. Kaplan, Marjorie A. Hoover, and Willard B. Moore, *The Minnesota Ethnic Food Book* (St. Paul: Minnesota Historical Society Press, 1986).

26. Glassie, "Folk Art," 266.

27. Sally Peterson, "Translating Experience and the Reading of a Story Cloth," *Journal of American Folklore* 101 (January–March 1988): 19.

28. For a nineteenth-century example of adjusting to relocation, see Scott Stevens, "Almon Whiting: Rural Chairmaker," *Otter Tail Record* 8 (Summer 1987): 1–4; Biloine Whiting Young, "On the Trail of the Cutlerite Settlers," *Minnesota History* 47 (Fall 1980): 111–13.

29. Alicia Maria González, "Murals: Fine, Popular, or Folk Art?" *Aztlan, International Journal of Chicano Research Studies* 13 (Spring–Fall 1982): 149–63; Shifra M. Goldman, "Mexican Muralism: Its Social-Educative Roles in Latin America and the United States," *Aztlan* 13 (Spring–Fall 1982): 127–29.

30. John Ritter, "Retirement Project Brings Back Pleasant Memories," *The Farmer,* April 6, 1985, p. 88.

31. Lena Homme to the author, ca. 1988.

32. For more on Landsverk, see p. 33, 39.

33. Glassie, "Variation of Concepts," 231.

34. Janet K. Meany, "Rag Rug Traditions," and "Log Cabin Rag Rugs," *Weaver's Journal* 9 (Spring 1985): 50–55 and 56–58. For a sociological study focusing upon the mingling of tradition and innovation, see Geraldine Niva Johnson, *Weaving Rag Rugs: A Woman's Craft in Western Maryland* (Knoxville: University of Tennessee Press, 1985).

Folk Art in Minnesota
and the Case of the Norwegian American

MARION J. NELSON

DETERMINING what is folk art in any area is difficult. Determining what it is in Minnesota is extremely problematic. The term *folk art* first entered scholarly literature in the 1890s through the work of the Austrian scholar Alois Riegl, who designated as *volkskunst* materials produced in the home for use there. Since in Europe such materials were the products of ancient tradition, Riegl and others of his time looked upon them as representing the cultural essence or fundamental spirit of the people. A concern with essences in the concept diminished, but the importance of tradition remained.[1]

About 1920, when the term *folk art* was first applied to the eighteenth- and nineteenth-century creations of the common man of eastern America, the matter of tradition created problems.[2] The people represented a variety of European folk cultures about which little was known, and even the earliest groups had been on the continent only three or four generations. American folk art, therefore, came to be interpreted as the material manifestation of a free society in which even the common man could be an artist and express himself in his own way.[3] More attention was given objects that were considered unique than standard handcrafted materials. Riegl's concept of folk art embodying the essential spirit of the culture, in this case democracy, enjoyed a

temporary revival, but it was no longer linked to tradition.

The "miracle" interpretation of the origin of American folk art, Athena rising full-grown from the head of Zeus, was challenged already in 1950 by John Kouwenhoven, and it has been rejected by most recent scholars. The fact remains, however, that being severed from the culture of their origin, Americans were left more dependent on imagination and ingenuity than were the people of long-settled countries.[4]

The historic circumstances in the eastern United States that led to difficulty in determining what should be called folk art exist to an even greater degree in Minnesota. In the East, the various ethnic groups had come in stages and settled together in rather large areas, which facilitated the retention of traditions from the place of origin. Examples are the English in New England and the Germans in Pennsylvania. In Minnesota various ethnic groups came almost simultaneously and were forced to scatter to wherever there was tillable land or other possibilities for income. For example, the Norwegians settled primarily in the southeastern, central, and northwestern parts of the state; but between these areas, and even in pockets within them, groups of other ethnic origins dominated. This settlement pattern broke down the cultural cohesiveness of a group and worked against the retention of tradition.

Settlement was also a century or more later in Minnesota than in the East, reducing the time when the hand production of domestic materials was economically feasible. Industrialization was already well in progress along the waterways of the state when the rural areas were being populated.

If we define folk art as the product of traditions in handcraftsmanship carried on in a community setting and restrict ourselves to Minnesota, we will be dealing with the art of a very limited segment of the population. Considering that folk art was once looked on as embodying the soul or essence of an entire group, it becomes clear that the use of the term for material in Minnesota creates problems. *Folk art* has continued to be associated with handcrafted traditional objects that could once legitimately be called "the people's art," but the position of such material in the culture of our time has totally changed. The people that produce it now represent a diminishing minority that is consciously resisting change while the people who originally produced it represented an unselfconscious majority. Henry Glassie, who is largely responsible for establishing the importance of tradition in the definition of folk art, realized that this was putting folk art on a dead-end street. In spite of the material folk culture that he saw around him in the 1960s, he conceded that there was little place for it "in our world. It cannot last."[5]

To get us temporarily off the dead-end street and to gain new perspective on the subject of folk art in Minnesota, we will for the moment reject the definition in which handicraft and tradition are important elements and assume that the term *folk art* means what it says, the art of the people.[6] What do the average citizens of Minnesota create in and about their homes that reflects in a material way their values, customs, and tastes as domestic handicrafts reflected those of Europe's rural population over a century ago?

Commodities are the media through which the culture of Minnesotans during most of the state's history has found material expression, and shopping is the beginning of the creative process. It is through shopping that we create our dress, an important area of the folk arts even in the past, and it is through shopping that we give individual character to our homes.[7] Through it we also manipulate our environments to reflect the seasons and times of celebration. Our vehicles, those all-important extensions of our feet, also become manifestations of our visual creativity through the selective process that takes place in the car lot.

The replacement of natural materials with manufactured goods as the media for folk expression has been going on for several centuries.[8] In Norway, most of the pigments used for rosemaling (decorative folk painting) were commercially produced and selected by artists in shops.[9] Eventually even the paints came in prepared form. Many of Norway's famous national costumes by the late eighteenth century incorporated mass-produced and imported kerchiefs or had vests, bodices, or aprons of brocades or prints that were selected from a peddler's stock rather than produced by the maker.[10] Comparable examples are also found in America, where the classic folk assemblages from mass-produced materials are quilts.

With our commodity-saturated environment, the choices we have for creating our individual or group material cultures are much greater than in the past. This is particularly true in dress, the area where the process is most prevalent and interesting. Clothing is generally sold in parts, such as skirts, jackets, and shoes. The creative process begins in the department store and reaches fulfillment in the bedroom each morning. Advertisements, peer pressure, popular heroes, and, not to be forgotten, tradition, enter into the selection; but

these only help establish common norms against which the individual choices are made. The meeting of culturally determined conformity and individual deviation is not unlike that in the great early folk traditions in dress, such as the Norwegian and Hungarian. Conformity and deviation are also found in what we do with our houses, yards, cars, and such ephemeral items as Christmas trees and birthday cakes. The major difference between early folk art and such contemporary creations is the rapidity of change, a result of modern media and planned obsolescence.[11]

I stress the importance of selection and assemblage because that is what distinguishes between the products of our temporary approach and popular art. The latter is mass-produced material that is disseminated through mass media or mass distribution systems. Examples are comic books, comic strips, movies, posters, and cutesy figurines. They can be the raw materials of folk art, as we are tentatively defining it, but they do not become folk art until they are selected by individuals and made part of a new visual whole. The selection and assemblage become comparable to what was craftsmanship in traditional folk art.[12]

A problem with our definition is that the products do not lend themselves well to exhibition. House interiors or lawns with their sections of cast-plastic fence and commercial ornaments cannot easily be presented in museums. Dress, indeed, could be, but catching full assemblages precisely as they have been put together would require collection techniques and procedures in which we are not yet especially sophisticated. And, to present the creation in its entirety, we should include the individual by and for whom the material was selected. The pieces of clothing are accessories built around a body, a face, hair; it is precisely the interrelationship between the selector and the selected that is the work of art.

The same is also true, but to a lesser degree, of interiors, yards, and vehicles.

Our exhibition problem is based on the fact that the products of our approach are so closely related to life that they cannot be plucked from it without losing qualities essential to their total character. This is true for folk art of the past as well, but we have so long treated it like high art— material that is sufficient unto itself—that its intimate relationship to a greater social, economic, and human whole has generally been lost. That makes our tentative approach appear to have nothing to do with traditional folk art, while it may in actuality be closer to it than our established conceptions allow us to realize.

People have a set of material demands which they fill in various ways. Originally many of the parts in that set had to be made by hand. Gradually these parts became available as mass-produced objects. In selecting them and pulling them together, however, one is still creating something new—one's own immediate material environment. Its nature is determined by many things, including tradition; but an individual has given it form. This is what makes it art, folk art.

But there is another folk art in Minnesota: those objects made by hand, usually at home, that carry on traditions of the past or those unusual creations of the common man that may reflect little of tradition but appeal to popular or elite taste. Including the latter with the former is justifiably an abomination to the purists for whom tradition is the key element in folk art.[13] But the exceptional work of the artistically naive has acquired such a firm place in what has come to be called folk art in America that it must be taken into account. In Minnesota the line that divides traditional from naivist (untutored) art is also far from clear. The work of some traditional craftsmen like Lars Christenson (1839–1910), who

become isolated by retaining their traditional ways while others around them change, often acquires eccentric or naive qualities. It appears that the craftsman who attempts to remain constant in a changing environment has two alternatives. The person becomes a naivist, like Christenson, from lack of interaction with a group, or the person becomes an academician, like Leif Melgaard, through constant study of the tradition he/she represents (Cat. nos. 86, 87).

The folk art of tradition and naive creation in Minnesota consists of material made for many reasons: for economy, such as early rag rugs or quilts; for amusement, such as whirligigs and miniatures; for adornment or self-satisfaction, such as paintings or crocheted doilies; and, not infrequently, for the desire to maintain something distinctive and meaningful from the past that may be threatened with extinction, such as rosemaling, egg decoration, porcupine quillwork, or acanthus woodcarving. Much of the material can be considered ethnic in that it has characteristics that relate to a specific cultural group. Even people from the eastern United States in Minnesota constitute an immigrant ethnic group because they entered from outside with their own culture almost simultaneously with the immigrants from abroad, and they were not a majority.[14]

Although the folk art of direct tradition is probably on the dead-end street that was foreseen for it, creations by the naivists continue to appear and find a public. If this work and the products of folk art revivals can justifiably be accommodated under the rubric of folk art, there may still be a future for it without making the leap, which we have just done, into an entirely new way of looking at the art of the people in an industrial and commercial age.

THE NORWEGIANS in Minnesota are well-suited for a case study in the history and evolution of an ethnic folk art in the state. They arrived in fairly large numbers comparatively early, shortly after 1850. Settling first in the southeast, they soon fanned out to cover half of the state from a line running diagonally from the southeast to the northwest corner. They originally settled in rural communities, but by the late nineteenth century they were also substantially contributing to the population of Minneapolis.[15] And since industrialization came late to Norway, they still had a living folk art tradition at the time of emigration. This, together with the fact that the first immigrants came to territory where mass-produced goods were not immediately available, led to some direct transfer of arts and crafts traditions from Norway to Minnesota. By the late nineteenth century Norwegian Americans also included a number of people without training in the arts and crafts who, sometimes with little or no reference to their heritage, created works of aesthetic interest out of sheer personal compulsion. Since the 1930s, many Norwegian Americans have been involved in an ethnic arts and crafts revival that remains strong today.

Direct transfer to Minnesota of early Norwegian folk arts and crafts traditions occurred primarily in textiles and woodwork. If hands and minds retained the early techniques, the materials—wool and wood—were there for their application. The question was one of economic feasibility. Crafts that could be done in spare time, such as knitting socks and mittens, were money saving and continued. Those that required taking time from other work, such as furniture making, did not pay for themselves after mass-produced materials became available, and they soon died out as general practices.

Looms were both brought from Norway and made by the immigrants in Minnesota, but only two examples of early

Knitting and quilt by Mari
Storvik; coverlet by Thor
Flatgard. (Photograph by Charles
Langton, courtesy Vesterheim)

Norwegian weaving in the state, other than the weaving of rugs, are known to me. One is a small collection of everyday textiles in the Blue Earth County Historical Museum. The other is a remarkable twill-weave striped coverlet, now lined with sheepskin, woven in Jackson County about 1900.[16] Even early examples of knitting are rare, but stockings and gloves knitted by Mari Storvik near Tracy (Lyon County) between the 1860s and the turn of the century reveal fine craftsmanship and design, including traditional Norwegian two-color knitting and a less common tie-dye technique.

Although Norwegian-American women dropped their native custom of weaving coverlets, they quickly picked up quilting, a technique used by the middle class in Norway but not common in the folk culture.[17] Mari Storvik quilted her Norwegian woven coverlet in America, perhaps for additional warmth or perhaps to have it conform with the bedclothes of her neighbors. She ultimately became a prize-winning quilter at the local county fair.[18] The work of Mathilda Quaal is an interesting example of the prominence of quilting among Norwegian Americans whose descendants to this day have continued to quilt. Some transfer of Norwegian color tradition, primarily a fondness for red and blue, appears to have occurred in immigrant quilts (Cat. nos. 4, 10, 14, 55, 70). The bold designs of American patchwork would have had an air of familiarity to immigrant women because of their similarity to the designs of tapestry-woven Norwegian coverlets.[19]

Of the traditional Norwegian objects of wood, spoons are most often produced by immigrants. Both the spoons themselves and the tools for their production appear to this day in southwestern Minnesota immigrant homes. Evidence of early immigrant wooden shoe and clog carving is also found in that area and in central Minnesota.[20] A superb example of direct transfer in the design and decoration of wood objects is a pair of skis, dated 1891, in the collection of the Otter Tail County Historical Society (Cat. no. 38).

Much of the handcrafted furniture of early Norwegian immigrants in Minnesota also continued traditional Norwegian folk types. Benches with seats that pulled out to make a bed, comparable to the Finnish example from Cokato (Cat. no. 54), are known in most areas settled by Norwegians in the nineteenth century. Even more prevalent was a small Empire commode, often with half-columns flanking the two middle drawers (Cat. no. 25). Victorian elements, such as carved pulls

or handkerchief drawers, were occasionally added, perhaps to make the piece more modern or simply more American. To the immigrant, modern and American may have been one and the same. Also widespread, but slightly less common, were the massive cupboards or secretaries that had claimed a prominent position in rural Norwegian households since the late eighteenth century. As immigrant furnishings they ranged from practical cabinets with a work area for the kitchen to showpieces, often including a desk, generally placed in the living room or parlor. Even less common, but known in two examples as far apart as Whalan in the southeastern and Vining in the west-central parts of the state, were the fold-down tables hinged to the wall and with one broad hinged leg at the front.[21]

Several characteristically Norwegian types of immigrant furniture appear to be limited primarily to the rural areas of southeastern Minnesota. They are the bracket-footed kitchen wall cupboard, the three-legged chair with bentwood back, the peasant Empire chair with tapered legs and plank seat, and the bench or low table with a box base containing a compartment entered through a door on the side.[22] Rare in Minnesota, although found in nearby Wisconsin and Iowa, are early examples of the *kubbestol* or log chair. Shortly after 1900, however, it appears in furniture of national romantic character in both the southeast and in Minneapolis (see page 34).

If we limited ourselves to material directly continuing tradition and produced in a community context, the above examples would be about the extent of Norwegian-American folk art in Minnesota. But there is a large body of material produced more to satisfy personal drives than to fulfill community needs. Glassie foresaw that the folk community would reduce itself to individuals, and that is indeed what happened early among the Norwegian Americans.[23] Not all

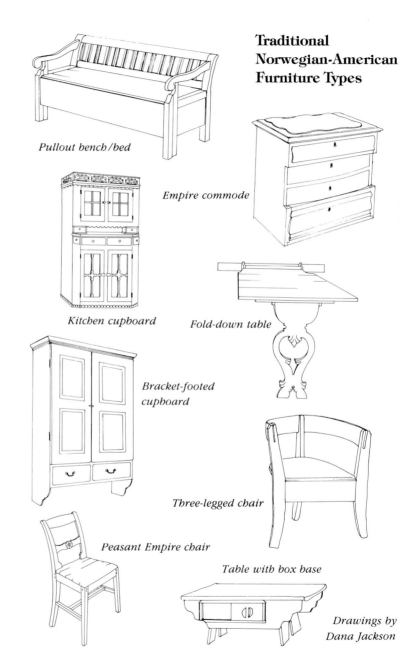

Traditional Norwegian-American Furniture Types

Pullout bench/bed

Empire commode

Kitchen cupboard

Fold-down table

Bracket-footed cupboard

Three-legged chair

Peasant Empire chair

Table with box base

Drawings by Dana Jackson

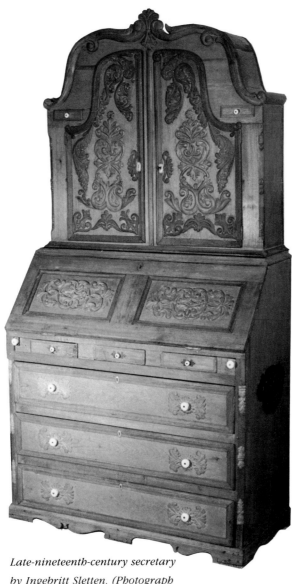

Late-nineteenth-century secretary
by Ingebritt Sletten. (Photograph
by Marion Nelson, courtesy
Marian Kenyon)

these creative individuals in the group, however, were the cultural conservatives that Glassie would consider folk. A number found new paths of expression that had little connection with tradition other than continuing handcraftmanship. Even the works of immigrant craftsmen whose point of departure is clearly in Norwegian tradition often ended up being highly individual.

Woodworkers tended to dominate among the individual creative spirits in Minnesota's Norwegian community, and furniture tended to dominate in their creations. Early examples are Lars Christenson of Benson, Ingebritt Sletten of Wanamingo, and King Olson (known through oral tradition only) of Lake Park, all of whom were active during the last two decades of the nineteenth century. Sletten is known for only two secretaries made for his children that are tours de force of the woodworker's craft. Both are based on established traditions in design and construction, but freedom in the nature and placement of the decoration and the proliferation of drawers has led to works of strong personal character.[24] King Olson takes his point of departure from small hanging cupboards or shelves that had a traditional place near the end of the table in early Norwegian rural homes. His examples are elaborately framed objects with palmette and chip-carved decoration of early origin used in a nontraditional way. One of the two objects known has an incised dedication to a man and wife and the date 1886.[25] Like the furniture of Sletten, these clearly stand apart from the comparatively simple furniture typical of the early immigrant home and must be considered products of an individual who stood equally outside the dominant culture of his community.

Christenson's only documented pieces of household furniture are two cupboards for members of his family. They, too, can be classified as slightly eccentric interpretations of

traditional types. For example, one from the 1880s is decorated with biped serpents with apples in their mouths and spiraling tails that form the double scrolls of the crown. These serpents of temptation may be the only direct transfer of the medieval Scandinavian dragon to Minnesota decorative arts. Christenson left Norway in 1864, well before the revival of the Nordic style was underway, but he knew the original material well from being baptized, confirmed, and married in the richly carved twelfth-century Stedje Church where such serpents were found on the portal.[26] Incorporating them into a cupboard of essentially baroque design, however, was his own invention. Christenson, like Sletten, was fascinated by drawers (an uncommon feature in early Norwegian furniture) and incorporated nine of them into what would ordinarily be an open counter space in such a cupboard. The American sewing machine cabinet may have been among the sources of design.

Christenson's major creation was an altarpiece, 1897–1904, based on German-Norwegian altars of the seventeenth century but incorporating elements of traditional Norwegian acanthus carving of the eighteenth century and iconography from illustrations in a Norwegian-American Bible from the 1890s.[27] He utilized these sources with exceptional creativity, producing a completely unified but highly distinctive work. The fact that the altar was not of interest to the congregation for which it was intended and that no reference was made to wood carving in Christenson's extensive obituary in the *Swift County Monitor,* December 9, 1910, indicates the segregation that had occurred by the turn of the century between the Norwegian craftsman who continued to work in the traditional mode and the Norwegian-American community.

A counterpart to Christenson's altarpiece in folk painting is John Rein's *The Last Supper,* 1895, made for the Rose Lutheran Church in Roseau County (Cat. no. 6). Rein also used

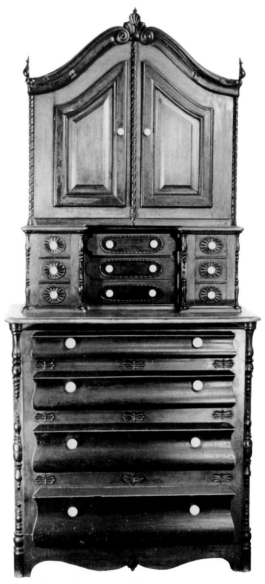

One of Lars Christenson's cupboards, 1880s. (Photograph by Darrell D. Henning, courtesy Vesterheim)

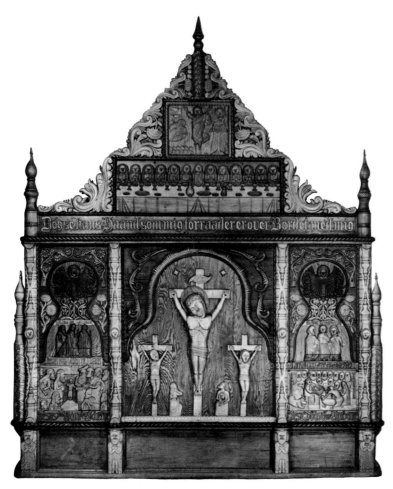

Lars Christenson altarpiece, around 1900. (Photograph by Charles Langton, courtesy Vesterheim)

not, continuing a tradition found in many Norwegian folk altars. The painting, like Christenson's carving, represents a meeting of old- and new-world elements in an artist with a strong sense of organization and the expressive possibilities of line.[28] Like Christenson, Rein received no recognition from his group in his day.

A fourth and more recent Norwegian-American carver, Hermund Melheim (born 1891) of Ray (Koochiching County), relates to our trio from the late nineteenth century in having some base in Norwegian tradition and concentrating his production on furniture. But he carries his departure from tradition—both in the types of pieces and the nature of their decoration—much farther than his earlier counterparts. Melheim's only typically Norwegian piece is a *kubbestol,* and it has been incorporated into a platform rocker.[29] Although heavy in clocks and candelabra, Melheim's work includes such contemporary furniture types as radio and TV cabinets. The decoration has its point of departure in traditional Norwegian palmette and acanthus carving, but this is treated as three-dimensional sculpture which consitutes the very structure of most pieces. Behind their apparent eccentricity, however, is a sure sense for rhythm and balance, the strongest traditional element in the works. Except for clocks, a number of which were sold or given away, and furnishings made as a contribution to the Kabetogama United Methodist Church, Melheim's production was largely for his own satisfaction. Most of his work was done after he went into semiretirement at about age fifty. The bulk of it was ultimately donated to the St. Louis County Historical Society, Duluth.

Norwegian-American Bible illustrations as models; he drew the heads of Christ and the Apostles from portraits (after Leonardo da Vinci) in some editions of the Bible used by Christenson. In placing the figures around the table, Rein was, knowingly or

The work of Sletten, Olson, Christenson, and Melheim gives no evidence of nostalgia or conscious concern with maintaining a heritage. These attributes, however, do enter into the carving of Tarkjil Landsverk (1859–1948) of Whalan,

Minnesota.[30] In addition to farming, house building, and carving, he wrote poetry in Norwegian that reveals his deep devotion to the land he left. His carving is ethnic not only in its acanthus decoration but in its use of national motifs such as Vikings and dancers in native costume. Landsverk may also have been the first Minnesota craftsman to reintroduce to immigrants that most national of furniture types, the log chair. The demand for specifically national material in Landsverk's day was not great enough to bring him much success. That came first to his son Halvor, who has made a living from log chairs since the late 1960s. The somewhat disillusioned father ended a late poem in Norwegian with the lines "Of great things life gave so little, but much of another kind."[31]

BEFORE CONSIDERING the revival of traditional crafts, we must look at several Norwegian Minnesotans who contributed distinguished examples of arts and crafts that neither continued nor consciously reintroduced specific ethnic elements. These people directly fit the popular conception of American folk artists—common people with limited or no training who through ingenuity and imagination create uncommon things. Halvor Landsverk (born 1909) belonged for a time to this group. During the 1920s and 1930s he created monumental sculpture of colored concrete and found materials.[32] In line with American folk tradition, he was drawn to subjects of national character. Several Indian sculptures known from photographs are lost, but a bust of Lincoln from the 1930s still stands in the artist's yard. A Norwegian *nisse* (elf), now at Vesterheim, the Norwegian-American Museum at Decorah, Iowa, is the only work in concrete with a Norwegian subject known to me. Even more in line with American tradition was Melvin Hall of Lanesboro, whose whirligigs and ornaments for house and yard are precisely the kind of objects

Chair, clocks, candelabra, and radio cabinet by Hermund Melheim. (Photograph by Darrell D. Henning, courtesy St. Louis County Historical Society)

considered typical of American folk art (Cat. no. 65). Having begun making "uncommon" objects after retirement, he could be partly under the influence of the American tradition. The same could be true of Olaf Gunvalson, whose remarkable

Tarkjil Landsverk and his work, including a kubbestol *or log chair. (Photograph courtesy Nordis Landsverk)*

Progress (1950) reveals the awareness of changing times and flat geometric style characteristic of naivist painting in America (Cat no. 1).

WOMEN played a major role in the direct transfer of tradition primarily through knitting and needlework, and they were also among the artists who created exceptional works that fall outside specific Norwegian tradition. A Minneapolis woman, who has not been identified, recorded in three satin-stitch embroideries her response to the immigrant experience.[33] One of what appears to be a matching pair shows the sailing from Norway toward the setting sun, while the other presents Minneapolis—identified by name—under the arch of a rainbow and a heaven of flowers and foliage. The third embroidery, which is a more realistic and perhaps later version of the Minneapolis panel, is dated 1933. Pictorial satin embroidery became popular as a middle- and upper-class craft in both Norway and America during the late nineteenth century. The style of the Minneapolis piece has echoes of both Art Nouveau and Art Deco but is not directly imitative of either. The works are original creations that directly address the immigrant experience, apparently a good one for this artist.

Nettie Bergland Halvorson, a second-generation immigrant in a family from Telemark, was a dressmaker in Minot, North Dakota, before settling as a housewife on a farm near Houston, Minnesota. There, in about 1912, she produced one of the most unique and monumental examples of folk art to have come to light in the state. It is a 6-by-11-foot textile that in technique, design, and inscription is without known prototype on either side of the Atlantic. The structure consists of a carpet warp net. Into each opening Halvorson threaded small packs of tiny cloth squares in different colors to create a landscape

with a rainbow. Against the sky are symbols of the Christian faith and a Norwegian inscription that translates: "The law of Moses fell to the earth and became nothing, but what remained was faith in Jesus." According to Halvorson's son, the work was the product of religious fervor that possessed the maker for several years. When completed, the piece was put in a closet where it remained until the contents of the house were sold at auction over sixty years later.[34]

Although having some characteristics of a rug, the Moses textile does not appear to have been made with any specific purpose in mind. Giving form to the message may have been its sole mission. It is an extreme case of the separation that had developed between an individual wanting to find expression through a handmade object and both a tradition for doing so and a community for which it might have meaning. We will see that gulf bridged, to a degree, in the ethnic and the arts and crafts revivals of the past twenty years.

Conscious retention of or returning to traditional arts and crafts, a phenomenon generally called revival, began almost as early as emigration itself. Revival was inevitable because Norway had already become aware of its arts and crafts as a national treasure before the period of greatest emigration around the turn of the century. In 1868 Eilert Sundt, a pioneer Norwegian sociologist, published a work resulting from considerable research in the field entitled *Om husfliden i Norge. Til arbeidets aere og arbeidsomhetens pris* (Concerning Home Crafts in Norway. To the honor of Work and the Praise of Industriousness). In 1876 the Museum of Industrial Arts in Oslo was founded with an educational program that included regional schools in traditional arts and crafts.[35] The element of revival in Tarkjil Landsverk's work may have resulted from exposure to these elements. From his early years Landsverk was a friend of the national romantic poet Jørund Telnes and

Halvor Landsverk's bust of Abraham Lincoln. (Photograph courtesy Nordis Landsverk)

Satin-stitch murals by unknown artist. (Photograph by Marion Nelson, courtesy Vesterheim)

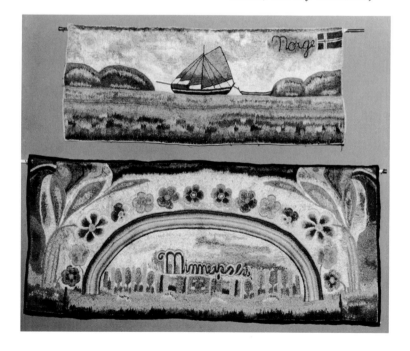

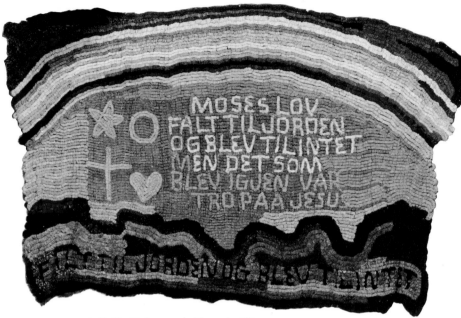

Nettie Halvorson's Moses textile.
(Photograph by Charles Langton,
courtesy Vesterheim)

continued to correspond with him after emigration.[36] Not far from Landsverk's home was Bø, a center of traditional culture, where a school of wood carving was founded as a part of the revival shortly after the Landsverks emigrated.

Hardanger embroidery in America is also primarily the result of revival in spite of its early appearance (Cat. nos. 35, 99). As part of a romantic adaptation of folk elements into Norwegian urban life during the late nineteenth century, the geometric, thread-count, cut-out embroidery that had originally had its place on the cuffs and collars of blouses and the lower borders of aprons in Hardanger and surrounding areas of Norway was transferred to bed and table linens and

other accessories for the home. In this form it was picked up by the European and American arts and crafts movement and was also promoted internationally by embroidery floss companies at the turn of the century.[37] Almost all the Hardanger embroidery that is found among the immigrants stems from this phase of its history, but its early arrival and popularity in America led to its again becoming a folk art in its revived form. These circumstances have also given it a demographic base different from other immigrant ethnic arts and crafts. While retaining special significance to Norwegian Americans, it has become as much a regional as an ethnic craft. A walk through the Creative Arts Building at the Minnesota State Fair will confirm this, as do the surveys of ethnic arts in Minnesota made by Hulda Curl, Joseph Ordos, and John Berquist around 1980. Only four of their ten interviewees who made Hardanger embroidery were of Norwegian background. The person who has led the recent Hardanger movement in that bastion of Norwegianism— Milan, Minnesota—is a Dutch-born woman, Riet Kramer.

IN 1925 the Norwegians in Minnesota got a head start on what in the late 1950s would mature as the new ethnicity. The year marked the centennial of the first organized emigration from Norway to America, and the Norwegian Americans took the opportunity to remuster their forces after having been weakened by the restrictive attitudes toward immigrants that prevailed during World War I.[38] The decision to make the Twin Cities the focal point of this national celebration was especially significant for the Norwegians in Minnesota. A part of the celebration was an exhibition at the state fairgrounds that included the arts and crafts of Norway and the Norwegians in America. Judging from the numbers attending other events, a total of about seventy-five thousand saw the

exhibition during the three-day celebration. To most of the second-generation immigrants, who had never visited the homeland, the exhibition was the first opportunity to experience the folk design and craftsmanship of Norway beyond what remained in immigrant homes.

A major centennial gift of folk objects presented to the Norwegian-American people by museums in Norway was put in trust at the Norwegian-American Museum in Decorah, giving it the most comprehensive collection of material relating to any immigrant ethnic group in America.[39] The museum remains a source of visual inspiration for Norwegian Americans and has been used especially by Minnesotans because of their proximity to it. In 1967 it developed an educational program and judged exhibitions in traditional arts and crafts that became closely associated with the ethnic crafts revival.

The revival arts and crafts that preceded the centennial were primarily echoes of the traditional crafts revival that began in Norway shortly before the turn of the century. Following the centennial, but not reaching significant proportions until the 1960s, was an immigrant-based crafts revival that grew out of the psychological needs of displaced peoples. It encompassed most American ethnic groups. Many of the people involved had no background in the traditional arts and crafts that they were reclaiming as their own. They acquired their knowledge through books, study abroad, teachers from abroad, or, in isolated cases, from older members of the group who had acquired knowledge of the crafts through direct tradition. It is likely that never before in Minnesota had so many people, other than the American Indians, been involved with arts and crafts; in addition, for the first time there was also a substantial buying public to give the production of ethnic arts and crafts a financial base.[40]

A number of circumstances contributed to the ethnic crafts revival. It was part of a larger wave of ethnic awareness in the American population that was in turn linked to the civil rights movement. The term *ethnic* had been limited to those people whose physical and cultural characteristics set them clearly apart from the Anglo-Saxon base of American society and who therefore were most subject to discrimination. The group was expanded by Michael Novak who in 1971 rose to the defense of the PIGS (Poles, Italians, Greeks, and Slavs).[41] Paralleling this broadened concern with group discrimination was a growing interest in cultural distinctiveness among peoples for whom that distinctiveness created no particular social or economic problem—primarily the non-Anglo-Saxons of Germanic background. The rapid advance of mass culture and the naive application of the melting pot theory had brought many Americans to an identity crisis. They sought an opportunity to investigate personal origins and acquire better understanding of their individual positions in the evolving society. Genealogy became a common concern, largely due to the impact in 1976 of Alex Haley's *Roots*. Traditional crafts furnished the visual symbols for the new ethnicity creating the first substantial market in America for ethnic folk art or material of its type.[42] International and ethnic fairs, a product of America's new ethnic awareness, became major marketplaces for products of the ethnic crafts revival.

Another development that reinforced the ethnic crafts revival was a second general arts and crafts movement comparable in many ways to the one that occurred at the end of the nineteenth century.[43] It, like the ethnic revival, was a reaction against mass culture, not because of its oppressive consequences for minority groups, but because it removed the presence of the human hand from objects of everyday use and reduced the possibilities for self-expression even among members of the larger society. Pacifist interests were also at

work. By taking the production and distribution of everyday objects out of the hands of big business, one was no longer supporting its military interests.[44] The major public reflection of this second arts and crafts movement was the great boom in art fairs and boutiques. These became markets for the ethnic folk craftsman as well, supplementing those of the international and ethnic fairs and festivals.

The affluence of the time was important to both the general and the ethnic arts and crafts movement. As mentioned earlier, handcraftsmanship is not economically feasible in an industrial society. The products, unless produced as a hobby without concern for making a living wage, become luxury items because of their cost. During the 1960s and ensuing years, however, such items were within economic reach for a large portion of society. The idealistic goals of the movement alone could not have sustained it. Since 1980 its decline has closely paralleled a decline in the economy.

Scholars and collectors have had difficulty recognizing the products of the ethnic arts and crafts revival as folk art. The revival crafts—the result of a self-conscious effort to produce ethnic objects by people who have had to learn the traditions from scratch—come from social and economic contexts quite different from traditional ones. However, as the product of a specific group need—now psychological rather than utilitarian—the revival material is nearer that of early folk art than those isolated examples of creativity that occurred during the middle period of our immigrant history. It was first during the revival that *traditions* in the arts and crafts of Minnesota's ethnic communities developed. Nothing comparable to the cross-influences that have led to a Twin Cities style in Ukrainian egg decoration or a Milan style in Norwegian rosemaling existed in the state, except among the Indian people, until about thirty years ago (Cat. nos. 5, 10, 108).

THE RECENT ethnic and arts and crafts revivals are reflected directly in what has happened among the Norwegians in Minnesota. For them the movement began with rosemaling, which in Minnesota has roots going back to about 1940. No rosemaling was done in Minnesota previously on which to base the movement. It was a direct extension of a slightly earlier rosemaling revival in Wisconsin, for which Per Lysne of Stoughton was responsible. He was involved in the arts and crafts revival in Norway before he emigrated in 1907, and he served as a link between Norway and the quite separate recent ethnic crafts revival among the immigrants.[45] In 1939 Lysne was commissioned by Eleanor and Edward Ericson of St. Paul to decorate their kitchen, and this led to Eleanor's learning Lysne's basic rosemaling techniques. Bullard's Jewelry Store in Minneapolis became her outlet, and she painted thousands of plates for the store in the 1940s and 1950s. These plates, together with a story on the Ericson kitchen in a July 1940 article in the *St. Paul Dispatch* and the fact that Macalester College was using Lysne plates as presentation gifts, led to general interest in rosemaling throughout the Twin Cities.[46] When Hans Berg, a trained artist from Norway, settled in Minneapolis in 1950 he found little demand for teaching in the fine arts but a great demand for instruction in rosemaling. This he taught to adults at Augsburg College from 1951 to 1959. Berg's involvement with rosemaling in Norway had been limited, but he conscientiously taught basic rosemaling techniques to the first group of Minnesota painters in the rosemaling revival.[47]

In 1967 Minnesota painters were among the participants at the Norwegian-American Museum, now called Vesterheim, when it held its first national exhibition of rosemaling with a Norwegian painter on the panel of judges and established its program of workshops taught by painters from Norway. At

that time the Minnesota painters took second place to painters from Wisconsin and Seattle, but they developed very quickly and now claim eight of the twenty-nine gold medals presented at the Vesterheim exhibitions for accumulated awards.

Two centers of rosemaling exist in Minnesota. One is the Twin Cities, where the two major regional styles in Norway, Telemark and Hallingdal, have been maintained in rather pure form (Cat. no. 66). The other is Milan, which has its own version of the Telemark style, developed largely by Karen Jenson (Cat. nos. 10, 108). The state's two most original styles, as might be expected, were developed by painters living outside these major centers of activity: Suzanne Toftey of St. Cloud, who incorporates figures in both a realistic and traditional style into her rosemaling, and Trudy Peach of Howard Lake, who has developed an intricate style of geometric painting based on the rosemaling of Rogaland.

A movement in traditional Norwegian weaving in Minnesota did not get underway until the 1970s, and it has not reached the dimensions of the rosemaling revival. The space required for equipment and the time for production may contribute to this. Like rosemaling, weaving had little tradition from the pioneer period on which to build, and the few Twin Cities tapestry weavers from the earlier arts and crafts movement did not leave an adequate legacy for further development. The centers of activity are the Minnesota Weavers Guild in the Twin Cities, which has a small auxiliary group called De norske vevere (the Norwegian Weavers), and the Rochester/Zumbrota area, where the inspiration and teaching of Elisabeth Lomen, an immigrant from rural Valdres, Norway, has played a major role in stimulating interest. As in rosemaling, the classes by teachers from Norway, the exhibitions judged by them, and the study trips to Norway sponsored by Vesterheim have also been important. Several

weavers affiliated with the movement, such as John Skare of Bricelyn, are finding a place in the world of contemporary art weaving.

Unlike rosemaling and weaving, recent Norwegian-American wood carving had a local tradition behind it. Major links in that tradition are the two Landsverks, whose carving in Minnesota spans more than one hundred years. When demand for ethnic crafts arose among the immigrants in the late 1960s, Halvor Landsverk, who had returned from sculpting in concrete to the tradition of his father, was ready to fill it. He left a factory job in Winona about 1967 and has since then carved most of his 275 log chairs with acanthus and other typically Norwegian decoration.[48] Through a widely distributed film on him, through his demonstrations at the Nordic Fest in Decorah, and through much newspaper coverage, Landsverk has been a major inspiration to young carvers.

Two other decorative carvers of significance in the recent revival, Gunnar Odden (1895–1977) and Leif Melgaard (born 1899), received their foundation in carving shortly after 1900 in remote areas of Norway where local traditions were being met by the national craft revival. They did little carving during their first fifty years in America but returned to it in the 1960s and 1970s when the reawakening of interest in traditional crafts occurred. Odden, a meticulous carver from Seljord, Telemark, who spent most of his life in the Hazel Run and Canby areas of west-central Minnesota, died just when his work was beginning to receive attention in the late 1970s.[49] Melgaard, who spent his first twenty-one years in the old wood-carving milieu of Sør-Fron in Gudbrandsdalen and who also studied with Lillevik, a major Norwegian carver, before immigrating to Minneapolis, continues to be a force in the Norwegian-American wood-carving revival. His ongoing ability

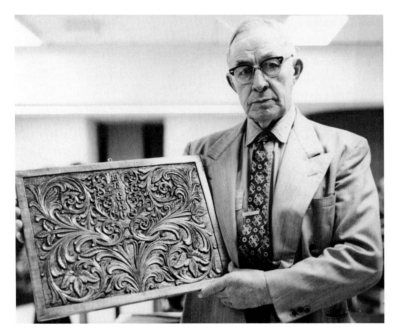

Gunnar Odden and decorative plaque dated 1973. (Courtesy Erma Iverson)

in these techniques at about eighty after a long life of other occupations in America. His exceptional understanding of wood and the fact that he continued to make traditional vessels until his death at age 104 made him something of a hero to the younger generation of craftsmen.[50]

Somewhat apart from the decorative carvers and woodworkers are the figure carvers. They, too, have local traditions to build on and lines going directly back to Norway. The most monumental example of early immigrant figure carving is the Lars Christenson altar from the turn of the century, but figures were also being carved at the time by the elder Landsverk and others in southeastern Minnesota. The horses of Hans Engen (1833–?), Spring Grove, form a direct link between the early period and the revival by being an inspiration to his grandnephew, Sander Swenson, Spring Grove, (Cat. no. 92) who is carving today. The horses of the elder immigrant have given to Sander's a timeless stylization that has its origin in early Norwegian tradition. The fact that Sander is now primarily carving model cars, however, into which it is difficult to transfer Norwegian folk qualities, indicates how fragile the situation is for truly ethnic folk arts in our industrial society.

The link that had been established during the revival between the producers of ethnic arts and crafts and an appreciative public created a social and economic base for the rise of new traditions rooted in the old. Some have already emerged, such as Eastern European Easter eggs and Norwegian rosemaling. The extent to which they continue will depend on how long the members of ethnic groups retain the need for an identity beyond the American and how long they have adequate affluence to purchase handcrafted materials that answer to that need. The number of people who have fit both qualifications even during the recent wave of affluence and

at ninety to create freely but with absolute purity in both ethnic and classical traditions makes him a rare folk phenomenon (Cat. nos. 86, 87). Although he does not teach, his legacy is being carried on by such young carvers as Hans Sandom of Minneapolis.

The woodworker Severt Rasmuson (1883–1987) of the Detroit Lakes area (Cat. no. 68) had a history similar to that of Odden and Melgaard. He was acquainted with the stave and bentwood techniques of making vessels from his boyhood in Nordfjord, Norway, during the 1890s and returned to working

ethnic awareness has been small in comparison to the total population of the state, and there are indications that even this number is diminishing.

It may be that the next exhibition of folk art in Minnesota will have to take an entirely different character if, as indicated earlier, what is considered folk art at that time will lend itself to exhibition at all. Or, it might be that future exhibitions will resemble this one, with a body of new material that will have arisen from the new base in handicrafts being established by the current revival. John A. Kouwenhoven, who as early as 1948 argued that the art of the American people has its roots in modern industry rather than in crafts, relates a surprising observation near the end of the work. "Forms inherited from an older generation still must play an important role if we are not to be aesthetically starved, or at least undernourished."[51] Perhaps he is right.

Dr. Nelson is professor of art history, University of Minnesota, and director of Vesterheim, the Norwegian-American Museum in Decorah, Iowa.

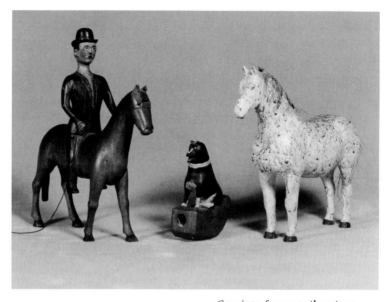

Carvings from southeastern Minnesota: horse and rider by George Wong, pipe bowl and horse by Hans Engen. (Photograph by Charles Langton, courtesy Vesterheim)

NOTES

1. It is generally accepted that Riegl established *folk art* as a scholarly term in his *Volkskunst, Hausfleiss und hausindustrie* (Berlin: 1894). See Simon J. Bronner, *American Folk Art, A Guide to Sources* (New York: Garland Publishing, Inc., 1984), xv; Bengt Jacobsson, *Svensk folkkonst,* Del 2 (Lund, Sweden, 1985), 9.

2. The historiography of folk art in America has been written many times; see, for example, Bronner, *Guide to Sources,* ix–xxvii, 1–30. A well-researched account of the discovery of American folk art is Beatrix T. Rumford, "Uncommon Art of the Common People," in *Perspectives on American Folk Art,* ed. Ian M. G. Quimby and Scott

Swank (New York: W. W. Norton & Company for Winterthur Museum, 1980), 13–53. It was the stylistic relationship of early American art by the common people to modern art that led to the first wave of interest in folk art. This art, in a sense, legitimatized modernism in America. Tradition was neither noticed nor was it a concern. Art in which the carrying-on of a specific European tradition was an obvious feature, such as the Pennsylvania German *fraktur,* was not included in the seminal 1930 exhibition of folk art at Harvard University; Rumford, "Uncommon Art," 23–26.

3. The purest and most concise statement of this position is the

first paragraph of Jean Lipman's contribution to "What is American Folk Art? A Symposium," *Antiques* 57 (May 1950): 359.

4. John A. Kouwenhoven, in "What is American Folk Art?" 359; Henry Glassie, *Pattern in the Material Folk Culture of the Eastern United States* (Philadelphia: University of Pennsylvania Press, 1969). Glassie defines the folk in America as a culturally conservative minority that retains earlier values and practices against pressure from a majority "popular" group and a progressive "elite." Glassie's position was essentially shared by an entire generation of scholars of folk art in America, including Michael Owen Jones, John Michael Vlach, and Simon J. Bronner. All have degrees in folklore and all hold academic positions. A group of scholars more oriented to museums and art history, including Robert Bishop and Herbert W. Hemphill, Jr., have made room in their definitions for the exceptional creations of the essentially untutored.

5. Glassie, *Pattern*, 4–7, 237. It is revealing that after mapping out the material folk culture of the eastern United States, Glassie in the late 1970s and 1980s turned his attention to Ireland and Turkey, where circumstances have allowed greater retention of folk traditions as he sees and respects them.

6. John Kouwenhoven flirted with this idea in his *Made in America* (New York: Doubleday and Company, Inc., 1948), 15–16, but abandoned the word *folk* for *vernacular* in considering the material that typified American culture. In *Pattern*, 240, Glassie refers to Kouwenhoven's tentative reference to folk in his theory on the vernacular as "made in a weak moment."

An excellent presentation of the intuitive way in which *folk* is used even by scholars is found in Michael Owen Jones, "L-A Add-ons and Re-dos," in *Perspectives on American Folk Art*, ed. Quimby and Swank, 351–56. I consider the difference between American and European conceptions of the term the major reason for confusion in the use of it. Norbert F. Riedl, "Folklore and the Study of Material Aspects of Folk Culture," *Journal of American Folklore* 79 (Oct.–Dec. 1966): 559, sums up the European view of folk culture "as being the unconscious, unreflective, traditional part of the culture . . . an integral part of the lifeway of a people." With that definition, our tentative view of what is folk art in Minnesota today would be the only justifiable one.

7. Jones, "L-A Add-ons and Re-dos," treats modern assemblage in amateur house alterations as folk art, although he explains his difficulty with the use of this term for any phenomenon. The paper,

first presented at the Winterthur Folk Art Conference in 1977, was in advance of its time.

8. The incorporation of industrial "popular" materials into folk patterns, as well as the reverse, is dealt with by Glassie, *Pattern*, 17–28, and "Artifacts: Folk, Popular, Imaginary and Real," in *Icons of Popular Culture*, ed. Marshall Fishwick and Ray B. Browne (Bowling Green, Oh.: Bowling Green University Popular Press, 1970), 106–10.

9. Nils Ellingsgard, *Norsk Rosemåling* (Oslo: Det Norske Samlaget, 1981), 18.

10. Kjersti Skavhaug, *Våre vakre bunader* (Oslo: Hjemmenes Forlag A/S, 1978), 15.

11. Glassie considers "temporal continuities and regional differences" as basic characteristics of folk culture; see *Pattern*, 239. With our tentative definition, we find temporal change and regional uniformity to be the rule.

12. Michael Owen Jones dealt with choices in *The Hand Made Object and Its Maker* (Berkeley: University of California Press, 1975), especially preface and p. 242. The approach is behavioral and the aim is to gain understanding of how a handcrafted object comes into being and acquires its ultimate form. In this sense, the study was still artifact-oriented. Jones came nearer our tentative approach in "Modern Arts and Arcane Concepts: Expanding Folk Art Study," a paper presented at the Midwestern Conference on Folk Arts and Museums, St. Paul, 1980, when he dealt with the organizing of garbage cans on the curbs of Los Angeles suburbs as folk art. The Swedes have become very sophisticated in such behavioral and holistic approaches to modern folk (ethnological) culture. See Barbro Klein, "Swedish Folklife Research in the 1980s," *Journal of American Folklore* 99 (Oct.–Dec. 1986): 461–69.

13. "Another big piece of 'folk art' is not folk . . . the daubling of untutored geniuses"; Glassie, "Artifacts," 110. While Glassie is a strong advocate of precise definition, he is also acutely aware of its problems. In "Artifacts," 105, he admits "The mind of every man is apt to include ideas which can be classed as elite, popular, and folk: at least there is no one in America who does not carry both folk and popular culture . . . the objects we can touch may be purely of one category, or they may represent syntheses—often, very complicated syntheses."

14. John Rice, "The Old-Stock Americans," in *They Chose Minnesota: A Survey of the State's Ethnic Groups*, ed. June D. Holmquist (St. Paul: Minnesota Historical Society Press, 1981), 58–59.

15. Carlton Qualey, *Norwegian Settlement in the United States* (Northfield: Norwegian-American Historical Association, 1938), 113.

16. The loom on which the Blue Earth County examples were woven and the Jackson County coverlet and loom are in Vesterheim, the Norwegian-American Museum at Decorah, Iowa.

17. An example from urban Stavanger, Norway, dating from the early nineteenth century is in the Vesterheim collection, but no early folk examples from Norway are known to the author. Anna-Maja Nylen, *Swedish Handcraft* (New York: Van Nostrand Reinhold Company, 1977), 78–79, confirms that the quilt was primarily a middle- and upper-class object in Scandinavia.

18. The object is in the Vesterheim collection; information from the maker's granddaughter, June Kvam, Montevideo.

19. The eight-pointed star, which was the major motif in Norway's tapestry-woven coverlets, also appears in American quilt design. See Carleton L. Safford and Robert Bishop, *America's Quilts and Coverlets* (New York: E. P. Dutton & Co. Inc., 1972), 92–93, 102–3.

20. According to John Haltmeyer, a Stoddard, Wis., antique dealer, wooden-spoon-making tools and groups of spoons that appear to be by the same hand frequently show up at auctions in southeastern Minnesota, primarily the Spring Grove area; telephone interview with the author, February 5, 1988. Clogs made in the Willmar area by the Norwegian grandfather of the late Mrs. Ellwood Downs, Minneapolis, are in the possession of the author. At Vesterheim is a Norwegian-American blacksmith and shoemaker's shop, built in Caledonia, Minn., in 1855, with its equipment for making wooden shoes intact.

21. The Vining example, from about the 1880s, was moved with the log house to which it belonged to the Museum of Emigration in Hamar, Norway.

22. Both known examples surfaced in private collections in Rochester and had been obtained from immigrants' farms in the southeastern part of the state. The type is medieval and had gone out of use in most areas of Norway by the nineteenth century. Their production in Minnesota may have been limited to one craftsman.

23. Glassie, *Pattern,* 4.

24. Information on Sletten from author's interview with his great-granddaughter Marion Kenyon, Zumbrota, May 31, 1981.

25. Darrell D. Henning, et al., *Norwegian-American Wood Carving of the Upper Midwest* (Decorah, Ia.: Norwegian-American Museum, 1978), 14, 29; Marion Nelson, "The Material Culture and Folk Arts of the Norwegians in America," in *Perspectives on American Folk Art,* ed. Quimby and Swank, 118–19. Information on the second shelf and the possible name of its maker from Bruce Tomleson, Alexandria, through Donald Gilbertson, Minneapolis, in an interview with the author, Jan. 5, 1988.

26. Henning, et al., *Norwegian-American Wood Carving,* 33, 77; Nelson, "Material Culture," 110–14.

27. Marion John Nelson, "A Pioneer Artist and His Masterpiece," in *Norwegian-American Studies* 22 (Northfield: Norwegian-American Historical Assn., 1965), 3–17; *Bibelen eller Den Hellige Skrift* (Chicago: Waverly Publishing Co., with permission from A. J. Holman and Co., 1890).

28. Rena Neumann Coen, *Painting and Sculpture in Minnesota, 1820–1914* (Minneapolis: University of Minnesota Press, 1976), 60, 62, 135, and plate 31; Nelson, "Material Culture," 118–23.

29. Nelson, "Material Culture," 127–28; see also Henning, et al., *Norwegian-American Wood Carving,* 17–18, 56–57, 81.

30. The most complete presentation of Landsverk's creative work is Marion J. Nelson, "American Woodcarvers from Telemark," *Telemark Historie* (Bø, Norway) 8 (1987): 24–51. See also Henning, et al., *Norwegian-American Wood Carving,* 16, 46–47, 80; Nelson, "Material Culture," 126–29.

31. Tarkjil Landsverk, *Solglad* (published privately by Ole Godfred Landsverk, 1944), n.p.

32. The elder Landsverk may have contributed to this essentially nonethnic phase in Halvor's career. While Tarkjil was doing traditional wood carving at home, he was also designing and executing unusual architectural monuments in stone and concrete in the surrounding area. The first was a bandstand, constructed in 1925 for his local community of Highland Prairie. This was followed in 1929 by a pioneer monument for this community and in 1934 by a pioneer memorial amphitheater at Luther College in Decorah, Iowa. Elements of exceptional originality show up in these works and also in some of his carving. The occasional introduction in it of realistic snakes or rams heads gives an eccentric quality to otherwise traditional pieces. Being cut off from tradition left its mark even on this conscious cultural conservative.

The 1920s and 1930s was a time when the use of cement as an art medium received much attention. The dedication in Pedro J. and Reta A. Lemos, *Color Cement Handicraft* (Worcester, Mass.: Davis Press,

1922), reads "To Robert B. Harshe, Director of the Chicago Art Institute, for his early recognition and encouragement of Color Cement Handicraft."

33. All three pieces were found in Minneapolis antique stores, the first two as a pair and the third later. All are now in the possession of Vesterheim.

34. The work was purchased by Vesterheim from a dealer who had obtained it at the auction of the maker's estate. Information about Nettie Halvorson is from the author's interview of her eighty-year-old son Alvin, 1979. The materials for the Moses textile might have been scraps from her work as a seamstress. The work was included in the Museum of American Folk Art exhibition entitled *Religious Folk Art in America* and appears in the catalog of the same name by C. Kurt Dewhurst, et al. (New York: E. P. Dutton, 1983), 103, 148.

35. Peter Anker, *Folkekunst i Norge* (Oslo: J. W. Cappelens Forlag A.S, 1975), 21; Inger-Marie Kvaal Lie and Lauritz Opstad, eds., *Kunstindustrimuseet i Oslo* (Oslo: Kunstindustrimuseet i Oslo, 1976), xii.

36. Ole Godfred Landsverk, *The Landsverks of Seljord, 1778, 1984* (Rushford, Minn.: Ole Landsverk, 1984), 63.

37. The major instruction books used for Hardanger embroidery in the 1980s are reprints from the first quarter of the century, such as Sigrid Bright, *Hardanger Embroidery, A Complete Practical Course* (New York: Dover Publications, Inc., 1978, originally published by the Spool Cotton Company, New York).

38. The most detailed discussion of the Norse-American Centennial is Odd Lovoll, *A Folk Epic, the Bygdelag in America* (Boston: Twayne Publishers for the Norwegian-American Historical Association, 1975).

39. From its inception in 1877 the collection included Scandinavian material. In the 1890s collecting Norwegian immigrant material became a major aim. Not until 1925, however, did it become the official repository for historic objects of the Norwegians in America.

40. According to Joseph Janeti, "It might be asserted that an audience for folk song did not exist in the United States before the 1920s"; "Folk Music's Affair With Popular Culture: A Redefinition of the 'Revival,'" in *New Dimensions in Popular Culture*, ed. Russell B. Nye (Bowling Green, Oh.: Bowling Green University Popular Press,

1972), 228. The same could be said for much that is called American folk art, at least that from after the mid-nineteenth century.

41. Michael Novak, *The Rise of the Unmeltable Ethnics* (New York: The MacMillan Company, 1971), 53.

42. The craze for Pennsylvania Dutch and southwestern Indian material in the 1930s preceded these developments.

43. The relationship of these two movements is discussed in Alf H. Walle and M. L. Brimo, "Elbert Hubbard, The Arts and Crafts Movement and the Commercialization of Folk Art," *New York Folklore* 10 (Summer–Fall 1984): 60.

44. There was a political element in the ethnic revival as well. Janeti, "Folk Music's Affair," 233, considers the link with politics a key factor in bringing folk music into the popular realm in the mid-twentieth century. The great arts and crafts fairs of the 1960s and 1970s were permeated by a peace and civil rights movement atmosphere.

45. The most complete work on Lysne is Kristen Margaret Anderson, "Per Lysne, Immigrant Rosemaler," written in partial fulfillment of the requirements for the M.A. degree, University of Minnesota, 1985.

46. Telephone interview with Eleanor Ericson, St. Paul, February 5, 1988. An employee of Macalester College, Synnove Hovland, was from Stoughton and was responsible for giving Lysne rose-painted plates their special position there; Ericson interview.

47. Marie Dorn, "Hans Berg, Norwegian-American Rosemaler," a paper written for an art history class, University of Minnesota, 1975, copy in this author's possession; additional observations from author's interviews with Berg's students. A second painter with some training in rosemaling from Norway, Martin Engseth (1903–72), settled in Minneapolis in 1926 and did some painting in the 1930s. This may be the first rosemaling done in modern times in the state. His work was limited until the larger wave of rosemaling got underway in the 1960s, and he does not appear to have contributed initially to that wave; information on Engseth from Marie Dorn.

48. Nelson, "American Woodcarvers from Telemark," 38.

49. Nelson, "American Woodcarvers from Telemark," 44, 47.

50. Information on Rasmuson from Darrell D. Henning, curator at Vesterheim, who is preparing a slide tape on the processes of Rasmuson's production.

51. Kouwenhoven, *Made in America,* 268.

Giant Mosquitoes, Eelpout Displays, Pink Flamingos: Some Overlooked and Unexpected Minnesota Folk Arts

COLLEEN J. SHEEHY

IN HIS 1980 keynote address at the Midwestern Conference on Folk Arts and Museums, Louis C. Jones characterized proponents of the two major approaches to folk arts as the moldy figs and the pink flamingos. Director emeritus of the New York State Historical Society and professor of folk arts and museum administration at Cooperstown Graduate Programs in New York, Jones had long collected as well as studied American folk art; he was well qualified to comment on the history of interest in these materials. The terms vividly described the two camps: moldy figs were followers of those who had developed an interest in American folk art in the 1920s and 1930s—artists, collectors, dealers, museum staff, and some art historians—and who were attracted to the "simple" paintings and sculpture created by artists who were outside of professional art circles. Moldy figs were primarily concerned with the aesthetics of an object and with comparing it to styles in modern art. The pink flamingos, on the other hand, were mostly folklorists who had begun to study material culture, including folk art, in the late 1960s. They were interested in a group's traditions as expressed through the creation and use of objects; the scholars turned their attention to the techniques and processes used to construct artifacts as well as the social and aesthetic values they embodied. Pink flamingos were not as concerned with distinguishing between craft and art, admitting to the circle of folk art objects such as tools and household utensils that many moldy figs did not consider "art."[1]

At the same conference Michael Owen Jones, a folklorist and prominent pink flamingo, argued that folk art was "a feeling for form" that was shaped by social groups. Rather than limiting folk art to objects that have a certain appearance or that are created by a few individuals, Jones maintained that the rubric could cover such things as the way people in a given neighborhood regularly arranged their garbage cans in patterns on their boulevards. In taking his advice to examine people's feeling for form, my own work veers into the realm of pink flamingos—that netherworld where folk and popular, handwrought and mass produced, traditional and contemporary, and local and larger worlds intersect.[2]

Folk arts in the late twentieth century include more than things old, quaint, and homey like quilts that emit the aroma of grandma's homemade bread, however reassuring a connection to the past those things may provide. For if quilts and carvings are worth considering as folk art—and they are—so too are contemporary forms that express bawdier sensibilities, or that use exaggeration and irony, or that employ sophisticated technology or mass-produced items. By

45

examining some unexpected and overlooked folk arts in Minnesota—a giant mosquito sculpture, a display of fish at a town festival, St. Patrick's Day costumes, family snapshots, and arrangements of pink flamingos—we can learn something about the public nature of much late twentieth-century folk art and about the urge for visual display so central to American culture of the era. By considering artifacts that reveal a feeling for form shaped by group values and experiences, we can take what might be called a postmodern approach to folk arts, an approach that does not view the modern world as forever split from the premodern world of the peasant but instead sees folk arts as integral to the way we make and manipulate things.

A postmodern view of folk art would include someone like Mike Schack, a retired electrician, who created a giant mosquito that sits poised for take off in his front yard in Grand Rapids, Minnesota. Mike could be called a self-taught artist. He did not learn how to build the mosquito—or any of the other sculptures in his yard—from his father or within an occupational group or from members of his ethnic group. He made it up himself, learning skills of carving and woodworking as he needed, drawing on his knowledge of materials gained in his work as an electrician and a farmer. Yet his four-foot-high mosquito should be considered an example of Minnesota folk art.

Self-taught artists have posed problems in the study of folk art, particularly for folklorists. If tradition is central to a definition of folk art, and tradition means passing down techniques, designs, and values within an identifiable group or community, then those who are self taught do not qualify as authentic folk artists. Much of what they create are unique objects, not those showing tradition and variation within a circumscribed group. Yet if we examine particular people and their creations more fully, it is possible to recognize that they interpret or express a group sensibility, even if it takes a unique form.[5]

Mike Schack made his pony-sized mosquito in the late 1970s and has not heard the end of it since. He had begun creating sculptures and planters for his yard after he and his wife, Ann, moved to Grand Rapids from their nearby farm in 1953. Freed of farm chores, Mike had time on his hands when he got home from working at the Hanna Mining Company. So he turned his energies to creating sculptures to decorate the family's sizable garden and yard. The mosquito joined old stoves that served as flower planters, a birdbath built from a truck's crankcase, and other ornaments, both handmade and store-bought.[4]

The inspiration for the mosquito came from a Minnesota experience shared by dwellers in cities, towns, country, and wilderness: working outside and being deluged by the pests. Recalling his moment of inspiration, Mike said, "It seemed like the mosquitoes were so big, so I thought—I'll make a big mosquito for the yard." In preparation he studied their anatomy, often attempting the difficult task of slapping them gently so that he could examine them under a magnifying glass, a practice his coworkers in the mines found quite amusing. Once he had mastered the insect's anatomy, Schack constructed his mosquito using a cedar pole for the body, heavy conduit wire for the legs, half-inch rubber hose for the stinger, three-eighth-inch dowels for the feelers, plastic balls for the eyes, and plywood for its wings (later changed to steel). He painted it white and black. The results of this life study were rewarding, for when he first turned the colossal insect over on its legs, he related, "I'm telling you, it even surprised me, it was so good."

Many in his community agreed. Though the Schacks' yard had been popular among neighbors before the mosquito

landed, the new addition struck a responsive chord, sparking a stream of visitors that continues to be lively ten years later. Residents and vacationers alike stopped to see the sculpture and offer their compliments. Many have photographed themselves in front of the big bug and the sign that Mike added: "Caution. Mosquito Crossing." The artist and his creation have been profiled in the Grand Rapids newspaper. Several visitors have asked Mike to make them a giant mosquito, but he wants his "the one and only," insisting that people could make their own, if they liked.

Despite being a unique object and despite Mike's status as a self-taught artist, his mosquito is more than mere novelty. It is the visual parallel to traditional stories and jokes that express widespread beliefs about ourselves and about life in Minnesota. Mosquito stories in Minnesota—many of them patterned with horror, exaggeration, and humor—are nearly as ubiquitous during summertime as comments on the weather. We tell these tales to ourselves and to outsiders to highlight perceptions and stereotypes of the tough and slightly crazy life in Minnesota.

These jokes can also be found in a variety of visual forms as, for example, on a sign painted on an ice-fishing house featuring a map of Minnesota and a hyperbolic twist on the state slogan: "Minnesota—Land of 10,000 lakes, 21,407 swamps, billions of mosquitoes, and 9 fish." A flyer advertising a 1988 Minnesota Historical Society staff meeting also expressed these traditional attitudes. Mike Budak, the site manager from Grand Mound, an Indian burial ground in northern Minnesota preserved as a historic site, was to talk about "A Biting Issue." The notice, complete with a humorous drawing of a very large mosquito, cited gleeful facts about life in Minnesota: "Did you know that if you took all the mosquitoes on the 70 acres at Grand Mound during a typical

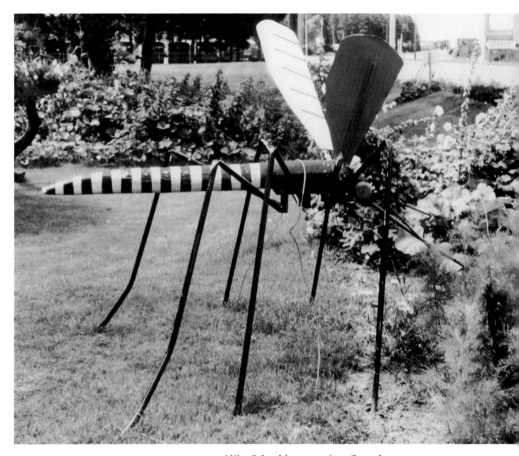

Mike Schack's mosquito, Grand Rapids, 1987. (Photograph by Colleen Sheehy)

mid-June day and placed them end-to-end they would stretch from St. Paul to Brainerd?"[5]

Mosquito jokes form part of a more general, self-deprecating style of Minnesota humor that pokes fun at residents for living in a place that suffers wind-chill factors in the winter and giant bugs in the summer. The nomination of the mosquito to be the new state bird, declared on postcards and T-shirts sold throughout Minnesota, has joined other tongue-in-cheek proposals that carp should be the state fish and lutefisk the state cuisine. The chance that this self-deprecating humor would change after the Minnesota Twins won the 1987 World Series was dubious, at best. Even the heroic Twins could not change a reputation for cold winters and summer wildlife, especially as long as the folks in International Falls kept competing for the distinction of being "the Nation's Icebox," complete with a colossal thermometer to prove it. Mike's mosquito shares traits with this thermometer (and the town's oversized Smokey the Bear statue) as well as the huge fiberglass walleyes, muskies, and other statuary throughout the state. These forms, civic boasting in a humorous style, express our tall-tale feelings about where we live. Mike's mosquito is Minnesota folk art because it puts thoroughly Minnesota attitudes into visual form.[6]

A GOOD DEAL of folk art, like the mosquito sculpture, is integrated with everyday activities and routines. But many other folk arts are made for events that punctuate routines, as do holidays and festivals. These occasions often involve the creation of objects for display and enjoyment. Some objects resurface each year, like the Christmas stockings that, once made, are carefully unpacked, hung on the mantel or staircase, and then repacked as part of the holiday customs. Yet some festive or seasonal objects are ephemeral, made for the day and then taken apart, thrown away, left to rot or melt.[7] They may be overlooked precisely because they violate our notions of art as something precious, protected, and passed down. Even if the thing itself is discarded or dismantled each year, however, it is the expected and repeated patterns of creating a jack-o'-lantern for Halloween, a display of fish at a fishing contest, or a holiday costume that provide a feeling for form and differentiate one time of the year from another.

Festivals offer many examples of ephemeral folk arts. With their emphases on temporal solidity—"this happens every year"—and on spatial stability—the annual parade down Main Street—festivals tend to expend material things in a display of confidence and prosperity.[8] Using things up is part of the pleasure of the annual cycle, and it also necessitates that they be re-created for the next time. Parade floats festooned with fragile tissue-paper flowers, for example, require that civic groups join to make new ones each year, thereby promoting the community bonds that festivals themselves dramatize in heightened form.

The display of fish at the International Eelpout Festival in Walker, Minnesota, is just such an ephemeral folk art form that expresses community values. Taking place in February, the festival centers on an ice-fishing contest on Leech Lake. But instead of competing for the largest walleye pike or muskellunge, generally the most prized catches in that area, the anglers seek the "elusive" eelpout, a rough fish that is usually avoided and often cursed by fisherfolk, since it has a charming way of wrapping itself around an arm or leg when hauled in.[9]

During this festival weekend a complete reversal takes place. Eelpout are hailed as the "best game fish on the face of the globe," while walleye, muskie, and other game fish are

relegated to rough-fish status. As the fishing contest proceeds from Friday evening to Sunday morning, eelpout catches are ceremoniously displayed at the entrance to Eelpout Headquarters, an old army tent set up on the shore of Leech Lake. As the spectacle grows, people from near and far gather to gaze on the bounty of fish, many taking pictures or posing in front of the display.

To see this display as an expression of a regional aesthetic requires some discussion about the place of fish in Minnesota culture. Bragging about good fishing has been a Minnesota tradition at least since white settlers populated the region in the nineteenth century. Promotional literature about the area as early as 1853 praised its abundant and varied fish population in hopes of attracting immigrants and tourists. Eighty years later, the *WPA Guide to Minnesota,* that grand summary of life and culture of the 1930s, still bragged about the excellent fishing to be found in the lake-studded region. More recently, a state agency brochure called Minnesota "the fishingest state in America" and claimed that residents were nearly "born with a rod and reel in their hands." This connection between state identity and fish found fitting expression in 1973 when Governor Wendell Anderson proudly displayed a northern pike on the cover of *Time* magazine to represent "the good life in Minnesota."[10]

Displays of fish that express the bounty of the state have a long history in Minnesota. Photographs from the nineteenth century before the advent of limits on catches show dozens of fish arranged symmetrically in rows, often with anglers and their tackle positioned nearby. In these pictures of plenty, the surrounding environment served as the measure of the size and accumulation of fish, providing dramatic evidence of Minnesota's bounty. Such images continued to be common in the early decades of the twentieth century when Minnesota

Harvest figure or "pumpkin girl," an example of ephemeral folk art, created by a neighbor for Caitlin Harvey (age four), Minneapolis, 1987. (Photograph by Colleen Sheehy)

The traditional aesthetic of fish displays: a fishing party, including the mayor of Walker, posed with its catch near the shore of Leech Lake, 1896. (Photograph courtesy of the Minnesota Historical Society)

resort owners routinely photographed guests with their catches, sometimes making the pictures into postcards advertising the resort. Increasingly since the 1920s, however, fish have been photographed in the hands of fishermen and women, the human body becoming the measure of fish size and the symbolic message changing from a statement about the bounty of an area to a more individualized claim about the skills of the angler.

The arrangement of fish at Eelpout Headquarters echoes the traditional forms of displays, expressing the bounty of Leech Lake in a way reminiscent of nineteenth-century imagery.[11] Yet at the same time, the eelpout display plays with that tradition. Part of its attraction is its playful praise for a normally scorned rough fish. The display overturns the accepted Minnesota hierarchy where the walleye reigns as king.

This joking reversal of values is enacted throughout the festival. The "pouters," as they are called, overturn winter's grip by engaging in summertime activities such as bowling, playing basketball, and barbecueing on the ice, all in below-zero wind chills. Some men have even golfed on the icy terrain, wearing only bathing suits and boots. At the ceremony on Sunday when prizes are given for the biggest and longest eelpout as well as the best camp and team having the most fun, participants make comments about the dastardly rough fish, the walleye, and its repulsive odor. The heady feeling of disorder marked by the eelpout's temporary reign permeates Walker for the weekend, transforming it from a sleepy winter town (population about one thousand) to a lively community that sometimes swells to between five thousand and ten thousand. Besides creating a good time and a break in winter boredom, the International Eelpout Festival stimulates Walker's economy, bringing in as much as $300,000, something noted as far away as the *Wall Street Journal*.[12]

The eelpout display, at the central site of the festival, acts as the symbolic center as well. These frozen eelpout speak of the area's resources in more ways than one. By referring to other displays of fish, their presence underlines the true hierarchy in the Walker area, where northern pike, muskies, and walleye are found in abundance. Only because those game fish are so plentiful can fisherfolk make fun of the eelpout. The display also attests to the resourcefulness of the Walker community, which through ingenuity and good humor succeeded in reaping financial bounty in difficult economic times for the region. Like other ephemeral works of folk art, however, the eelpout display is dismantled once the festival ends. The fish are prepared for a fry the following weekend at a local church or sometimes at the American Legion hall in neighboring Pine River, and then residents of the area dig in to wait for spring.

COSTUMES, especially those created each year to celebrate an event, are another class of ephemeral folk art common to festivals and holidays. Contemporary costumes rely on the art of assemblage, of making a total outfit from pieces of clothing, festival buttons, store-bought items, and face paint. Good examples of this phenomenon are the garb worn by participants in the St. Patrick's Day parade in St. Paul. On March 17 this parade winds through the city's downtown; families and friends typically have walked together holding banners or signs declaring their Irish surname or their ancestors' Irish home county or their own locale. (Groups from other Minnesota towns, such as Stillwater, also participate.)

Costumes are an important component of this annual ethnic event. The art of a St. Patrick's Day costume lies in putting together elements that express one's celebration of

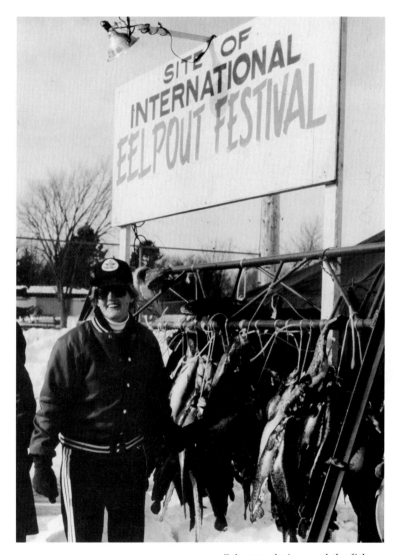

Eelpout admirer and the fish display at International Eelpout Headquarters, Walker, 1986. (Photograph by Colleen Sheehy)

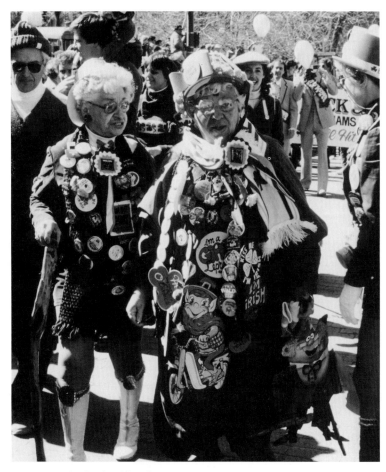

Expressing Irish identification through elaborate costumes, St. Patrick's Day parade, St. Paul, 1985. (Photograph by Colleen Sheehy)

Irishness, though often in a hyperbolic and humorous manner. Some paraders wear clothing associated with Irish culture, such as fisherman-knit sweaters or caps made or purchased in Ireland. But more common are the green outfits, emphasizing the connection to the Emerald Isle. A tame example might include a green baseball hat, green jacket, green turtleneck shirt, and green tennis shoes, finished off by a green shamrock painted on one's cheek. Others are more outlandish, constructed from green wigs or green leprechaun's hats, all-green clothing, and dozens of St. Patrick's Day buttons which are sold annually to support the celebration. These costumes give form to feelings of Irish identity and pride in a decidedly American way.[13]

Critics may cry that these are not authentic "folk" costumes because they are not authentic Irish culture, and the latter is certainly true. We should see them, however, as an expression of Irish-American culture, something that the elaborate St. Patrick's Day celebrations are themselves. In Ireland the patron saint's feast day is a religious holiday observed by going to church, not parading in the streets—at least not until the 1970s or so when the Irish themselves adopted a more public celebration like that of their American relatives. In the Irish agricultural year, the feast day marked the beginning of spring and the first planting. The religious occasion did involve wearing shamrocks, an Irish symbol of the Holy Trinity, and the lifting of Lenten restrictions on drinking.[14]

The holiday has long roots in American soil, having been celebrated as early as 1737 in Boston, 1762 in New York City, and 1771 in Philadelphia. In nineteenth-century America it became a celebration of Irishness more than a religious occasion, though attending Mass continued as an essential part of the day. In the 1840s, when large numbers of Irish

immigrants entered the country, groups in eastern cities began holding elaborate parades and dinners. In the face of considerable discrimination by native-born Americans throughout the century, St. Patrick's Day parades were vivid displays of power as well as pride.[15]

The shamrocks and items of green clothing worn in many of the St. Patrick's Day processions had political connotations, for in Irish culture green distinguished the Celts from the "Orangemen," the English and Scots who had taken over Irish lands. "The Wearing of the Green," a popular song banned in Ireland in the nineteenth century because of its political import, became a rallying cry on St. Patrick's Day in America, where Irish Americans could sing it freely while suitably attired.

In St. Paul, the first St. Patrick's Day celebration took place in 1852. The parade was suspended at the turn of the century, reputedly because of excessive drinking by participants and because Archbishop John Ireland and the Ancient Order of Hibernians, a fraternal group, wished to dispel negative images of the Irish. Not until 1967 did the parade resume, instigated by the St. Paul Downtown Council and the city's Irish-American mayor Thomas R. Byrne.[16]

The revived parade took on characteristics of other American festivals. Ethnic chauvinism was tempered by the participation of other ethnic groups, such as German and Swedish bands (present in earlier parades too), as well as by the many marchers who declared themselves "Irish for a day." Parade goers began to wear giant green cowboy hats and to blow green horns, both items that also appeared at American sporting events. The ragtag appearance of some St. Patrick's Day outfits resembles other American festive fashions, such as clown costumes or the impromptu ones made of souvenir pins worn over everyday clothing at many Minnesota town festivals.[17] Critics may decry such a clowning expression of Irish-American ethnicity, which draws on the tradition of Irish comics and the vaudeville stage, as disrespectful of Irish heritage. Yet the parade is not meant to be a somber homage to the Irish past but a good-humored and extravagant performance. Coming as it does during the bleak vestiges of winter, the St. Patrick's Day parade ushers in spring, offering a welcome splash of bright green amidst St. Paul's gray streets in a kind of midwestern Mardi Gras. The exaggerated symbolic displays in the paraders' costumes give concrete form to the heightened sense of ethnicity that is celebrated on this day.

Ephemeral folk arts like festival costumes and holiday displays offer a fruitful area for further investigation. One could also examine related phenomena like the artifacts and displays created as part of political demonstrations, events that resemble festivals in their gathering of crowds, transforming of social space, and breaking away from everyday routines and patterns.[18]

IF SOME UNEXPECTED folk art is ephemeral, much traditional art is intended to be passed down and preserved within the family. Family photographs are a prime example of this category. The content of such snapshots is generally influenced by an unspoken but broadly shared set of aesthetics that guide choices: which occasions to document, how to compose the picture, who should be included, and how the subjects should look. Almost everyone takes photographs, though relatively few people ever get formal training in how to take a good one. It is a skill developed through informal instruction and through trial and error, something learned mostly within family groups with those familiar Brownies and Instamatics that even children can use. Pictures displayed in homes and enshrined in albums say much about how a family

constructs its history and what it values. Furthermore, certain stock poses or images are shared among many American social groups.

Material culture scholar Thomas Schlereth has argued that family photography is a pervasive folk art form that can provide promising material for the study of social history. When researchers at the Office of Folklife Programs at the Smithsonian Institution in Washington, D.C., examined family photos and photo albums, for example, they found that the snapshots, like stories that family members told about themselves, were a "stylized reality" that expressed ideas and ideals—the way a given family saw itself or wished to be perceived. Certain patterned images turned up in nearly every family album—the baby picture, the birthday party, the holiday meal, the kids in the backyard swimming pool—to name a few.[19]

Family photography may be an unexpected folk art because of its reliance on the camera, a piece of technology. But more important than the tool are the traditional aesthetics that guide in creating familiar images and in deciding which pictures get passed around and passed on. The pervasiveness of photography in contemporary life offers a wide area to explore how the feeling for form takes shape and is expressed among different groups. One could examine differences in aesthetics among different classes, age and ethnic groups, or regions, taking into account what different people photograph and how the resulting pictures are shared or displayed.

As the examples of family photography and costumes assembled from store-bought items demonstrate, technology is not necessarily at odds with folk art. Folklorists in the 1980s have become more interested in art that uses mass-produced objects. They have studied holiday displays of store-bought ornaments, environments assembled from discarded objects, and customized items of mass production, such as hot-rod cars.[20] The displays of pink plastic flamingos found decorating lawns and gardens in Minnesota and across the United States—in towns, cities, and rural areas—provide an excellent case study in creativity and the customization of mass-produced artifacts. Since flamingo displays occur throughout the nation, understanding the Minnesota examples requires a broad historical, geographical, and cultural perspective.

Flamingo arrangements in middle-class American yards enjoy a respectable tradition, having first appeared on the multiplying suburban lawns of the 1920s. Those flamingos were made of cement with steel-reinforced necks, a construction technique shared with the skyscrapers of the day. The bird was associated with the idyllic environment of the zoo, where flamingo colonies had become central displays, often appearing at the entrance in a highly landscaped setting. In the 1920s the flamingo was also associated with another kind of paradise: Florida, specifically the wonderland of Miami. The twenties witnessed a boom in Florida land development, earning the state a reputation as the nation's premier vacation spot. Even though flamingos were no longer indigenous to the United States (Florida imported them from the Bahamas), the bird became a regional mascot, appearing in architectural details like wrought-iron work, murals, and bas-reliefs. It was also a hallmark of souvenirs, taken back to prove one's visit to Florida.[21]

Borrowing from those visions of paradise, the flamingo lawn ornament visually expressed idyllic notions about homeownership, something that in the 1920s was within reach of a larger middle class than ever before. At the same time, the cement statues drew on a long tradition of bird imagery—as sculptural elements and live specimens—in gardens since ancient times, though previously sculpture and rare birds had

been reserved for the wealthy, while chickens scratched in plebian yards. As recently as the Victorian era, peacocks had been kept on estate grounds of the well-to-do, but subsequently these birds were stuffed and moved inside by the fireplace, then discarded by the 1920s. In the Jazz Age, flamboyant flamingos were better suited to the new mood of the country and to the streamlined curves of art moderne. Two flamingos placed beside a birdbath or, for Catholic homeowners, placed near a religious statue, became the traditional arrangement.[22]

Cement lawn flamingos, however, were heavy and cumbersome to move for mowing and gardening. And despite steel reinforcements, the necks often broke. Over the next decades, the ornament went through several transformations, changing from molded concrete to molded ceramic and rubber and then to plywood cutouts. In the 1950s the polyethelene flamingo still popular thirty years later was created using a blow-mold construction technique. Like the era's Melmac dishes and Tupperware, this was an ornament that was light, inexpensive, and durable.[23]

The popularity of the flamingo—in yards and in domestic interior design—coincided in the 1950s with a pink explosion that transformed homes into pink paradises as kitchens, bathrooms, bedrooms, and family rooms were decorated with the color. *Life* magazine declared 1955 "The Peak Year of Pink." Americans were wearing the color as well as decorating with it. The pastel pink Brooks Brothers shirt for men and women constituted part of the Ivy League look of the time. Hotter pinks were associated with more rebellious and sensual spirits such as Elvis Presley and Marilyn Monroe.[24]

After falling into disrepute during the 1960s and 1970s when plastic and pink were unfashionable, the pink flamingo in the 1980s enjoys popularity similar to that of the 1950s. In the 1980s people from some groups display these ornaments in ways that play on the flamingo's associations with paradisical settings while others play on its association with bad taste. Many homeowners still frame birdbaths or the front door with the birds to create a pleasing display. Some Catholic homeowners, for instance, express the sacredness of the home by placing flamingos in flower-garden grottoes that center on a statue of the Blessed Virgin, Christ, or a saint, often the nature-loving St. Francis of Assisi. Like the religious statues themselves, which symbolize the holy figures, the flamingo ornaments in these arrangements refer to the actual bird, creating a vision of paradise as an appropriate and respectful setting for the statues.[25]

Flamingo ornaments displayed in new contexts and in new groupings express other attitudes. Some people choose to draw attention to the plastic pink flamingo as an artifact itself, rather than to its connotations of exotic or heavenly places. Such arrangements can make ironic comments on the setting or neighborhood, becoming a means of joking with one's neighbors or passersby. A plastic flamingo displayed on a fire-escape terrace in Minneapolis's warehouse district drew attention to its owner's unconventional "home"; the humor it created derived from placing a garden ornament in an unexpected urban setting. In Kenwood, a wealthy section of Minneapolis where the refined sensibilities of residents would usually preclude plastic pink flamingos, three of these birds were planted in a window box that accented the picture window of one home, an unusual arrangement that signaled a self-awareness about manipulating the usual garden design.

Other groups use the pink flamingo as a symbol of defiance or resistance to dominant values, drawing on its power to offend "good taste," a power strengthened through association with John Water's 1973 X-rated film *Pink*

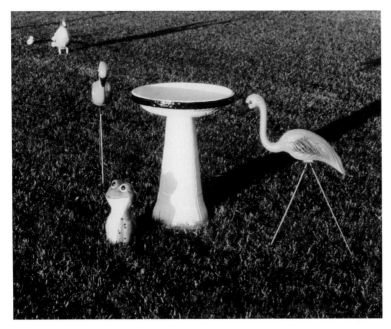

Traditional display of flamingos:
two birds on either side of a
birdbath near Battle Lake, 1985.
(Photograph by Colleen Sheehy)

Flamingos. Much that occurred in the film, which followed the adventures of Divine, a drag queen, violated common norms of behavior, just as the flamingos in the early 1970s offended the aesthetic sensibilities of the upper-middle and wealthy classes. Released at the beginnings of the Gay Pride Movement, the film gained a cult following in gay communities. Subsequently the flamingo became an emblem of gay culture. The pink flamingo displays found in the Cedar-Riverside area of Minneapolis, such as the flock often arranged in the picture window of Durable Goods, a cooperatively owned hardware store, also signal resistance in this neighborhood populated with counterculture activists who have opposed corporate control of their area since the 1960s.

Other people manipulate the aesthetics of pink flamingo displays to express attitudes about social roles and stages, a practice that has become common among new homeowners, especially those of the baby boom generation. Some displays in the Twin Cities have featured flamingos tied to the front yard's gaslight or flamingo pairs with necks intertwined, humorous arrangements that poke fun at the homeowners' new status or offer a tongue-in-cheek assertion of the owners' good taste. Teenagers sometimes earn the ire or chuckles of neighbors by "borrowing" all the flamingo lawn ornaments in a neighborhood and placing them in one front yard, mimicking a zoo's flamingo flock. By exaggerating the usual garden design of the ornament (limit of two), these pranks actually clarify the form of the acceptable display. In many cases, an observer must carefully read the flamingo arrangements to understand what their creators are communicating about the home, humor, taste, social groups, and social roles. The manner in which people arrange their flamingos reflects aesthetic choices that express affinity with certain groups and values every bit as much as did the arrangements of garbage cans that Michael Owen Jones observed.

SOME OF THESE unexpected folk arts are no longer entirely overlooked, as exhibitions like Circles of Tradition: Folk Arts in Minnesota begin to include lawn ornaments, garden displays, Halloween harvest figures, and chain-saw sculptures next to baskets and rosemaling. By examining the ways that people perpetuate, adapt, borrow, and invent traditions, this exhibition furthers our appreciation for the many ways people

create artifacts today. Quilts and carvings will remain important to understanding folk aesthetics and folk groups, but we need to enlarge the picture to include new forms, materials, and groups in order to consider the different ways that people construct things and the different avenues that tradition can take. Just as traditional foodways should include casseroles and hamburgers alongside tortillas and lutefisk, traditional arts should include lawn displays and family snapshots as pleasing forms that tell us much about the values of contemporary Minnesotans and Americans. A postmodern view of folk art rests on a belief in our powers to manipulate, assemble, dismantle, reconstruct, and to make meaning of the material world, a notion that has united those interested in folk art whether creators, collectors, or scholars, whether moldy figs or pink flamingos.

Colleen Sheehy, a doctoral candidate in American Studies at the University of Minnesota, is assistant director for touring programs at the University of Minnesota Art Museum. Her research interests include American yard displays, the subject of her dissertation, and the culture of recreational fishing in Minnesota.

Embracing birds as an assertion of the homeowner's good taste and sense of humor rather than a comment on the idyllic domestic setting, Minneapolis, 1985. (Photograph by Colleen Sheehy)

NOTES

1. Louis C. Jones, "American Folk Art, Westward Ho!" transcribed in [Jean E. Spraker, ed.], "Abstracts of Papers delivered at A Midwestern Conference on Folk Arts and Museums" (St. Paul: Minnesota Historical Society Education Division, 1980), 3–8. The conference was cosponsored by the University of Minnesota Gallery (name changed in 1983 to University Art Museum) and the Minnesota Historical Society's Center for the Study of Minnesota Folklife, with funds from the National Endowment for the Humanities. Jones referred to the discussion of moldy figs in Kenneth Ames, *Beyond Necessity: Art in the Folk Tradition* (Winterthur, Del.: Winterthur Museum with W. W. Norton & Co., 1977), 29; he attributed *pink flamingos* to folklorist Bruce Buckley. On the history of folk art

collecting and scholarship, see Beatrix T. Rumford, "Uncommon Art of the Common People: A Review of Trends in Collecting and Exhibiting of American Folk Art," in *Perspectives on American Folk Art,* ed. Ian M. G. Quimby and Scott T. Swank (New York: W. W. Norton & Co., 1980), 13–53; Eugene Metcalf, "The Politics of the Past in American Folk Art History," in *Folk Art and Art Worlds: Essays Drawn from the Washington Meeting on Folk Art,* ed. John M. Vlach and Simon J. Bronner (Ann Arbor: UMI Research Press, 1986), 27–50.

2. Michael Owen Jones, "Modern Arts and Arcane Concepts: Expanding Folk Art Study," transcribed in "Abstracts of Papers," 13–17.

3. Some folklorists have examined self-taught artists and how their creations reflect group values; see, for example, William Ferris, "Vision in Afro-American Folk Art: The Sculpture of James Thomas," *Journal of American Folklore* 88 (April/June 1975): 115–31.

4. Information here and two paragraphs below from author's interviews with Mike Schack, August 1987, March 1988, and August 1988.

5. Author photographed the ice-fishing house during the International Eelpout Festival on Leech Lake, February 1986. The flyer was posted at the Minnesota Historical Society in February 1988. Budak also was the featured speaker at Mosquito Day held at the Forest History Center in Grand Rapids, June 5, 1988. Mike Schack's mosquito was borrowed for the day to serve as the centerpiece of the festival; author's conversation with Robert "Skip" Drake, site manager, Forest History Center, Oct. 3, 1988.

6. The prominence of a self-deprecating style of Minnesota humor was discussed in Lise Lunge-Larson, "Legalizing Lutefisk," and Colleen Sheehy, "King for a Day: The Status of Fish in Two Minnesota Festivals," papers read at the Minnesota Historical Society (MHS) Annual Meeting and History Conference, Bloomington, Minn., Oct. 11, 1986. On statuary see Karal Ann Marling, *The Colossus of Roads: Myth and Symbol Along the American Highway* (Minneapolis: University of Minnesota Press, 1984); *Minneapolis Star and Tribune,* Jan. 12, 1987, p. 12A.

7. Avon Neal, *Ephemeral Folk Figures: Scarecrows, Harvest Figures, and Snowmen* (New York: Clarkson N. Potter, Inc., 1969); Jack Santino, "Halloween in America: Contemporary Customs and Performances," *Western Folklore* 42 (January 1983): 1–20, and "The Folk Assemblage of Autumn: Tradition and Creativity in Halloween Folk Art," in *Folk Art and Art Worlds,* 151–69.

8. Roger D. Abrahams, "The Language of Festivals: Celebrating the Economy," in *Celebration: Studies in Festivity and Ritual,* ed. Victor W. Turner (Washington, D.C.: Smithsonian Institution Press, 1982), 161–62.

9. Information on the International Eelpout Festival gathered during author's fieldwork, February 7–9, 1986, and from the annual souvenir editions of the *Pilot-Independent* (Walker), devoted to promotion of the festival, 1980–87.

10. John Wesley Bond, *Minnesota and Its Resources* (1856; reprint, New York: Redfield, 1893), 32; Federal Writers' Project, *The WPA Guide to Minnesota* (1938; reprint, St. Paul: Minnesota Historical Society Press, Borealis Books, 1985), 126–29; *Minnesota: Fishing the No. 1 Spot* (St. Paul: Minnesota Department of Economic Development, 1971), n.p.; *Time,* Aug. 13, 1973.

11. Matti Kaups discusses a similar fascination with reexperiencing the abundance of nineteenth-century Minnesota fishing in "Smelt-o-mania on the North Shore," *Journal of Popular Culture* 2 (Spring 1978): 959–76.

12. *Wall Street Journal,* Jan. 13, 1982, p. 33.

13. Author's fieldwork, March 1984, 1985, 1986.

14. E. Estyn Evans, *Irish Folk Ways* (London: Routledge & Kegan Paul, 1957), 260, 264–66; Kevin Danaher, *The Year in Ireland* (Cork, Ire.: Mercier Press, 1972), 60–65.

15. Patrick Blessing, "The Irish," in *The Harvard Encyclopedia of American Ethnic Groups,* ed. Stephan Thernstrom (Cambridge: Harvard University Press, 1980), 524–45; Carl F. Wittke, *The Irish in America* (New York: Russell & Russell, 1970), 199; Dennis Clark, *The Irish Relations: Trials of an Immigrant Tradition* (East Brunswick, N.J.: Associated University Presses, 1982), 193; Edward Wakin, *Enter the Irish-American* (New York: Thomas Y. Crowell Company, 1976), 151.

16. Ann Regan, "The Irish," in *They Chose Minnesota: A Survey of the State's Ethnic Groups,* ed. June D. Holmquist (St. Paul: Minnesota Historical Society Press, 1981), 145–46; 147–48; *St. Paul Pioneer Press,* Mar. 18, 1967, p. 4.

17. On the political implications of similar disheveled styles in costumes in the nineteenth century, see Susan G. Davis, *Parades and Power: Street Theatre in Nineteenth-Century Philadelphia* (Philadelphia: Temple University Press, 1986), 160.

18. For example, a twenty-foot-high puppet of Uncle Sam eating Earth served as the focal point of a political demonstration at the University of Minnesota, Minneapolis, in the spring of 1987. Or one might consider the displays that former union workers constructed in

their Austin, Minnesota, yards in July 1987 when Geo. A. Hormel & Company and the city celebrated Spam Days, honoring the fiftieth anniversary of that canned meat. At one home white crosses were placed in symmetrical rows, as if in a cemetery, to represent union workers dismissed during the Hormel strike of 1985–86.

19. Thomas Schlereth, *Artifacts and the American Past* (Nashville: American Association for State and Local History, 1980), 18; Steven J. Zeitlin, Amy J. Kotkin, and Holly Cutting Baker, *A Celebration of American Family Folklore: Tales and Traditions from the Smithsonian Collection* (New York: Pantheon Books, 1982), 182–99.

20. Santino, "Folk Assemblage of Autumn," 151–69; Verni Greenfield, *Making Do or Making Art: A Study of American Recycling* (Ann Arbor: UMI Research Press, 1986); Barbara Kirshenblatt-Gimblett, "The Future of Folklore Study in America: The Urban Frontier," *Folklore Forum* 16 (1983): 214–20. On yard displays see Fred E. H. Schroeder's seminal essay "The Democratic Yard and Garden," in his *Outlaw Aesthetics: Arts and the Public Mind* (Bowling Green, Ohio: Bowling Green State University Popular Press, 1977), 94–122; Daniel F. Ward, ed., *Personal Places: Perspectives on Informal Art Environments* (Bowling Green, Ohio: Bowling Green State University Popular Press, 1984); Mary Hufford, *One Space, Many Places: Folklife and Land Use in New Jersey's Pinelands National Reserve* (Washington, D.C.: The American Folklife Center, 1986), 88–91.

21. On the tourist trade to Florida in the 1920s, see Frederick Lewis Allen, *Only Yesterday: An Informal History of the Nineteen-Twenties* (1931; reprint, New York: Bantam Books, 1946), 301–21; for examples of flamingo imagery in Miami architecture, see Laura Cerwinske, *Tropical Deco: The Architecture and Design of Old Miami Beach* (New York: Rizzoli, 1981), 61, 87, 92; W. A. Watts, "Flame-feathered Flamingos of Florida," *National Geographic,* January 1941, p. 56–65.

22. On the values embodied in the American home, see Constance Perin, *Everything in Its Place: Social Order and Land Use in America* (Princeton: Princeton University Press, 1977); Gwendolyn Wright, *Building the Dream: A Social History of Housing in America* (Cambridge: MIT Press, 1983). See also Russell Lynes, *The Tastemakers: The Shaping of Popular Taste* (New York: Dover Publications, 1980), 165.

23. *People,* May 19, 1986, p. 125–27.

24. *Life,* May 2, 1955, p. 74–76; Ellen Melinkoff, *What We Wore: An Offbeat Social History of Women's Clothing 1950–1980* (New York: William Morrow & Co., 1984), 34.

25. Here and three paragraphs below, information on pink flamingos from the author's fieldwork and interviews in Minnesota, especially the Twin Cities, from 1984 to 1988.

Ojibway Drum Decor: Sources and Variations of Ritual Design

THOMAS VENNUM, JR.

[Nowadays] they wouldn't even start to begin to make [a drum]. They don't even take time. They'd rather go and buy a [bass] drum for a hundred dollars instead of making one for the people. And they don't even dress it up. They ain't anywheres near Indian, they don't dress it . . .
— *William Bineshi Baker, Sr., Ojibway drum maker, 1974*

IN ALL of native North American percussion, perhaps no instrument has been accorded such lavish decoration as the ceremonial dance drum of the central Algonquians. This drum and some of its attendant ritual practices originated about 1880 in the vision of Tailfeather Woman, a Dakota, who presented one to the Ojibway at Mille Lacs Reservation, Minnesota, and subsequently to other Indian peoples to promote intertribal peace.[1] The vision had come to her while she hid in a lake from United States soldiers who were slaughtering her people. Over the four days of her concealment, the Great Spirit instructed her to build a *big* drum, so that he was certain to hear it. He also taught her the songs that were meant to be performed when using the drum and explained details of the ritual.

Ojibway adoption of the so-called "Sioux drum" (*bwaani dewe'igan* in the Ojibway language) can best be interpreted as the spread of the Grass Dance eastward into the woodlands.

The Grass Dance, a ritual organization of Plains Indian warrior societies, had its origins in the Omaha Hethuska Society and diffused rapidly to most northern Plains tribes in the latter half of the nineteenth century. Grass Dance societies were structured around ritual officers, held their meetings in special dance houses, and utilized distinctive symbolic dance paraphernalia having connotations of warfare, such as "The Crow," an elaborate feather bustle worn by a society officer who had exhibited bravery on the battlefield. When the Ojibway adopted the Grass Dance, they retained much of the structure and many of the accoutrements of the northern Plains societies.

One of the distinctive features of the Grass Dance was the use of a large, horizontally supported drum surrounded by male singers. This arrangement marked a departure from former performance practices, where each singer held his own small hand drum and performed facing the dancers, not the other musicians. The large dance drum was a simple, double-headed membranophone; Ojibway refer to it by size, calling it *chi dewe'igan,* or "big drum." Plains Grass Dance societies used a hollowed-out section of tree trunk or, in some instances, simply adapted the military band bass drum, turning it on its side for performance. The central Algonquians, however, invariably converted a wooden washtub or barrel

cut down to size into a drum frame. Such a frame averaged about two feet in diameter at the top, tapering ten to fourteen inches down to a slightly smaller bottom. The two rawhide heads—usually of dehaired calfskin—were laced together or tacked to the frame. To enhance resonance when played, the drum was held a few inches off the ground by four straps attached at equidistant points around its circumference. These straps either rested in notches carved into support stakes or were lashed to these "legs," which were inserted in the earth or into holes of a fixed wooden stand.

In the Ojibway reinterpretation of the Grass Dance, the drum became the focal point around which each new society was founded. As in Grass Dance societies, officers were assigned specific duties—Drum Chief, Drum Owner, Drum Heater (to tighten slackened heads for a performance). Functioning as an icon, the drum became the very center of the new Drum Dance movement. Making a new drum or replacing one that had been passed on to another group was a solemn event involving minor ceremonies for each part of the instrument. Individuals were assigned separate tasks: men prepared the frame and attached the hide heads; four special women each made a quarter (eighteen inches) of the fully beaded belt. The undertaking was an expensive one, for people had to be paid for their work, and their materials were to be the best available. When given away, the drum had to be accompanied by money and goods for the recipients. As the Menominee drum owner Johnny Matchokamow spoke of his society's attitude toward the drum in the early 1950s: "That's the way we're supposed to do. And make him look good all the time; clean him up . . . you buy things for that Drum, you know, just to look good . . . Because . . . that Drum is from God; God put power in there, and we should take care of that."[2] This explains why mats and blankets were placed

beneath the drum so that it would never touch the ground and why clean linen was supplied to wrap it when not in use. When "resting," it was surmounted with a beautifully embroidered quilt; in its owner's house it was carefully stored in a place of safety and honor. Drumheads were to be repainted each fall and spring, and any damage to beadwork was repaired. Worn out or torn drumheads were replaced with much ceremony. Anthropologist Ruth Landes's eloquent words about the Potawatomi version of the drum apply equally to all others: "Cult ritual focused attention preeminently on the drum, regarding it as a materialized, personified mystery. Cult hierarchy was organized in its terms and symbolism flowered around it. Every eye was fixed on the drum, whether individuals sang, danced, ate, addressed the crowd, or idled. To do otherwise carried the worst disrespect. In the drum house, people tiptoed. When discussing the drum, people employed the active mode and personal turns of speech. . . . Physically, the drum was a washtub dressed in cheap ornaments; mystically, it was precious."[3]

Such was the instrument the visionary Tailfeather Woman and her people presented to Mahzoomahnay, head chief of the Mille Lacs band of Ojibway. The Dakota were encamped on the south shore of Mille Lacs Lake in the summer of 1880, teaching the songs and rituals to go with the drum before moving farther east to proselytize the dance complex. Oral tradition is vague concerning the details of the original ceremonial drum given to Mahzoomahnay. Generally, Grass Dance drums of the Plains Indians were far less lavish in design than what came to be the central Algonquian version. At least one version of the origin story suggests that "dressing up the drum" was remembered as a later development. According to James Littlewolf (born 1895) of Mille Lacs, the Great Spirit instructed Tailfeather Woman to build the large

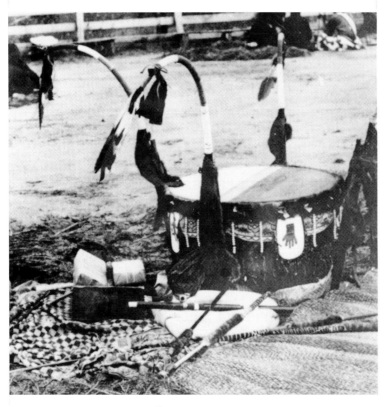

Dance drum, Lac Court Oreilles, 1899. (Photograph by Albert E. Jenks, courtesy of the National Anthropological Archives, Smithsonian Institution, neg. 49,399)

on it and it had dried somewhat but no design on it yet. They had no time to go further as they had to activate the drum."[4] Littlewolf mentioned that, although the drum was put to use for social dancing at the time, the drumhead was not painted, nor the legs made, until later. This recollection may well be an allegory implying that the original Dakota drum was far plainer than previously assumed. To my knowledge, nowhere in Dakota country were there Grass Dance drums even faintly resembling their Ojibway counterparts.[5] I contend that the drum was redesigned in Minnesota and that the sources of the decor were Woodlands rather than Plains in inspiration, most notably drawn from practices current among Ojibway drum builders and members of the *midewiwin,* or Grand Medicine Lodge, the aboriginal Ojibway religion.

In accepting the drum of peace from their former enemies, the Ojibway took seriously their responsibility to replicate the instrument and disseminate the ritual. The exact history of the elaboration of drum decoration is difficult to trace, but the earliest known photograph, from Lac Court Oreilles Reservation, Wisconsin, in 1899 shows a lavishly embellished instrument. Thus, less than two decades after its adoption at Mille Lacs it had been copied and spread some 120 miles eastward from one band of Ojibway to the next; in the process the decoration achieved a degree of elaborateness that became the standard by which we recognize its counterparts.

Elements of traditional Ojibway design quickly supplanted whatever decorations (if any) were on the drum presented at Mille Lacs. Those who have seen what is claimed to be Tailfeather Woman's drum at that reservation are immediately struck by the beadwork—definitely Ojibway in style. Basically, the Ojibway dressed the drum—once the heads were attached—with a cloth flounce or skirt having appliqué beadwork in the typically meandering Woodlands floral

drum from a washtub that U.S. soldiers had left behind. Taking the tub to her people, she said, "We must hurry . . . and get the drum active. The [Dakota] warriours went to work on the drum as night came and by morning they had the head

designs. The skirt hung freely to a few inches below the drum bottom. Over the skirt, around the drum's perimeter, was a four-to-six-inch wide belt, usually fully beaded. The very top of the drum was encircled with a fur strip. Four beaded pouchlike tabs were affixed to the belt at equidistant points. When the instrument was set up for performance, these tabs faced the gaps between the cardinal directions (southeast, southwest, and so forth).[6]

While the details of the skirt, belt, and tabs varied considerably with each new drum made, the red, yellow, and blue design believed to have been painted on the original Sioux drumhead remained virtually intact as the instrument was copied and passed eastward—from Mille Lacs to other Minnesota bands, to the St. Croix Ojibway, thence farther into Wisconsin to Lac Court Oreilles, Bad River, and Lac du Flambeau reservations and from these Ojibway communities eventually to the Menominee, Potawatomi, Winnebago, Fox, Sauk, and Kickapoo tribes. Over time and distances, drum builders remained adamant that the drumhead adhere to the original design, which was also repeated on the bottom (usually unexposed) head. Fred K. Blessing, Jr., who researched the drum movements, came to refer to this as the "orthodox Sioux drumhead pattern." When the skirt material and beadwork on the tabs conformed to the red/blue dichotomy as often they did, the drum, suspended in space, provided an equally divided three-dimensional universe, separated only by the yellow "path of the sun." While the simplest and perhaps oldest drums show only the three fields of color, the addition of thin lines of red and blue in later renditions of the drumhead design lent further definition to the yellow stripe while integrating the three colors in an elaborate scheme in which the earth (red), sky (blue), and passage of time (yellow) are amalgamated.

DECORATION for the Ojibway ceremonial drum seems to derive from three principal sources already current by the time the Grass Dance drum arrived: the system of military honors, the practices of the *midewiwin,* and the tradition of displaying dream symbols.

Despite the peaceful motivation behind the transfer of the first Sioux drum, vestiges of warrior customs are evident throughout the organization and rituals of drum societies, which, in turn, influenced decor. Society structures and position titles closely duplicated those of warrior groups, with their chiefs, pipe bearers, messengers, and young warriors.[7] When drums were made to be given away, the size and degree of lavishness were commensurate with the recipient's standing in his community. A chief's drum (*ogimaa dewe'igan*)—the most prestigious in size and appearance—was distinguished from the warrior's drum (*ogichidaa dewe'igan*), a slightly smaller and less elaborate version, which would be donated to anyone of lesser status in the band.

Of great importance to the drum were its four decorated, curved support stakes. These clearly derive from ceremonial lances or coup sticks, customarily adorned with eagle feathers and wrapped with fur, widely used by Plains warriors. Landes found explicit symbolic references to warfare displayed on Potawatomi drum legs: each was painted a different color to represent a war deed of an original drum owner. Traditionally, eagle feathers attached to the legs either hung or stood erect in a socket partway along their curved tops—the latter if the instrument was a chief drum. Feathers themselves were sometimes differentiated according to which leg they adorned. On one drum at Red Lake, Minnesota, the south leg's feather was plain, the west leg's had a red dot on its center, the feather assigned to the north stake was notched on one edge, and the one on the east leg was split halfway down the quill.

Orthodox Sioux Drumhead Pattern, Variations, and Dream Drumheads

Walter Drift Drum, Nett Lake, Minnesota, about 1880

Kemewan's Drum (Menominee), arrived 1942, probably from Lac du Flambeau; horseshoe symbols said to represent forty ponies given away by Sioux at first drum presentation.

Bijikens Drum, originally from Bad River, Wisconsin, given to Wiskino, a Menominee; also Johnny Matchokamow Drum (Menominee), probably originally from Lac du Flambeau, Wisconsin, arrived 1928.

Henry Davis Drum, Mille Lacs; also dream drum from Sawyer, Minnesota, 1916.

George Pindegagash Drum, Mille Lacs, Minnesota; also Whitefish Drum, Lac Court Oreilles, Wisconsin, 1910.

Dream drum design, probably from Mille Lacs, date unknown

Pete Sam/Jim Beaver Drum (Menominee), probably arrived from Lac du Flambeau about 1918

Thunderbird Drum in Madeline Island Museum, Wisconsin, date and provenance unknown.

 Blue Yellow Red Green Black Light Blue

Drawings by Space Science Graphics, University of Minnesota

Although no explanation was given for this variety, it must be connected to the Ojibway tradition of war-honor feathers, insignia worn only by those who had distinguished themselves in battle. A notch in the feather meant the warrior had killed and scalped a Dakota enemy, and dots of rabbit skin on the feather showed how many bullets were in the victor's gun at the time of the scalping.[8]

The influence of the medicine lodge on the ceremonial drum is not coincidental. The new Drum Dance movement, far from supplanting older beliefs and practices, gained strength in precisely those conservative areas where the *midewiwin* was most active. Because the medicine lodge functioned as a religion while the Drum Dance was regarded more as a protective society with teachings and rituals consistent with the basic tenets of *midewiwin,* dual membership was customary. Blessing, who studied both groups, emphasized that the same leaders presided over drum societies and the medicine lodge and that both exhibited similar patterns of splinter groups and diffusion. Most drum societies originated between 1880 and 1900—in Blessing's opinion "the last great decades of the Midewiwin." As the *mide* priests began to die off, the drum societies experienced a similar decline, although Blessing perceived a slight resurgence of the drum groups in the late 1960s. He was also convinced that the Dakota originators of the movement selected the Mille Lacs band for the initial drum presentation because the Dakota, through intermarriage over several generations, had observed firsthand the conservative *mide* practices at Mille Lacs. Chief Mahzoomahnay, the first drum recipient, was himself partly of Dakota ancestry.[9]

A number of dance drum design features were directly transferred from sacred symbols used in medicine lodge rituals. Tabs on the oldest drums, for example, often show an outlined spirit figure, a form borrowed from the *mide* "sign badge," a sort of scapular donned by the initiate when meeting with his or her preceptors.[10] On drum tabs these figures eventually assumed more humanlike appearances. Fully beaded shapes filled in with solid colors and detailed with hair and facial features replaced outline forms; these newer figures were variously interpreted as representing the Great Spirit, Tailfeather Woman, or the drum owner.

Color symbolism was important to *mide* adherents, and there is evidence that the orthodox drumhead design may owe its inspiration more to them than to the Dakota. The division of the circle into red and blue fields separated by a yellow stripe allowed the drum, as ritual dictated, to be oriented east to west, with the blue half facing north. This placement duplicates the alignment of the medicine lodge. Similarly, the yellow "path of the sun" and the requirement that the drum be put up at sunrise and taken down before sunset parallel the duration and conduct of *mide* ceremonies; members enter the lodge early in the morning from the east and leave from the west exit at the conclusion of rituals.

Blessing considered red, blue, and yellow to be "vital Mide colors." Long before the Sioux drum arrived, red and blue were predominant in facial painting and in the ribbons affixed to one's clothing. (Ojibway freely wore face paint publicly for religious purposes before whites began to mock them for wearing "war paint.") In the *midewiwin,* face paint was used to represent the various degrees of advancement. While these patterns varied slightly from one medicine lodge group to the next or over time in the same community, the alternation of red and blue colors is strikingly consistent.[11]

Finally, there seems to have been a transference of auditory concepts from the *midewiwin* to the drum societies. Builders of the large dance drum customarily suspended a small bell on

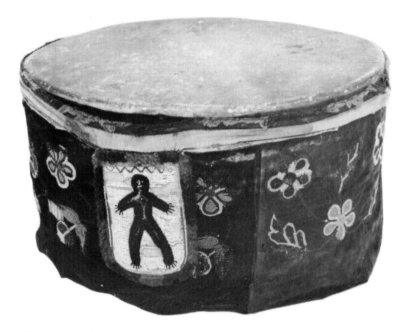

Walter Drift Drum, Nett Lake, about 1880, showing tab with spirit figure closely resembling mide *sign badges. (Photograph courtesy of the Glenbow Museum, Calgary, Canada)*

a thong stretched across the interior of the frame before applying the heads. From this hidden source a pleasant, almost distant, jingling sound called "the heart of the drum" emanated whenever the instrument was played. This concept seems equivalent to the *mide* belief that the high-pitched throbbing sound produced by the tall basswood water drum of the medicine lodge was the heartbeat of the creator.

NO SOONER had the Sioux drum become established than variants began to appear as a result of dreams. In dreams, spirits dictated new aspects of decoration to be superimposed on the orthodox ones or even replace them. While the drum's form, size, and mode of construction remained constant, nearly every design element became subject to change and new interpretation.

Traditionally, it was common for Ojibway people to seek communication with the spirits through dreams or visions, wherein they might receive a symbol or gift, special power songs, or instructions for making some ritual object or article of clothing that incorporated a symbolic vestige of the experience. The puberty fast deliberately sought to induce such a supernatural covenant, but many young Ojibway either did not undertake this rite or did not attain a vision. At some other point in life, however, they might be visited by such a dream during a time of stress, prompted perhaps by a death or extreme illness or suffering.[12]

Any sort of symbolic representation on an Ojibway drum is an almost certain indication that the design was dream imparted, its interpretation was known only to the dreamer, and the drum's use was restricted to its owner(s). The war drum, for example, had protective powers for its owner in battle; almost always its heads displayed some sort of vision-inspired symbol.[13] The moccasin game drum, a thin, double-headed hand drum, was similar in form and manner of playing to the war drum and the drum used in the Chief Dance (a curing ceremony); unlike them, however, it was a common, secular instrument that anyone could make. Its rawhide heads were almost always left undecorated. Similarly, secular versions of the Sioux drum, made for powwow use, were left with unpainted heads and tabs devoid of symbolic representations.

The Minnesota Historical Society collections include a number of such drums dating from the late nineteenth century. Documentation for them is scant, so that it is difficult to know whether they predate the dance drum, although many of the drumhead designs seem related. One example from White Earth Reservation, said by its donor to be a moccasin game drum, shows a horizontal line across its center; perched on the line are two birdlike figures. A Chief Dance drum of the Wisconsin Potawatomi has a nearly identical design—the principal distinction being the directions that the birds face. Because the languages, material culture, and ritual practices of the two tribes are so close, it seems clear that both drums had sacred functions; the one from White Earth most likely is not a moccasin game drum. Other drums with dream symbols in the collection include one showing two horses and a rising sun and another with two heads and upper bodies of birds painted in blue with a red circle between them. Among other designs, more abstract and equally impossible to interpret, are narrow brown and orange lines across the diameter of one drum, and the outline of a five-pointed star enclosing a circle that contains another star.[14]

Of particular interest are two undated hand drums from the Mille Lacs area donated by Harry D. and Jeannette O. Ayer, who operated a trading post there for many years. These drums display designs and configurations that eventually became elements of ceremonial drum decor. One head of a drum-rattle (containing pebbles or shot, probably used by a sucking doctor) displays a dark-blue human figure in its center and has a thin red line spanning its 49-centimeter diameter; the reverse is divided, with one half unpainted and the remainder dark blue with a reddish-brown hand painted over it. The other drum, slightly smaller, uses red and blue to show a male figure contained within a small circle on one head and a

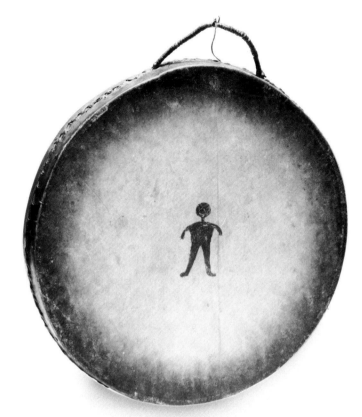

Drum-rattle from Mille Lacs, date unknown. (Photograph by Paul Malcolm, courtesy of the Minnesota Historical Society)

female in similar fashion, with the color scheme reversed, on the other. These figures are so consistent with the color schemes and various tab motifs—the hand of God, Tailfeather Woman, the drum owner, and such—that found their way onto the large ceremonial drum that there must be some

association. Unfortunately, insufficient data makes it impossible to suggest in which direction the transfer of symbols took place.[15]

Some fifteen years after the adoption of the original Sioux drum, the Ojibway vision mechanism began to affect the drum's replication when its first documented variant, the so-called "dream drum" (*inaaji-dewe'igan*) made its appearance at Dead Fish Lake near Sawyer, Minnesota (Fond du Lac Reservation). In 1895 Ishquayaush (Outside Drifter), at age forty, became very sick and in dreams at intervals—like Tailfeather Woman before him—heard spirit voices instructing him to organize a society, build a drum, and learn the thirty-two songs to go with it. For twelve days he supervised the drum's construction from his sickbed, as aides lifted him up to direct them concerning every detail, including the drum's legs and the pipe to go with it. A special dance arena was built for its dedication, and Ishquayaush, it was said, was carried into it on his bed. As the ceremony progressed, he began to stir, eventually sitting up to join the singing and gradually regaining his strength. In later dreams, Outside Drifter was instructed to organize a second society and to make another drum, which he presented at Isle (Mille Lacs) in 1916 to Gahgaydjeewun (Forever Flowing) and Weenanggay (Low Hanging Cloud). When the latter died, the drum was taken over by his son, Henry Davis (see page 64).[16]

Ishquayaush's drums were but two of many dream-inspired instruments that evolved from the original Sioux drum. From 1958 to 1968 Blessing conducted an exhaustive search to inventory drums still in Ojibway possession. From as far north as Roseau River, Manitoba, through Manitou Rapids Reserve, Ontario, into Minnesota at Red Lake, White Earth, Leech Lake, East Lake, and Mille Lacs and eastward as far as Lac Court Oreilles in Wisconsin, he accounted for thirty-eight drums,

seventeen of them still active; in all, only nine were orthodox Sioux drums, while twenty-two were dream drums.[17] A common type of dream drum was the Thunderbird Drum (*bineshii dewe'igan*). Typical was one that Maggie Wilson of Manitou Rapids received in her sleep during World War I. Thunderbirds brought it to her, showed her how to make and use it, and taught her the eighty songs that went "on the drum." The instrument and its ritual were to have protective powers for her people's relatives fighting overseas. The head was painted like the Sioux drum but had a white thunderbird superimposed on it.[18] In the same community Albert Medicine dreamed a Thunderbird Drum in 1948; its drumhead shows two opposing thunderbirds, reversing the light and dark color backgrounds; the drum's belt, when Blessing viewed it, had eight leather thunderbird tabs.

IN THE TWENTIETH CENTURY, as many traditional beliefs and customs declined due in part to the cessation of intertribal fighting, incursions of Christianity on reservations, and the abandonment of the vision quest, the older ways of making and "dressing up" drums have been largely abandoned. Although Ojibway music is still very much alive and enjoys great popularity, especially with younger people, the tendency has been to purchase a ready-made bass drum to accompany secular powwow song. Its plastic head is usually decorated to some degree but rarely with abstract dream symbols. Instead, one finds realistic motifs commonly identified as Indian—the feathered war bonnet, bow and arrow, or pan-Indian stylized thunderbird. Along the circumference of the drumhead might be spelled out the name of the singing group identifying it by locality—Red Lake Singers or Two Rivers Drum. But just as often a drum group will select a name for itself associated with some animal, bird, or natural phenomenon—Lone Eagle

Singers, Ottertail Drum—and represent it in the center of the drumhead. In that the association of the name and picture with the group is symbolic rather than explicit, this practice shows continuity with the dream insignia tradition.

What began a century ago as the adoption of the large Grass Dance drum and the transfer of beliefs through symbols applied to it has changed more in style than in function. Central Algonquians quickly transformed the comparatively unadorned Grass Dance drum prototype into the lavish iconic centerpiece of the new Drum Dance movement, drawing on military insignia and traditional religious and dream motifs for its decoration. Despite the decline of drum societies and their beliefs in the twentieth century, the large drum has been retained for secular events and is commonly seen at powwows today. With a recent resurgence of cultural revitalization, there is some inclination to abandon the expediently purchased bass drum and return to the homemade variety of former times. Not unexpectedly, the older traditional models of the ceremonial dance drum appear to inspire elements of new decoration; in time, new descendants of Tailfeather Woman's drum of peace may yet emerge to put to rest William Baker's 1974 complaint.

Dr. Vennum is senior ethnomusicologist, Office of Folklife Programs, at the Smithsonian Institution and author of The Ojibwa Dance Drum: Its History and Construction *(1982) and* Wild Rice and the Ojibway People *(1988).*

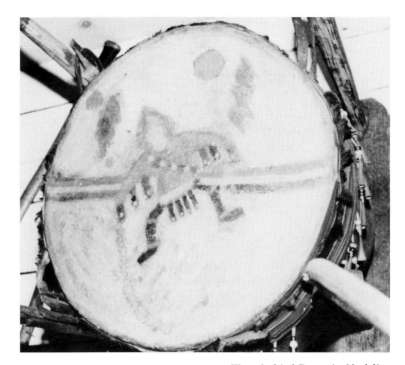

Thunderbird Drum in Madeline Island Museum, date and provenance unknown. (Photograph by Thomas Vennum, Jr.)

NOTES

1. See Thomas Vennum, Jr., *The Ojibwa Dance Drum: Its History and Construction,* Smithsonian Folklife Studies 2 (Washington, D.C.: Smithsonian Institution Press, 1982); Frances Densmore, *Chippewa Music—II,* Bureau of American Ethnology Bulletin 53 (Washington, D.C.: GPO, 1913), 142–80; S[amuel] A. Barrett, "The Dream Dance of the Chippewa and Menominee Indians of Northern Wisconsin," *Bulletin of the Public Museum of the City of Milwaukee* 1 (November 1911): 251–406; James S. Slotkin, *The Menomini Powwow: A Study in Cultural Decay,* Milwaukee Public Museum Publications in Anthropology 4 (1957); James A. Clifton, "Sociocultural Dynamics of the Prairie Potawatomi Drum Cult," *Plains Anthropologist* 14 (May 1969): 85–93. *Central Algonquians,* a term based on linguistic stock, includes the Ojibway, Potawatomi, Menominee, and Sauk.

Spellings of Ojibway words here conform to the system used in John Nichols and Earl Nyholm, eds., *Ojibwewi-Ikidowinan: An Ojibwe Word Resource Book,* Minnesota Archaeological Society, Occasional Publications in Minnesota Anthropology no. 11 (St. Paul, 1983). The only exceptions are *Ojibway,* which follows Minnesota Historical Society Press style, and proper names, which are spelled as they appear in source material. Although current usage frequently employs *Dakota* for *Sioux,* the terms are used here as they appear in historical sources.

2. Slotkin, *Menomini Powwow,* 74.

3. Ruth Landes, *The Prairie Potawatomi: Tradition and Ritual in the Twentieth Century* (Madison: University of Wisconsin Press, 1970), 242.

4. Littlewolf to Fred Blessing, August 3, 1969, Blessing manuscript 46, p. 2–3. Blessing's field notes and papers, which are privately held, were inventoried by the Minnesota Historical Society in 1976. The manuscript numbers were assigned at that time.

5. The only exception is a photograph mentioned in James H. Howard, "The Henry Davis Drum Rite: An Unusual Drum Religion Variant of the Minnesota Ojibwa," *Plains Anthropologist* 11 (1966): 123. It shows Nebraska Santee Sioux dancers posed with a ceremonial dance drum. Howard admits it in no way indicates they had accepted the ritual. The drum could easily have been borrowed for the occasion.

6. Various details of dance drum decor can be traced to elements from traditional Ojibway material culture merged with symbols reflecting their cosmology. These symbols appear on other Ojibway drum types as well; see Vennum, *Ojibwa Dance Drum,* 170–208.

7. In an additional correlation to warrior customs, drum society ceremonial included an elaborate Dog Feast, an act borrowed from the Grass Dance and performed by distinguished warriors to demonstrate bravery.

8. Landes, *Prairie Potawatomi,* 264–67; Blessing manuscript 74, information apparently from William Dudley, Red Lake, August 28, 1966; Densmore, *Chippewa Music—II,* 62.

9. Blessing manuscript 11, [p. 8].

10. Albert B. Reagan, "Some Notes on the Grand Medicine Society of the Bois Fort Ojibwa," *Americana* 27 (1933): 508.

11. For examples of color and patterns and variations over time, see W[alter] J. Hoffman, "The Midewiwin, or 'Grand Medicine Society' of the Ojibwa," in *Seventh Annual Report of the Bureau of American Ethnology, 1885–86* (Washington, D.C.: GPO, 1891), 180, and plate VII, no. 3; Blessing manuscript 22, p. 14.

12. For example, Maingans (Little Wolf), a singer Frances Densmore recorded at White Earth, as a child had frozen his feet during a blizzard, and he was forced thereafter to walk on his knees. During periods of intense pain later in life his "dream songs" came to him, giving him powers to use in curing the sick. See Frances Densmore, *Chippewa Music,* Bureau of American Ethnology Bulletin 45 (Washington, D.C.: GPO, 1910), 118, 119 note a.

13. See, for example, the photograph of the war drum belonging to Odjibwe, an Ojibway singer from White Earth Reservation. It has a distinctive dream design of a small snapping turtle and spiraling lightning bolts; Densmore, *Chippewa Music—II,* 62, and plate 7.

14. Minnesota Historical Society collections, accession nos. 296/E92, 69.138.1, 1981.4.63, 10.000.68, 6935.36a, 10.000.67; Robert E. Ritzenthaler, *The Potawatomi Indians of Wisconsin,* Bulletin of the Public Museum of the City of Milwaukee, vol. 19, no. 3 (1953), 155.

15. MHS collections, accession nos. 10.000.65, 10.000.562.

16. Blessing manuscript 16, p. 2.

17. Blessing manuscript 21, p. 34. The others were drums for the Woman's Dance, a secular accretion to the ceremonial Drum Dance; see Vennum, *Ojibwa Dance Drum,* 85–87.

18. Ruth Landes, *Ojibwa Religion and the Midéwiwin* (Madison: University of Wisconsin Press, 1968), 207–9.

Nicolás Castillo and the Mexican-American Corrido Tradition

JOHANNES RIEDEL

NICOLÁS CASTILLO was born in 1911 in Delores, Texas, into a family of migrant farm workers. Even as a child he created stories believable not only to his peers but to adults as well. His family encouraged young Nicolás in his performances, building a makeshift podium in the Texas fields where they were working so that he could be both seen and heard to better advantage. In the evenings after work had ceased, he entertained with a mixed repertoire of tales and songs.[1]

Like many migrant families, the Castillos trekked by car every year to upper midwestern states to harvest crops in spring and summer and to work in canning factories through the fall; then they returned to the south and west to repeat the operation. In Minnesota they found work around the towns of Owatonna and Hutchinson. Like many migrant workers, the Castillos wearied of the constant traveling and sought a place where they could settle and raise a family. In the 1930s they found such a place in the lower West Side neighborhood of St. Paul, which became a Mexican-American community. Family members took work with the railroads and in the stockyards. The Castillo home soon became a haven for other migrants, some of whom were on their way to work in other states. Family members fed and boarded them, something they did not do in Texas; in Minnesota, however, they were all *compadres* in the migration experience.

In the 1940s Nicolás began performing with his brothers and friends in dance bands, playing guitar and saxophone and singing popular tunes. He served in the United States Army during World War II, then returned to St. Paul, took a job as a cement finisher, married Tomasa Perez, and began a family. Over the years Castillo became one of the main pillars and activists of the West Side's Mexican-American community. He worked to establish medical clinics for low-income families, and he fought to support the newly formed Chicano Studies department at the University of Minnesota in the early 1970s. He and his family became community role models, pushing hard for change and garnering personal recognition.

By the 1950s Castillo had begun writing dance music; ''The West Side Mambo'' was his first composition. But he also continued to perform the work of others, including corridos, the Mexican-American ballad tradition that began to experience a revival in St. Paul around the 1970s. Not until 1969 did he begin writing his own corridos as an outgrowth of his political activism and his perception of his responsibilities as a father; his first two were to nationally known Chicano leaders Cesar Chavez (United Farm Workers Organizing Committee) and Corky Gonzalez (La Raza). In his corridos he was outspoken about social and racial injustices.

*Nicolás Castillo, a typical
expression on his face, playing
tenor saxophone, St. Paul, 1986.
(Photograph by Johannes Riedel)*

For Castillo, corridos expressed a point of view, and it was his involvement in community affairs that prompted him to compose and occasionally perform this form of Mexican-American music.

THE CORRIDO is a narrative ballad in the Spanish language, the function of which is to relate any event of historic, national, regional, or local importance. Typically, the songs signified resistance to outside encroachment. Their heroes, who often became part of oral tradition, were usually local people who struggled for their rights within the period of living memory.[2] The ballads vary in length; they may be as short as six *coplas* (stanzas) and as long as twenty, each usually composed of four lines. The opening *copla* usually sets the time and location of the story and the last offers a *despedida*, a farewell. The narrative builds around a specific encounter by means of a series of speech events involving the main characters. Descriptions are generally quite formulaic, drawing upon traditional ways of portraying a person or a way of speaking. It is said that corridos originated during or shortly before the middle of the nineteenth century on the Mexican side of the Texas-Mexico border or possibly in the state of Michoacán.

For Mexican Americans of the twentieth century, the corrido became a traditional form of poetic/musical communication. It related stories of events that occurred wherever Mexican Americans lived, including Texas, New Mexico, Arizona, California, Colorado, and many midwestern states. The John F. Kennedy corridos, for instance, told the story of the assassination of a president beloved to the Chicano population. Numerous corridos across the country memorialized Kennedy, during whose administration many Mexican Americans began to feel and express a new sense of

"La Raza." These songs remind us that this was an event not only of national importance but one felt deeply on a local level as well.

Escuchen, señores	Listen gentlemen
lo que ha sucedido,	To what happened here,
aquí les voy a cantar.	I am going to sing to you.
El mes de noviembre,	In the month of November,
veintidos por cierto,	The twenty-second for sure,
el año sesenta y tres,	The year sixty-three,
John Kennedy en Dallas	John Kennedy in Dallas
fué asesinado	Was assassinated
Y quien lo pueda creer!	And who would believe it![3]

IN GENERAL Nicolás Castillo's corridos resemble the Mexican ones. Castillo was a traditionalist throughout his life, freely incorporating traditional themes into compositions dealing with issues in St. Paul. Careful observation reveals the close connection between the corridos learned from his father and grandfather and the ones he himself wrote. His father introduced him to the sounds and performance techniques of Mexican as well as of Mexican-American folk and popular instrumental music. From his father Nicolás also learned to read music, an ability of which he was extremely proud and one that set him apart from most folk composers. His skills, however, were rudimentary and his compositions rather skeletal.[4]

Most of Castillo's corridos give an account and interpretation of events that took place in St. Paul or Minneapolis. Some, however, contain nuances that go beyond the traditional scope of the Mexican-American corrido, and not all are about his midwestern hometown. A number of the titles, for instance, refer to his early years in Texas. In "Mi Texas Querido" (My Beloved Texas), written in 1980, he reminisces about the time when he was an itinerant farm worker and musician in that state and recalls his former sweethearts, one to a town, making the song an autobiographical and geographical commentary on his youth.

In chronicling the history of his neighborhood, Castillo took a more traditional stance, although his lyrics sometimes departed from the usual poetical/historical style of commentary. In the concluding lines of "Mi Viejo Westside" (My Old Westside), written in 1974, he recites with nostalgia the names of neighborhood streets and urges people to cling to the memories of the past:

Adiós calle State,	Goodbye State,
la Eva y la Fenton	Eva and Fenton
Tambien la Saint Lawrence	And also St. Lawrence
y la Tennessee.	and Tennessee.
Adiós calle Texas	Goodbye Texas
y la Minnetonka	and Minnetonka
Adiós la Kentucky	Goodbye Kentucky
y tambien la Fairfield. . . .	and also Fairfield. . . .
Adiós barrio Viejo	Goodbye Old Westside,
aunque ya no existes	Although you do not exist
dentro de mi pecho no	anymore
quieres morir	My heart will not forget you.
como dice un dicho	I believe in the saying:
que lo creo muy cierto	To be able to remember
saber recordar es	Is to be able to return.
volver a vivir.	

Nicolás Castillo's stories came easily because he was a keen observer and a sensitive listener. Very possibly, for example, his corrido "El Cuatro de Julio en Harriet Island" (The Fourth

The Fourth of July on Harriet Island

Music and words by Nicolás Castillo

Era el 4° de julio
allí en el Harriet Island
Andaba crudo el borracho
y gritando 'asi se baila'

Pero llego su esposa
que lo andaba buscando
le dijo 'don ta la leche,
el niño esta llorando'

'Desde que te saliste
tienes una semana
y por alli me contaron
que trais americana

'De tantas que me cuentan,
ya ni las quiero oír,
que trais 2 puertoricas y una
 mexicana
y hasta una vietnamis.'

It was the 4th of July
There at Harriet Island.
The drunkard had a hangover
And was shouting, "This is how
 it's danced."

But his wife arrived
Who was looking for him.
She told him, "Where is the
 milk?
The child is crying.

"Since you left
It's been a week.
And I've been told
That you have an American
 [woman].

"Of all I've been told
No longer do I want to hear
That you have two Puerto Ricans
 and a Mexican
And even a Vietnamese [woman]."

Tocaban los Castillos
Quien, Kiko y Sabroson
y tambien los J-Mars
tocando rock n roll

Seréan como las cuatro
todo estaba callado
llego Juan Charrasqueado
de alla del otro lado

Buscando a la del moño
del moño colorado
porque ella, alla en el terre,
lo dejo sin caballo

Si ven a la del moño
que se anda vacilando
no le hagan mucho aprecio
que Juan la anda buscando

The Castillos were playing
Quien, Kiko and Sabroson
And also the J-Mars,
Playing rock 'n roll.

It was around four.
There was silence.
Juan Charrasqueado arrived
From the other side [Mexico].

Looking for the one with the
 ribbon,
The red ribbon,
Because she, there in the
 homeland,
Left him without a horse.

Should the one with the ribbon
 be seen,
The one who is hanging around,
Don't admire her!
That Juan is looking for her.

Charrasqueado llego	Charrasqueado arrived.
llego muy enojado	He arrived very angry.
Se paso por el rio	He crossed the river.
y andaba de mojado	As a wetback he came.
Pues yo me retiré	Well, I distanced myself
a tomarme una soda	To drink a soda
Pôrque vide a Pomposo	Because I saw the pompous one
que traiba su pistola	Who had his pistol.
Se encontraron Juan y	Juan and the pompous one faced
Pomposo	each other
y se prendio la vola	And the fight began.
y por darse balazos	And for shooting at each other
hirieron a doña Lola	Doña Lola was wounded.
Gritaba don Pomposo,	The pompous one shouted
feros como un demonio,	Fierce like a demon,
'Si se me muere mi Lola	"Should my Lola die
te quito a la del moño'	I'll take from you the one with the
	red ribbon."
Y Juan le respondia	And Juan responded,
'Pomposo estas chizquiado	"Pompous you're crazy.
yo aqui y en donde quiera	Here and anywhere
yo nunca me he rajado'	I'll never back down."
Otro dia amanecieron	The next day they awoke,
Pomposo y Juan muy crudos	The pompous one and Juan with
fueron a ver al Chato	hangovers.
a ver si hacia menudo	They went to see Chato
	To see if he made menudo.
Pero el Chato les dijo	But Chato told them,
'yo ya no hago esas cosas	"I no longer make those things
ahora lo traen de Chicago	It is brought from Chicago
todo lleno de moscas'	Now full of flies."
Pues yo ya me despido	Well, I bid you farewell
porque se me hizo tarde	Because it is late.
si no me quieren creér	Should they not want to believe me
por favor no me paguen.	Please, don't pay me.

— translation by Santos Martinez

of July on Harriet Island) was based on his observation of a domestic quarrel between a drunken, good-for-nothing husband and his jealous wife. Following this initial scene, however, Castillo added colorful incidents from two traditional corrido stories, drawing upon the escapades of "Juan Charrasqueado" (Juan the Rascal) and "la del moño colorado" (the girl with the red hair) and upon the adventures of "Don Pomposo" (the pompous one) and "Doña Lola" (Mrs. Lola). To make the story seem more authentic, Nick set it in the front yard, so to speak, of his audience and populated it with familiar characters. Listeners could easily picture the traditional Fourth of July celebrations that the Castillos held on St. Paul's Harriet Island in the Mississippi River. They were familiar with the bands that played there and with the refreshment stands originally established by Tomasa Castillo and her children. And most of the old-timers knew about a local character, Chato (Flat Nose), who helped Fourth of July celebrants sober up by serving the traditional breakfast of menudo (tripe soup), tamales, and coffee on July 5! The end product was a highly entertaining piece of Mexican-American story and music combined.

For those of his listeners who doubted the veracity of his stories, Castillo added the following text to the last stanza: "si no me quieren creér, por favor no me paguen" (should they not want to believe me, please don't pay me). This line is revealing as a sign of bravado, for he never expected payment for composing and singing.

"The Fourth of July on Harriet Island" is a typical corrido, drawing on the narrative as well as musical formulas of the genre. It consists of sixteen *coplas*, each with four lines usually of eight syllables each. The first and last *coplas* follow customary procedures, setting the time and location of the story and offering a farewell. The score begins with an

instrumental *estribillo* (refrain) of ten measures. The second part, measures eleven through twenty, is the corrido proper accompanying the lyrics. *Estribillo* and corrido proper actually overlap on measure eleven. Although the music to "The Fourth of July on Harriet Island" on the whole is Castillo's, similarities between his composition and a "Juan Charrasqueado" melody from southern California are noticeable.[5]

IN ADDITION TO his corridos about West Side life, Castillo wrote some in homage to fellow artists, musicians, friends, educators, and activists. Depending on the person to be honored, the text might express or imply political or religious sentiments as well. Both feelings are evident, for example, in "A Marcella Trujillo," a tribute written in 1984 after the death of a friend and key member of the faculty of the Chicano Studies department of the University of Minnesota, of which Castillo was a long-time supporter and defender.

The political activist side of Nicolás Castillo comes through even more loudly, for example, in "Año del 84" (The Year of '84), written that year as an open declaration of contempt for racial discrimination, and, more specifically, for the United States Immigration and Naturalization Service.

Año del 84.	The year of 1984.
Me recuerdo lo que	I remember what happened
nos pasó.	to us.
Por reclamar el derecho	For demanding equal rights
Nos echan, la immigración.	The immigration threw us out.
Quieren que los Mexicanos,	They want us Mexicans,
Chilenos y otra nación	Chileans and other nations
que de noche a mañana	To change over night
nos cambienos de color.	The color of our skin.

Many of Castillo's texts reveal his awareness of the difficulties of being a Chicano in twentieth-century America.

Juan Charrasqueado G. Villagrano

y en esos campos no de - jaba ni una flor _____

El Cuatro de Julio en Harriet Island N. Castillo

Era el cuatro de Julio allí en el Harriet Island

The songs provide some sort of guidance for the old-fashioned Mexican American attempting to cope with a rapidly changing society. In the past, the decision about keeping ethnic and bicultural values had been a personal one for each Chicano. By the 1970s, however, being Chicano became a matter of collective pride, and people were not ashamed to assert themselves in public demonstrations for causes in which they deeply believed. Nicolás became an ardent standard-bearer of the new movement. He wanted to pay musical tribute to the national and regional leadership of the Chicano movement and to the fathers and sons, including his own, who participated in the Vietnam War and who later joined labor union movements. Corridos such as "Nick Castillo," written to his son in 1977, and "De Vietnam" (About Vietnam) in 1984 testify to his commitment.

NICK CASTILLO and his generation of Mexican Americans, as traditionalists, were so rooted in their culture that they did not make academic distinctions between types of music. It was not uncommon for them to integrate both folk and popular styles into one corrido. Similarly, he and his peers did not distinguish between folk music (corridos) and popular dance music (boleros, cumbias, and polkas).[6] The Castillo dance band—which had evolved to include Nick's brother Paul, Nick's son Michael, and another family member—often performed both folk and popular music for the same event, and its audience most likely danced to all of it without knowing—or caring—about the difference.

For Castillo, the purpose of the corrido was to relate a story, to comment on events of significance to his own community, while the function of popular music was to entertain, to provide music for dancing once the stories had been told. Although he composed more than eighty corridos,

Nick performed them only occasionally, rarely at large gatherings. Some were never performed. Dances and parties were settings that called for "good-time music," while corridos were reserved for making statements, speaking out either for himself or his community, sometimes arousing anger. But since he perceived no conscious separation between story music and dance music, Nick sometimes used corridos as dance pieces and cumbias to relate a story. His legacy of corridos notwithstanding, his foremost public image was as a dance musician rather than as a corrido composer or performer.

Castillo's traditionalism manifested itself not only through his music but in his spiritual life as well. His mother, whom he worshiped, advised him to practice actively the Roman Catholic faith as his rightful heritage. Of his early Christian training he said: "We ate by the church, we slept by the church, the church was everything before anything."[7] This training stayed with Nicolás throughout his life and comes through in many of his compositions, including the corrido "A Armando Estrella," written in 1980.

Dile a mi Diosito santo	Speak to my dear God
que en el mundo nos quedamos	For all those who still stay here on earth
todavía sin aprender el modo	Without having learned how To be brothers.
de ser hermanos.	

Since his own children and grandchildren seemed to be in danger of losing that affiliation and identification with the church, Nick and Tomasa Castillo made conscious efforts to correct that situation. One of the ways they found was to observe not only the annual celebrations of the church year but also special birthdays. For example, Quinceañera, a girl's

fifteenth birthday, was a special church celebration that, at least in the Castillo family, had become almost obsolete. With the backing of the parish priest, the Castillos succeeded in reviving the celebration. In 1983, when one of his granddaughters observed the ceremony, he penned a corrido entitled "Quinceañera," and again in 1987, when such a celebration was planned for his younger granddaughter, Nicolás wrote a special bolero-song, "Quinceañera," part of which goes:

> Quinceañera, quinceañera
> Fifteen-year-old,
> Your beauty is greater than a flower.
> Your fitness spreads like the scent of a flower.
> I would like your permission to sing you this song,
> Because your pretty eyes steal my heart.
> You are worthy of this day with pride and devotion.
> Like I asked before an altar
> This that is born from the heart.
> With music from heaven I want to sing to you,
> To wish you, fifteen-year-old,
> Of these days a million more.

The birthday celebration was observed in the family's church, Our Lady of Guadalupe, on the West Side, the same church that several days later was to hold a funeral service for Nicolás.[8]

After a short illness, Nicolás Castillo died unexpectedly on October 26, 1987. Over five hundred friends and family members came to Our Lady of Guadalupe Church to grieve but also to give thanks for the man who had done so much for them and their community. Some, who were but minimally aware of Castillo's corridos, would simply miss the lovely sounds of his music. For many, however, Nicolás was not only a friend but was the personification of Mexican-American music. He was the foremost folk poet/composer of the Minneapolis-St. Paul area. Through his dance bands Nicolás Castillo helped keep the tradition of Mexican-American dancing and merrymaking alive. Through his particular brand of folk poetry, he became the voice and conscience of the area's Mexican-American community. In 1988 the city of St. Paul, in recognition of his musical and humanitarian contributions, renamed a park in the heart of the Mexican-American community Castillo Park.[9]

Dr. Riedel is professor of music emeritus at the University of Minnesota.

NOTES

1. Biographical information on Castillo, throughout, drawn from the author's association with Castillo, 1984–87.

2. Americo Paredes, *With His Pistol in His Hand: A Border Ballad and Its Hero* (Austin: University of Texas Press, 1958), 244–45.

3. Dan William Dickey, *The Kennedy Corridos: A Study of the Ballads of a Mexican-American Hero* (Austin: Center for Mexican-American Studies, University of Texas, 1978), 92–93.

4. Castillo scored his corridos for two trumpets, percussion, guitar, and one voice. In the course of his career, Castillo wrote more

than five hundred folk songs, including corridos, boleros, and cumbias, many of them never published or performed. The scores are in the possession of the Castillo family.

5. John Donald Robb, comp., *Hispanic Folk Music of New Mexico and the Southwest: A Self-Portrait of a People* (Norman: University of Oklahoma Press, 1980), 164.

6. The second saxophone score of his "La Casa del Pueblo" (The House of the People), for example, is called a cumbia, but another score calls it a corrido. The corrido "Mi Chicanita" (My Dear Chicana) also uses both classifications.

7. Johannes Riedel interview of Nicolás Castillo, July 31, 1984.

8. Mike Flores, "Esta Canción: Death and Rebirth in La Familia Castillo," in *Family Tapestries* (University of Minnesota, School of Journalism and Mass Communication, 1988), 2–3. The corrido translation is by Flores.

9. *Star Tribune* (St. Paul edition), May 1, 1988, p. B1, B7.

Anna Mizens,
Latvian Mitten Knitter

M. CATHERINE DALY

THE ART of knitting Latvian mittens represents a vital social and aesthetic folk tradition. Written and visual evidence from as early as the fourteenth and fifteenth centuries (and continuing in the twentieth) substantiates it as a flourishing art in this Baltic region. Historically, Latvian women knitted other items, such as stockings, but because mittens played an important part in social and religious customs they were the items that people most consistently saved. They are also the most thoroughly documented knitted apparel of the Latvian people. Historian Irena Tourneau has suggested that the Latvian practice may be among the oldest and most varied of "peasant" knitting traditions throughout Europe.[1]

Latvians, like people in many cultures, originally wore mittens for warmth and for protection while engaged in the physical labor of farm-related activities. In addition to providing physical protection, however, Latvian mittens evolved into socially significant items. They were made for and used on important occasions throughout the life cycle, including the various rites of passage surrounding births, marriages, and deaths. Young women knitted mittens for their dowries, giving them as gifts to potential suitors and, upon marriage, to close and valued wedding participants. Mittens also decorated the married couple's new residence. Whether adorning people or home environments, the handwork symbolically represented and ensured a productive future.[2]

Oral histories derived from regional folk songs, or *dainas,* not only celebrated but reinforced the social significance of the handcoverings in Latvian culture. One example suggests that "a young maiden could prove herself worthy of marriage through the quality and quantity of mittens she knit." Another phrase reiterates the social relationship between a husband and wife: "What a husband— fitting as a mitten." In all social contexts, however, each woman's production, use, and exchange of mittens reflected her particular position, roles, and relationships within the private domain of the family. While contemporary Latvian Americans regard landmark life-cycle events as significant occasions, they are less likely, in the context of their new culture, to knit mittens expressly for these situations.[3]

A visual analysis of the numerous patterns of Latvian mittens reveals many similarities in materials, processes, and techniques. Other mitten traditions, such as the Norwegian, parallel the Latvian textile art and show remote stylistic similarities in form and color. The Latvian tradition, however, derives from an indigenous aesthetic system peculiar to its people's sociohistorical context and experiences.

Latvian mittens are generally shaped like a gauntlet and are frequently oversized in relation to the hand, often extending beyond its circumference and the wrist. The bottom is not as fitted as are western-styled ribbed cuffs and so may be worn over or inside outerwear. This shape is in part attributed to a preference in fit, but more importantly it accommodates the complete repetition of the design motifs and the number of stitches within each repeat. The symmetrical silhouette of the mittens decreases to a point at the top, which also allows for less distortion of the knitted patterns.

Basic to the style and fabric structure of the Latvian mitten is the quality of the yarn. Traditionally, women spun a smooth and tight two-ply wool yarn with little loft. Colors were not blended but kept bright and pure. Such yarn in combination with the traditional color and geometric motif choices resulted in mittens that had crisp pattern definition, a Latvian design characteristic. Many local Latvian-American women who knit still prefer this kind of yarn and color effect.

Another distinctive aspect of Latvian mittens is their textile structure. The majority are knitted on five double-pointed needles using a dense gauge—usually eight to fifteen stitches per inch—which results in a compact fabric. (This fabric contrasts with conventional mittens knit at five to seven stitches per inch.) Such a gauge not only makes for mittens warm and smooth in texture but also allows for more intricate designs composed of a greater number of stitches.

The techniques used to create Latvian mittens also differentiate them from those of other traditions. They are produced almost exclusively in the functional stockinette stitch in two-color or multicolor patterning. Aesthetically, the mittens are colorful; structurally, they are warm because of the multiple stranding created on their insides as the various colored yarns are carried while being knitted. Latvian knitters integrate the color and motif designs into a continuous pattern that encircles the hand, including the thumb, which appears indistinguishable from the main body of the mitten. Frequently the cast-on edges of the cuffs are begun using two contrasting-colored yarns. These, referred to as the border and accent color, may be repeated in the color pattern of the cuff and palm, or alternative colors may be substituted. The utilitarian stockinette stitch allows the color patterns to predominate; variations, such as knitted braids, fringes, and scallops, worked exclusively on cuffs, add some surface texture without conflicting with the color patterning.

Design motifs, mostly geometric and symmetrical, derived from mythological symbols associated with traditional belief systems and the natural environment. Examples of patterns considered indigenous include a zigzag symbol for Mara, a powerful helper of God; crossed stalks of grain for Jumis, another mythological figure; the fire cross, symbolizing light, fire, health, and prosperity; and adder, the serpent. Over the past one hundred years floral patterns have been introduced, but Latvian knitters generally regard them as innovations, less characteristic of authentic styles.[4]

Mittens from the four Latvian districts of Latgale, Zemgale, Vidzeme, and Kurzeme show regional differences in color and design, often reflecting geographic and cultural influences such as a region's proximity to the Baltic Sea and other countries. In some instances variations in color and design existed within a district and township, making possible even more specific identification. Today, some Latvian-American knitters select patterns from a particular district while others knit with a more generalized notion of Latvian aesthetics.

THE STORY OF Anna Mizens, Latvian-American knitter and Minnesotan, provides an account of the continuity of one

woman's involvement in knitting and her loyalty to Latvian aesthetics. It also suggests that political circumstances transformed the social context and value of knitting mittens from the original, private, familial sphere in Latvia to a more public and political place of recognition in American culture. Anna's life history also illustrates the social importance of knitting Latvian-styled mittens to perpetuate an ethnic identity, not only for herself but among other Latvian immigrants as well.[5]

Anna Mizens was born in 1915. The only child of Ilze and Janis Altmanis, she lived on a farm with her parents in the southern part of the coastal province of Kurzeme on the Baltic Sea. Anna's family raised sheep for wool and grew flax for linen and cotton, although these were not principal activities on their farm. Her mother spun most of these fibers and dyed wool for knitted garments and woven blankets. Like other Latvian girls Anna learned to knit at a young age. Traditionally young women were socialized in the responsibilities for adulthood through gender-specific activities, which included both formal and informal instruction in domestic textile arts. The *process* of knitting as well as its end product proved a female's technical virtuosity and testified to her attainment of a specialized body of knowledge. By knitting mittens girls learned a technique *and* the design aesthetic exclusive to it. According to Anna, however, "It depended on the family. Not all families encouraged their daughters to knit." When she was between the ages of nine and eleven her maternal grandmother, Julija Springis, who lived with the family, taught her "plain knitting" using a single color and a uniform stockinette-stitch pattern. Together, Anna and her grandmother knit mostly "plain" socks and mittens for family members during the winter months.[6]

The responsibilities associated with agricultural activities governed a woman's degree of involvement in textile production. Generally, from the late fall through early spring months domestic schedules favored the pursuit of knitting and other textile arts such as embroidery and weaving; from late spring through the early fall concerns such as food production and preservation took priority. Today, though many Latvian Americans live in urban as well as rural areas, women maintain a similar cyclical pattern of textile production.

Once Anna started elementary school she, like other female students, received more formal instruction in the domestic textile arts. For their two lessons a week girls chose either knitting, embroidery, or crocheting while boys learned traditional male arts such as wood carving and leatherworking. A teacher supervised and graded each student's work for technical proficiency and project design, the latter being judged primarily for color and motif selection based on the regional styles.

From age fifteen to nineteen Anna lived with her relatives in the town of Liepaja, several miles from her home. In this more urban setting she attended a vocational high school, where her instruction in textile art progressed. There she also learned traditional Latvian weaving on table and floor looms. During her adolescence, however, she devoted more time to studying and socializing than to any significant textile production outside the academic environment.

Following graduation, when many of her peers sought employment in town, Anna returned home to care for her mother who was in poor health. For the next ten years Anna lived and worked on the farm. Although the relatively small size of her family required them to hire seasonal help, no strict division of labor existed; all shared the responsibilities of day-to-day living. By the late 1930s the Soviet invasion of Latvia interrupted the routines of daily life, and by mid-June of 1941

both Germany and the Soviet Union occupied the countryside. That same year Anna's mother died and Anna's work became more comprehensive and arduous. During this time she confined her textile work to producing necessities such as household linens.[7]

CONSCIOUS AND unconscious reasons motivated women to take mittens as they escaped their country during World War II. Many, like Anna and her father, left during the cold winter months, wearing their essential handcoverings. Because of their unassuming size and functional qualities, they were prime items, easily taken in haste. "You just took anything, without reason, anything close at hand that you thought you might need." Another woman mentioned the importance of mittens: "It is painful to leave one's homeland. Many who left wished to take something to 'remember by' . . . so they [mittens] were often taken as that memento."[8]

Anna and her father fled in 1944 with "a couple of suitcases and woven baskets. Just took without thinking. Comes suddenly, you leave." She brought along four or five pairs of knitting needles and some green, white, and brown yarn. The two arrived in Hamburg, Germany, and lived in three different displaced persons camps over the next six years. The barracks, with small apartmentlike quarters, were cold during winter months, so Anna began knitting again. But since materials were scarce she knitted mostly solid gray and natural-colored mittens and socks for her father. None of the items embodied the social or aesthetic aspects of Latvian culture.

All residents of the camps were free to come and go for employment and commerce, but because of limited resources most Latvian men and women volunteered their labor in exchange for goods or earned minimal wages. Their willingness to work made them welcome in adjacent communities; consequently, an informal trade network for goods and services developed among camp residents, the surrounding communities, and foreign contributors. Anna, like other women, often relied on her sewing skills to remake old garments for herself and others. Years later this same sense of community continued when Latvian-American women "get together and knit."

In 1947 Anna met and married Karlis Mizens, a distant acquaintance from Liepaja. They continued to live in the displaced persons camps for several more years, during which time their daughter Maija was born. The ability to leave the camps was contingent on having a sponsor in a host country. In 1950 an American family living near Clearwater, Minnesota, sponsored the Mizenses, so they moved to the United States. Within the year Anna started knitting traditionally styled mittens as gifts for fellow Latvians who had likewise emigrated. One of her earliest pairs was a gift for ten-year-old Elga Sprogis, the daughter of friends. On occasions such as birthdays and Christmas she intuitively "just thought mittens," and "just did." Later, before Elga's engagement, Anna joked, "When you get married, I'll knit you a pair of mittens."

Recollections of familiar customs inspired Anna to validate these life stages through her traditional female specialization. By the early 1960s she was knitting approximately three to four pairs yearly to give as gifts on special occasions. She noted at that time in Minnesota that "there weren't too many people who knit them," an observation that remained true through the 1970s. Anna continued making Latvian-styled mittens because they conjured images of distant people, times, and places.

Anna's experiences parallel those of many Latvian-American knitters. For most, the utilitarian motivation became less

important than the social, political, and aesthetic considerations. The creative process may represent different things to different knitters: a technical challenge in designing or replicating a valued object for a traditional purpose, or the desire to perpetuate the cultural continuity and remembrances of a people struggling to maintain an identity while occupied and politically dominated. Czechoslovakian writer Milan Kundera's observations on the function of Czech folksongs applies as well to immigrants knitting Latvian mittens: "What he [a Czech] hears in folk art is the sap that kept Czech culture from drying up. . . . they serve as the only bridge, the only link, the only fragile stem of an unbroken tradition during a period when the Czech nation almost ceased to exist."[9] For Latvian women the process of knitting mittens, though not overtly expressed as a political sentiment, closely resembles one; through knitting they validate their personal existence. The mittens symbolize for many—women and men alike—strong nationalistic ties to the homeland. Each re-creation helps perpetuate their country and culture, not only in their minds but in tangible, familiar objects.

AS AN OUTGROWTH of their participation in traditional Latvian-American celebrations in the Twin Cities, a group of women, including Anna, in 1978 formed an organization called *rokdarbu kopa* (handicraft group). Most of the traditional costumes they wore on special occasions were incomplete ensembles, brought as individual items from Latvia. The need to make items such as blouses, skirts, and belts was the impetus to explore many of the traditional textile techniques. The main objective of their early meetings was simply to reacquaint Latvian-American women with their expertise.

Eventually an interchange between Anna and a visitor to the group, Lizbeth Upitis, a weaver and American wife of a Latvian, led to a more rigorous exploration and documentation of Latvian mittens. This meeting created the bond between two women who were instrumental in cultivating and reviving the art of knitting Latvian mittens. As an outgrowth of her interest in textiles and exposure to Latvian culture, Upitis subsequently published *Latvian Mittens: Traditional Designs and Techniques* and in 1982 curated an exhibition of the same name for the Goldstein Gallery at the University of Minnesota. These activities introduced an awareness of the folk art and its functional, sociohistoric, and ethnoaesthetic aspects to a wide community of scholars and textile artists. The events also stimulated the support of the International Institute of St. Paul, sponsor of the annual Festival of Nations, whose directors encouraged local Latvian women to demonstrate their art at that spring event.[10]

Upitis and Mizens solicited help from other Latvian women in the community. Some had the skills but had not knitted in the traditional style since moving to the United States. As the women organized for the festival, they realized that they needed mitten projects that all—with their wide range of expertise—could demonstrate. Anna and Lizbeth designed miniatures to be worn on lapels that required of demonstrators less concentration and attention to color and design detail. They were convenient to knit and yet still encapsulated the Latvian traditions. These mittens became the hallmark of the handicraft group that evolved from *rokdarbu kopa,* the *adisana kopa* or "knitting togethers."[11]

To date the group meets bimonthly, providing an opportunity for Latvian fellowship as well as informal instruction in knitting and other textile arts. The women speak almost exclusively in the Latvian language and the occasional visitor, whether proficient or not, honors this custom. At their get-togethers, members celebrate significant events such as

birthdays and holidays while visiting, joking, singing, and eating. The majority of the women share first-generation status, but they welcome anyone interested in Latvian knitting or other of their homeland's traditional handicrafts. It is not uncommon for someone to bring a loom to warp, a hook for crocheting, floss and needles for embroidery. Members encourage this variety as long as projects are associated with traditional Latvian textile arts. This preference is especially evident in the kinds of items women bring to show the group. Some return from visits to Latvia with new and old mittens; others bring embroidered blouses, woven tablecloths and belts, crocheted collars, and knitted stockings made decades earlier while they were attending school. They also bring ongoing and completed projects and relate their experiences in making them. They plan and begin new projects such as the lapel mittens. Some receive instruction from Lizbeth, the group leader. The group allows members to translate their interests into Latvian textile arts as it suits them, maintaining a collegial atmosphere that supports a wide variety of personal, social, and cultural needs. For example, when knitting for others—especially young grandchildren—some women respond to western aesthetics and incorporate colors foreign to traditional Latvian combinations.

In contrast to some others, Anna knits mostly for personal enjoyment. Sometimes she knits specifically for family and friends; sometimes people place orders for mittens. On occasion she sells her work at church bazaars and at the Festival of Nations. She is not motivated by profit, however, but by the pleasure of giving to people who admire Latvian-styled mittens. According to Anna, those who purchase her mittens are "those that appreciate when they have something nice." Since Anna and Lizbeth began knitting mitten samples representative of each Latvian district, Anna has knit mostly

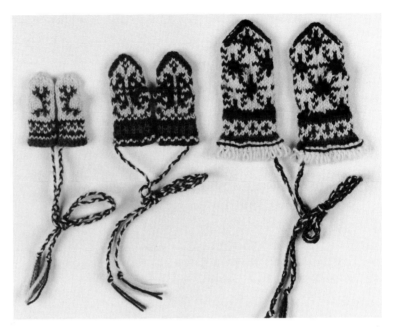

Miniature lapel mittens, created after the design of full-sized Latvian mittens, 1980s

for her own personal collection and for Lizbeth (Cat. no. 19).

Anna is loyal and disciplined in her color selection and technical execution of the patterns. Her sources of creativity are existing mittens, her recollections, and commercially printed knitting graphs, all representing varying degrees of complexity. When executing a complicated pattern, she retires to her room where she can knit uninterrupted; otherwise she

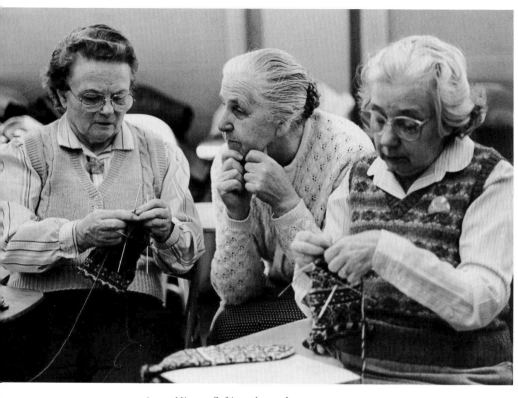

Anna Mizens (left) and members
of adisana kopa, *Minneapolis, 1988.*

works while conversing or watching television at home. Sometimes her husband evaluates her work and offers advice based on his personal preferences. Because of her confidence and expertise, however, Anna is the final judge of her own work.

Regardless of the variations she knits, Anna generally uses the traditional criteria for materials and techniques when choosing, planning, or evaluating a new project. Yet "some times a new pattern can't be refused. . . . I can't refuse to knit an idea!" A new idea, for Anna Mizens, is an innovative combination of colors and designs still within the traditional aesthetic guidelines (Cat. no. 46). What resonates in Anna's mittens and the work of other Latvian Americans is that they "carried into exile their strong national loyalty and zeal to preserve the Latvian culture in exile—its institutions, traditions, symbols, values." It is as if in the process of creating a new pair of mittens Anna and her fellow workers reknit into existence the history of Latvia and their own identity.[12]

Dr. Daly has published articles on Kalabari cloth use based on her fieldwork in Nigeria. In 1988 she revised the Minnesota Department of Education's textile and clothing curriculum to include multicultural perspectives.

NOTES

1. Irena Tourneau, "The History of Peasant Knitting in Europe: A Framework for Research," *Textile History* 17 (1986): 176.

The author wishes to acknowledge Anna Mizens and Lizbeth Upitis for their generosity and assistance in clarifying pertinent details.

2. Lizbeth Upitis, *Latvian Mittens: Traditional Designs and Techniques* (St. Paul: Dos Tejedoras, 1981), 8–9.

3. Upitis, *Latvian Mittens,* 6, 9.

4. Upitis, *Latvian Mittens,* 11–12.

5. M. Catherine Daly, "Use of the Ethnographic Approach as Interpretive Science Within the Field of Home Economics: Textiles and Clothing as an Example," *Home Economics Research Journal* 12 (March 1984): 361. Information on Anna Mizens, here and throughout, from author's field notes, Fall 1986 through 1988. Anna's life history exemplifies the range of issues associated with the use of textiles and clothing in everyday life.

6. Here and seven paragraphs below, see M. Catherine Daly, "Knitters and Their Knitting: From Home Art to Fine Art," paper read at College of Home Economics, University of Minnesota, St. Paul, in conjunction with exhibition From the Magic Knitting Needles of Mary Walker Phillips, April 14, 1987.

7. Many Latvian-American women had similar experiences, both of learning the textile arts and of assisting their families in rural life. Most women emphasized that the social and political value of knitting mittens increased after they emigrated.

8. Upitis, *Latvian Mittens,* 2.

9. Milan Kundera, *The Joke* (New York: Penguin Books, 1982), 111. On the preservation of Latvian culture in exile, see Timo Riippa, "The Baltic Peoples," in *They Chose Minnesota: A Survey of the State's Ethnic Groups,* ed. June D. Holmquist (St. Paul: Minnesota Historical Society Press, 1981), 329.

10. Lizbeth Upitis, *Latvian Mittens: Traditional Designs and Techniques* and exhibition of the same name, Goldstein Gallery of the Department of Design, Housing, and Apparel, University of Minnesota, St. Paul, 1982.

11. Lizbeth Upitis, "Mitten Miniatures," *Knitters Magazine* 12 (Winter 1987): 50.

12. Juris Veidemanis, quoted in Riippa, "The Baltic Peoples," 329.

The Catalog

1. Progress, *1954*
Olaf Gunvalson
Minnesota
Oil on board; 17⅞ in. x 23⅞ in.
Lent by the Minnesota Historical
Society
Perceived Tradition

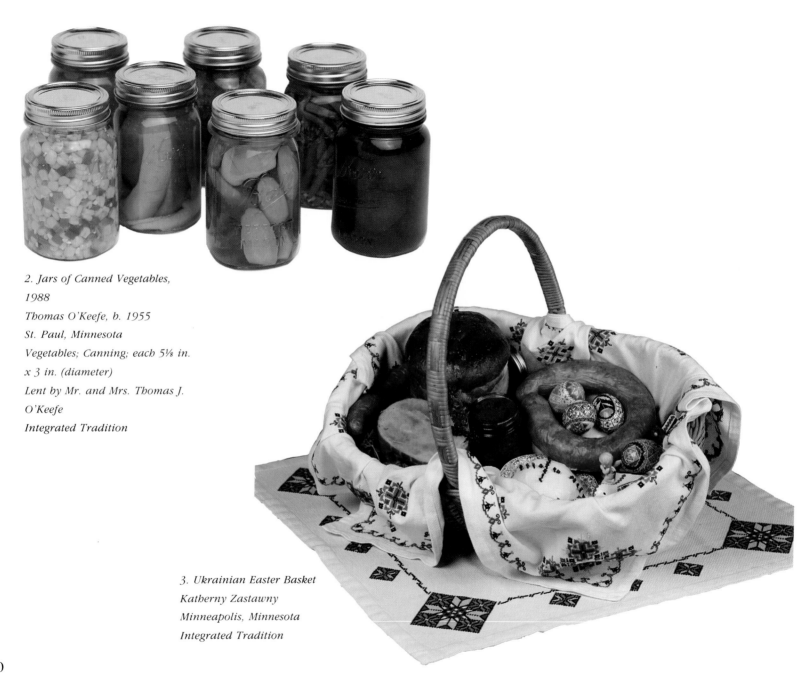

2. *Jars of Canned Vegetables,*
1988
Thomas O'Keefe, b. 1955
St. Paul, Minnesota
Vegetables; Canning; each 5⅛ in.
x 3 in. (diameter)
Lent by Mr. and Mrs. Thomas J.
O'Keefe
Integrated Tradition

3. *Ukrainian Easter Basket*
Katherny Zastawny
Minneapolis, Minnesota
Integrated Tradition

90

4. Crazy Quilt, ca. 1892
Mathilda Quaal, 1878–1961
Appleton, Minnesota
Wool; Quilting; 63 in. x 78½ in.
Lent by Sharlene Jorgenson
Integrated Tradition

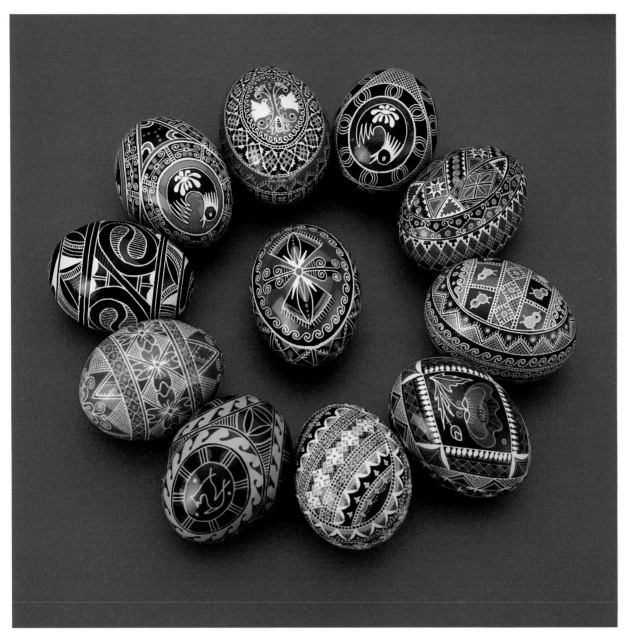

5. *Ukrainian Easter Eggs*
(Pysanky), 1987
Luba Perchyshyn, b. 1923
Minneapolis, Minnesota
Dyes, beeswax, blown eggs; Resist
wax; 2 ½ in. x 1⅝ in. (diameter)
Lent by the Ukrainian Gift Shop,
Inc.
Integrated Tradition

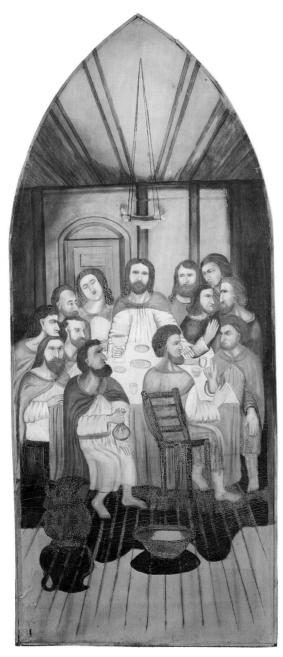

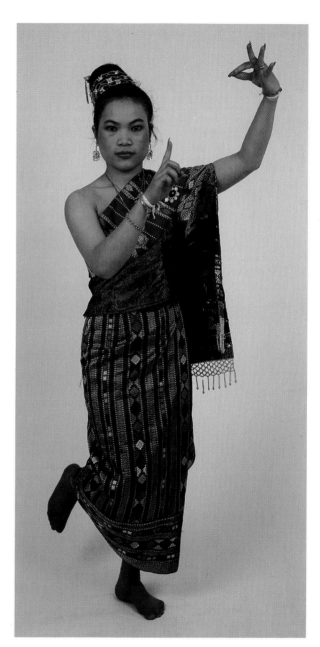

6. Altarpiece: The Last Supper,
1895
John A. Rein, 1858–1916
Hendrum, Minnesota
Oil on canvas; 84 in. x 38 in.
Lent by Roseau County Historical
Museum and Interpretive Center
Integrated Tradition

7. Laddavahn Chanthraphone,
b. 1971, in traditional Laotian
costume
Minneapolis, Minnesota
Integrated Tradition

93

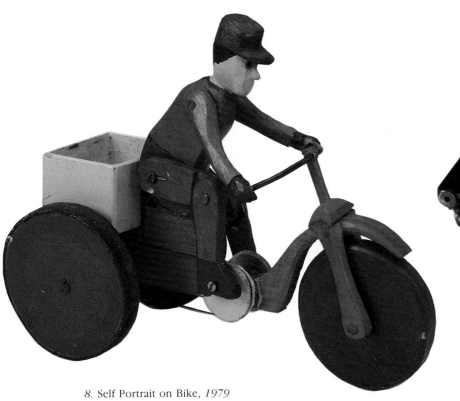

8. Self Portrait on Bike, *1979*
Bernard Schmitz, Sr., b. 1899
Red Lake Falls, Minnesota
Pine; Jackknife carving; 7¾ in. x
9¾ in. x 4 in.
Lent by Bernard Schmitz, Sr.
Integrated Tradition

9. *Canopy, 1982*
Karen Jenson, b. 1935
Milan, Minnesota
Oil paint on wood, gold leaf;
Rosemaling; 23½ in. x 87½ in. x
66½ in.
Lent by Karen Jenson
Celebrated Tradition

94

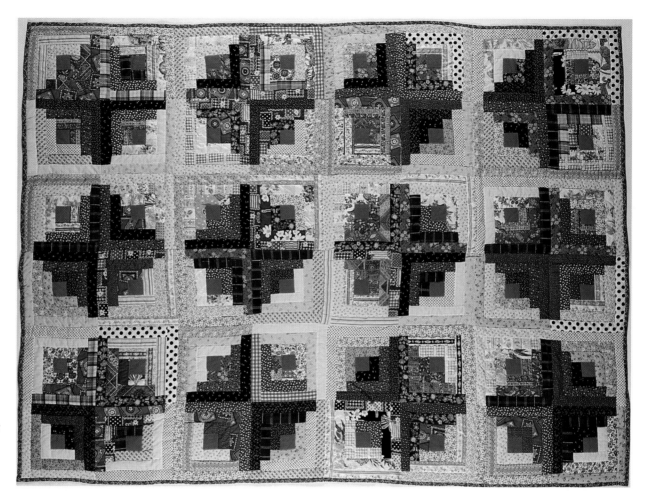

10. Log Cabin Quilt, 1982
Angela Tostenson, b. 1965
Montevideo, Minnesota
Cotton; Quilting; 98¼ in. x
72¾ in.
Lent by Angela Tostenson
Integrated Tradition

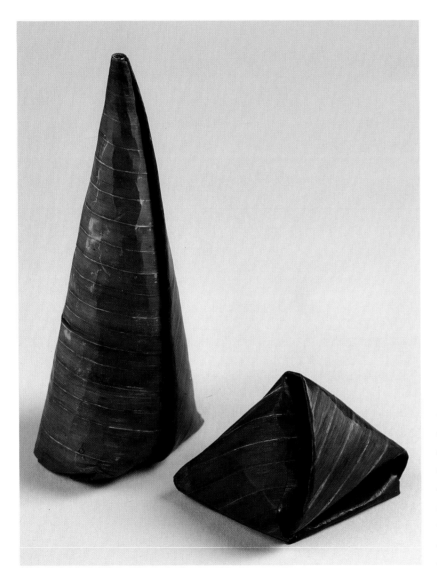

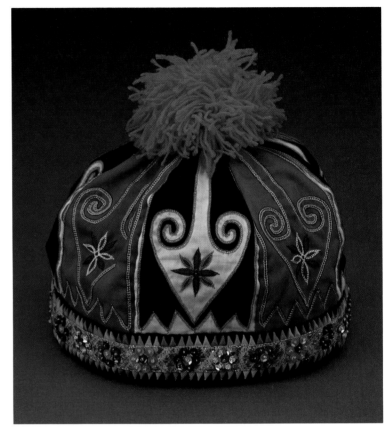

11. *Laotian Rice Cakes in*
Banana Leaves (Kau-tum)
Bounxou Chanthraphone,
b. 1947
Minneapolis, Minnesota
Banana leaf, sweet rice, banana;
6 ½ in. x 2 ½ in. x ½ in.; 2 in. x
2 ½ in. x 2 ½ in.
Integrated Tradition

12. *Traditional Boy's Hat, 1987*
Xaiv Muas
Minneapolis, Minnesota
Fabric; Appliqué, cross-stitching;
4 ½ in. x 7 in. (diameter)
Lent by Carol and Pierce Smith
Integrated Tradition

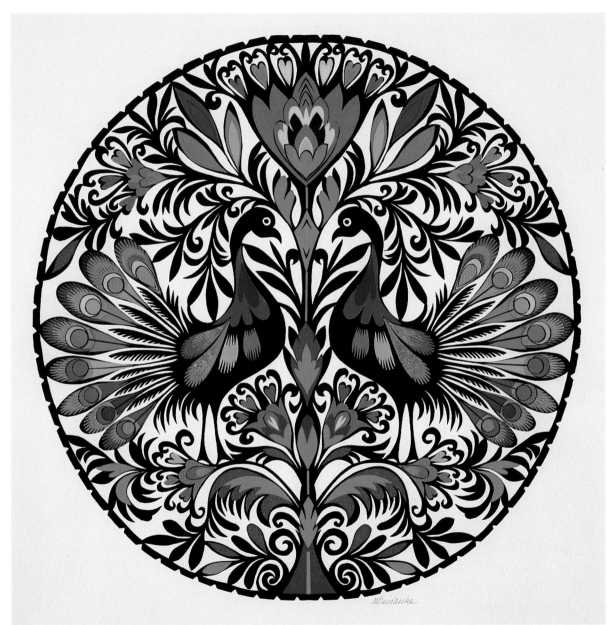

13. *Polish Paper Cutting*
(Wycinanki), *1988*
Magdalena Swiderska, b. 1925
Minneapolis, Minnesota
Colored art paper, glue;
Freehand paper cutting; 13⅝ in.
(diameter)
Lent by Magdalena Swiderska
Perceived Tradition

97

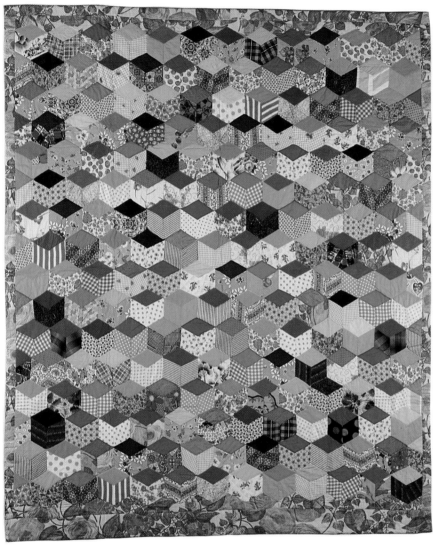

14. Tumbling Blocks Quilt, 1969
Marlys Johnson, b. 1927
Dawson, Minnesota
Cotton; Quilting; 79 in. x
66½ in.
Lent by Marlys Johnson
Integrated Tradition

15. Braided Rug, 1988
Mabel Lyson, b. 1912
Battle Lake, Minnesota
Old wool garments, blankets;
Braiding, stitching; 69½ in. x
103½ in.
Lent by Mabel Lyson
Integrated Tradition

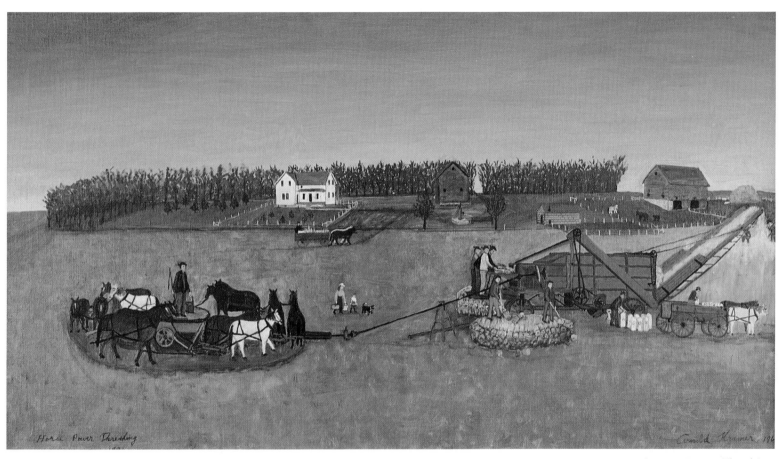

16. Horse Power Threshing,
1896, *1967*
Arnold Kramer, 1882–1976
Wabasso, Minnesota
Oil on masonite; 18¾ in. x
34¾ in.
Lent by Southwest State
University, Marshall
Perceived Tradition

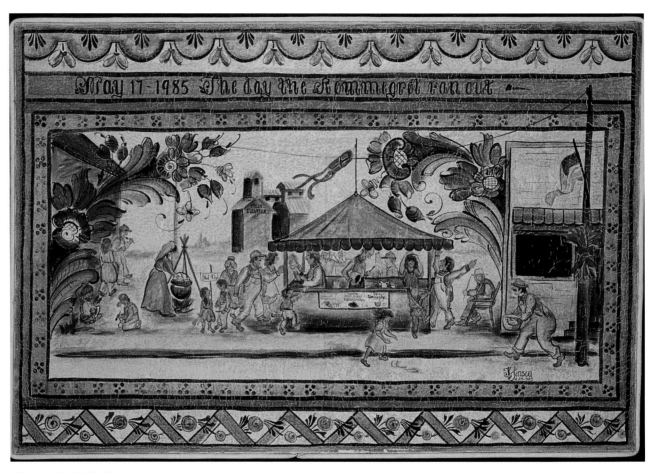

17. May 17, 1985, The Day the
Rommegrot Ran Out, *1985*
Karen Jenson, b. 1935
Milan, Minnesota
Glue, dry pigment; Swedish
Dalmålning; 25 in. x 37 in.
Lent by Karen Jenson
Perceived Tradition

18. Hungarian Needlework Wall Hanging, 1975–77
Magdolna K. Fulop, b. 1927
Minneapolis, Minnesota
Cotton canvas, tapestry and crewel wool; Tapestry and crewel work, cross-stitching; 42¼ in. x 29 in.
Lent by Magdolna K. Fulop
Perceived Tradition

19. Latvian Mittens, 1982, 1987
Lizbeth Upitis, b. 1946
Minneapolis, Minnesota
Wool yarn; Knitting; 11⅛ in. x 5 in. x ½ in.; 10 in. x 4⅜ in. x ⅜ in.
Lent by Lizbeth Upitis
Perceived Tradition

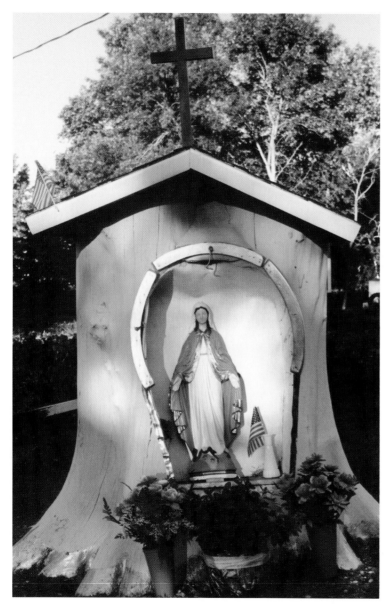

21. Old Order Amish Quilt,
ca. 1964
Lovina Miller, b. 1939
Canton, Minnesota
Cotton; Quilted; 75 in. x 68 in.
Lent by L. D. Miller
Integrated Tradition

20. Family Shrine to John
Redick, 1984
Mary Redick
Brandon, Minnesota
Carved elm stump, wood, plastic,
glass, copper; 50 in. x 44 in.
Photo: W. B. Moore, 1985
Integrated Tradition

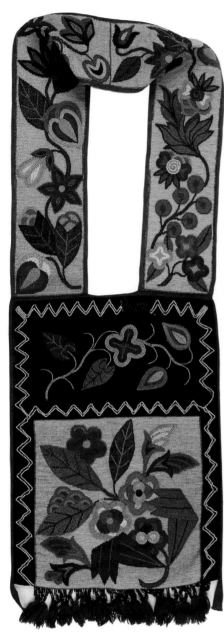

22. Bandolier Bag, probably
Ojibway
Unknown; worn by Dakota man
in dress parade
Cokato County, Minnesota
Beads, cloth; Weaving, beading;
39½ in. x 12½ in.
Lent by Cokato County Museum
and Historical Society
Integrated Tradition

23. Polish Easter Eggs, 1988
Magdalena Swiderska, b. 1925
Minneapolis, Minnesota
Goose-egg shell, paint; Painting,
lacquering; 4 in. x 2¾ in.
(diameter)
Lent by Magdalena Swiderska
Integrated Tradition

103

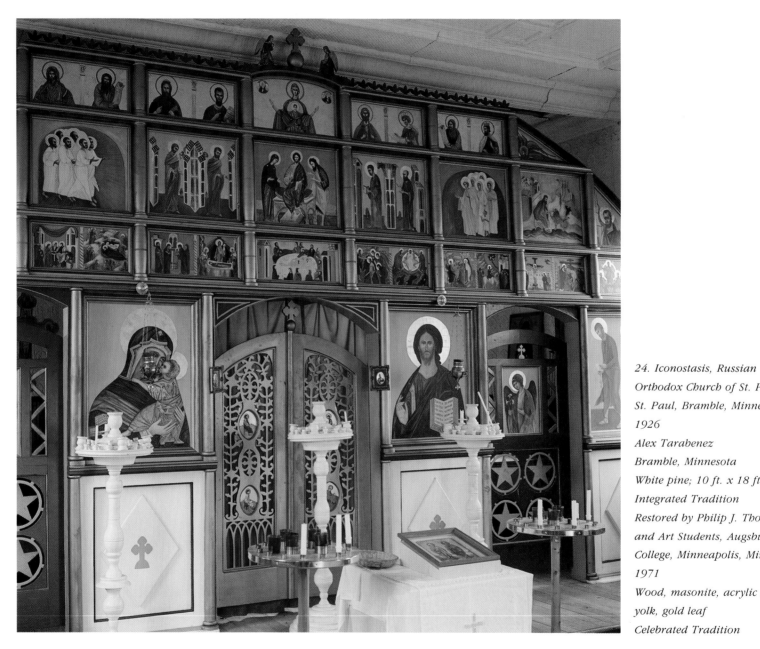

24. Iconostasis, Russian
Orthodox Church of St. Peter and
St. Paul, Bramble, Minnesota,
1926
Alex Tarabenez
Bramble, Minnesota
White pine; 10 ft. x 18 ft.
Integrated Tradition
Restored by Philip J. Thompson
and Art Students, Augsburg
College, Minneapolis, Minnesota,
1971
Wood, masonite, acrylic and egg
yolk, gold leaf
Celebrated Tradition

Integrated Traditions

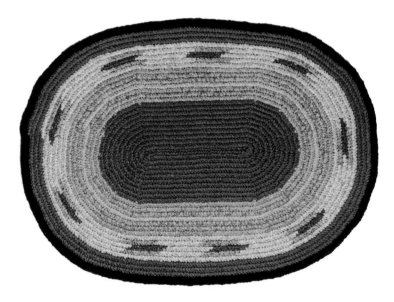

25. Chest of Drawers with
Separate Base, 1872
Unknown
Clay County, Minnesota
Butternut, pine, bone; Dovetail
joining; 41 in. x 38 in. x 16 in.
Lent by Marion and Lila Nelson

26. Swedish Toothbrush Rug
(Nålbinding), 1987
Lyli S. Holcomb, 1902–87
Kelly Lake, Minnesota
Cotton; Braiding; 44 in. x
30½ in.
Lent by Diane Holcomb Fields

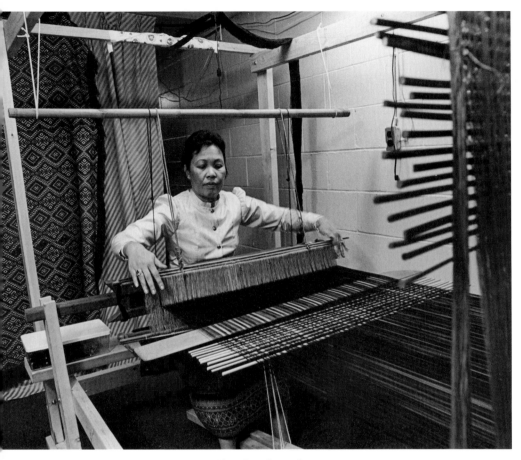

27. Bounxou Chanthraphone, b.
1947, weaving silk into
traditional skirts at Laotian
loom
Minneapolis, Minnesota

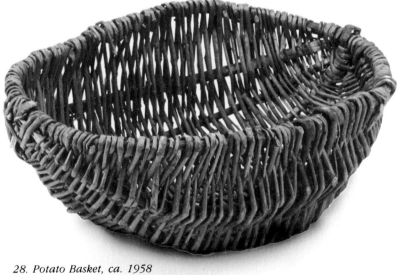

28. Potato Basket, ca. 1958
William Damer, b. 1900
Long Prairie, Minnesota
Willow; Weaving; 5½ in. x 16
in. x 11 in.
Lent by Dianne Bjornson Damer
and Lewis Damer

106 INTEGRATED TRADITIONS

30. Old Order Amish Caps, 1987
Susie Gingerich, b. 1942
Utica, Minnesota
Taffeta, organdy; Hand sewing;
10 in. x 7 in. (diameter); 10 in. x
7 in. (diameter)
Lent by Susie Gingerich

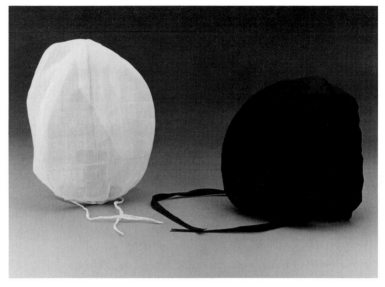

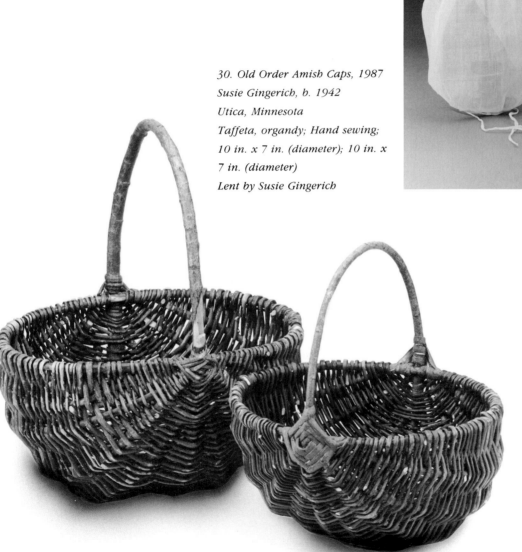

29. Potato Baskets with Handle
William Damer, b. 1900
Long Prairie, Minnesota
Willow; Weaving; 20½ in. x
17½ in. x 15 in.
Ray Schabel
Long Prairie, Minnesota
Willow, metal brads; Weaving;
15 in. x 14½ in. x 14 in.
Lent by Dianne Bjornson Damer
and Lewis Damer

*31. Drake Family Log Barn
(Swedish), 19th century
Chisago County, Minnesota
Hewn timber, sawn boards
Photo: Lena Andersson-
Palmqvist, 1981
Lent by the Nordiska Museet,
Stockholm, Sweden*

33. *Jewish Wall Hanging*
Pointing to the East and
Jerusalem (Mizrach), 1986
Barbara R. Davis, b. 1953
Minneapolis, Minnesota
Rag paper; Paper cutting; 12⅝
in. x 12⅝ in.
Lent by Barbara Rahel Davis

32. *Jewish Marriage Contract*
(Ketubah), 1988
Peggy H. Davis, b. 1950
Minneapolis, Minnesota
Ink, watercolor, rag paper;
Calligraphy, painting; 29 in. x
23 in.
Lent by Peggy H. Davis

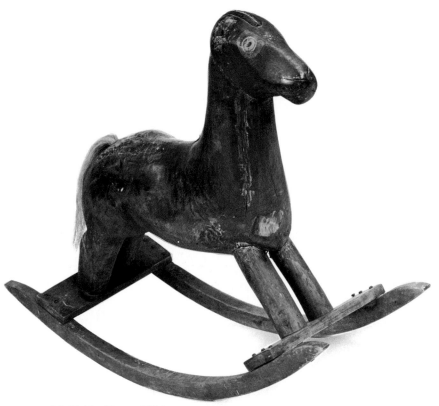

34. Hobby Horse, 1935
Senja Jokinen, b. 1908
Angora, Minnesota
Poplar trunk; Carving with
homemade knives; 30 in. x 13 ¼
in. x 39¾ in.
Lent by Senja Jokinen

35. Hardanger Lace Baptismal
Towel, 1982
Florence Gilbertson, b. 1922
Milan, Minnesota
Hardanger cloth, perle cotton
thread; Hardanger embroidering;
10⅝ in. x 6½ in.
Lent by Erik John Maursetter

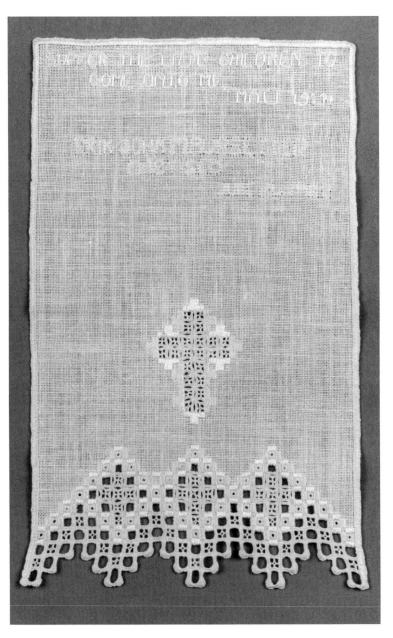

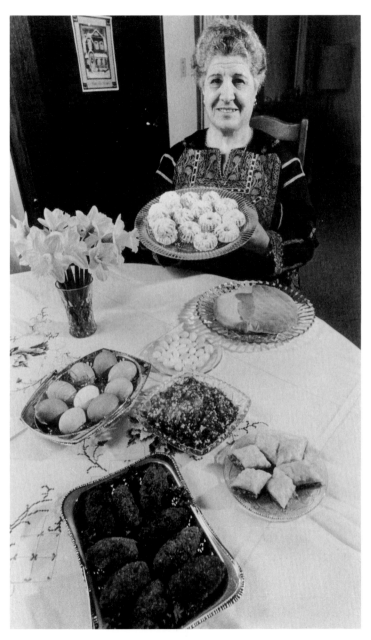

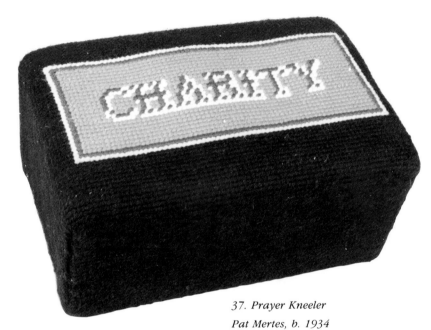

37. *Prayer Kneeler*
Pat Mertes, b. 1934
Winona, Minnesota
Canvas, wool; Needlepointing;
9½ in. x 14½ in. x 6½ in.
Lent by St. Paul's Episcopal
Church, Winona

36. Rose Hanna, b. 1926, with
date-and-nut-filled sweet buns
(Kaick-wa-maamoul) and other
foods for traditional Palestinian
Easter dinner
St. Paul, Minnesota
Photo: Minneapolis Star Tribune,
1985

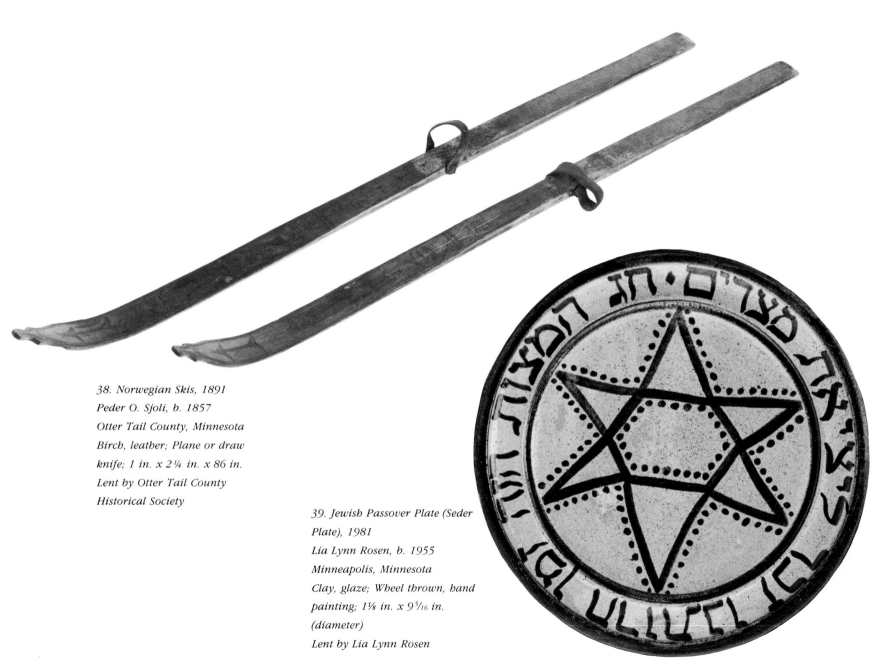

38. Norwegian Skis, 1891
Peder O. Sjoli, b. 1857
Otter Tail County, Minnesota
Birch, leather; Plane or draw
knife; 1 in. x 2¼ in. x 86 in.
Lent by Otter Tail County
Historical Society

39. Jewish Passover Plate (Seder
Plate), 1981
Lia Lynn Rosen, b. 1955
Minneapolis, Minnesota
Clay, glaze; Wheel thrown, hand
painting; 1⅛ in. x 9⁵/₁₆ in.
(diameter)
Lent by Lia Lynn Rosen

41. *Finnish Kick Sled*
(Potkukelkka), *ca. 1920*
Victor Juslin, b. 19th century
Brimson, Minnesota
Wood, handmade bolts, metal
runners; 29 in. x 21 in. x
75½ in.
Lent by Gerry Kangas

40. *Stone Flower, 1985*
Alexander Rennie, b. 1908
Minneapolis, Minnesota
Indiana limestone; Carving; 18½
in. x 21¾ in. x 4⅛ in.
Lent by W. B. Moore
Photo: Minneapolis Star Tribune,
1985

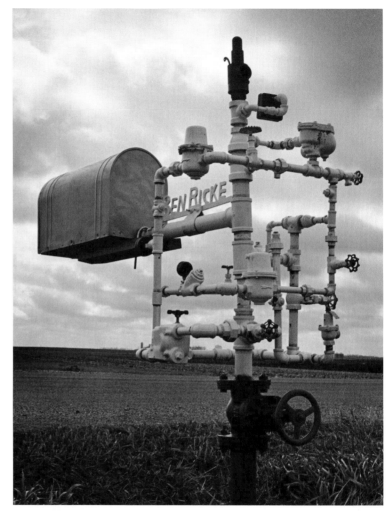

42. Banner of Life: The Old
Country and the New World,
1976
Elisabeth Lomen, b. 1918
Zumbrota, Minnesota
Ada cotton, Hardanger cloth;
Cross-stitching; 28 in. x 5 in.
Lent by Elisabeth Lomen

43. Mailbox, 1977
Ben Ricke, b. 1929
Cottonwood, Minnesota
Plumbing pipe, steam valves,
gauges
Photo: Alec Bond, 1981

44. Amos Owen, Dakota pipe
carver, b. 1917
Welch, Minnesota
Photo: Nicholas Vrooman, 1985

45. Woven Rug, 1973
Helga Johnson, b. 1914
Two Harbors, Minnesota
Plastic bread bags, utility bag;
Weaving on floor loom; 38 in. x
29 in.
Lent by Helga Johnson

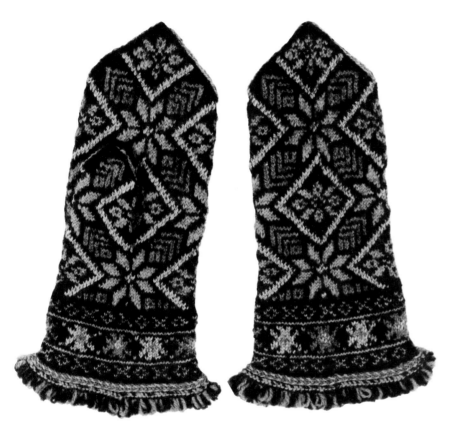

46. Latvian Mittens, 1983
Anna Mizens, b. 1915
Minneapolis, Minnesota
Wool; Knitting; 10¼ in. x 6 in.
x ½ in.
Lent by Anna Mizens

47. Kitchen Curtain, ca. 1920
Mrs. McMahan
Waseca County
Cotton flour sack; Cut-and-tie
working; 32¾ in. x 23¾ in.
Lent by the Waseca County
Historical Society

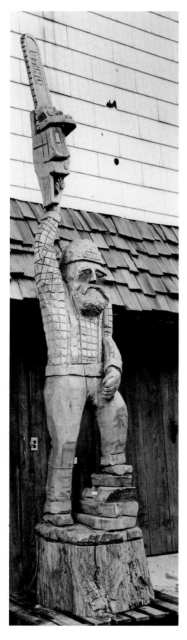

48. Chainsaw Man, *1985*
Larry Jensen, b. 1954
Brainerd, Minnesota
Elm; Chain-saw sculpting; 16 ft.
x 23 in. x 17 in.
Lent by AARCEE Rental and
Sales, Minneapolis

49. Safe Chainsaw, *1981*
Friends of Albert Stimac
Hoyt Lakes, Minnesota
Pipe chain, spark plug, wire;
Metalworking, welding; 8 in. x
19 in. x 1 in.
Lent by Albert Stimac

50. Loom
Unknown
Minnesota
Wood; 68 in. x 53 in. x 64 in.
Lent by Mary Lee Carlson

51. Hay Rake, 1915
August Mankinen, b. 1884
Minnesota
Wood; Ax, knife, plane, auger;
80 in. x 26 in. x 4 in.
Lent by Edwin Saari

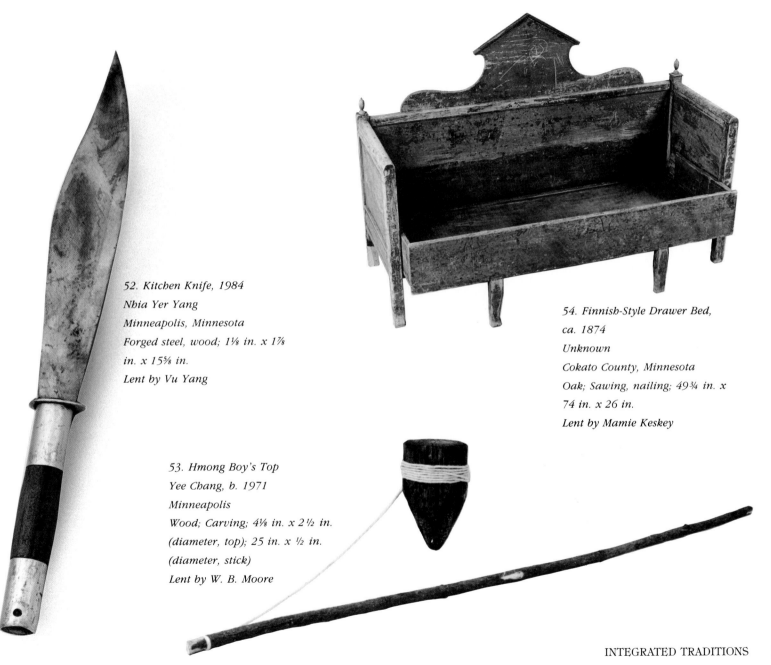

52. *Kitchen Knife, 1984*
Nhia Yer Yang
Minneapolis, Minnesota
Forged steel, wood; 1⅛ in. x 1⅞
in. x 15⅝ in.
Lent by Vu Yang

53. *Hmong Boy's Top*
Yee Chang, b. 1971
Minneapolis
Wood; Carving; 4⅛ in. x 2½ in.
(diameter, top); 25 in. x ½ in.
(diameter, stick)
Lent by W. B. Moore

54. *Finnish-Style Drawer Bed,*
ca. 1874
Unknown
Cokato County, Minnesota
Oak; Sawing, nailing; 49¾ in. x
74 in. x 26 in.
Lent by Mamie Keskey

56. Goose Decoy, ca. 1900
Unknown
Minnesota
Wood, paint; Hand carving; 6
in. x 10 in. x 31 ½ in.
Lent by Bruce and Cheryl Iverson

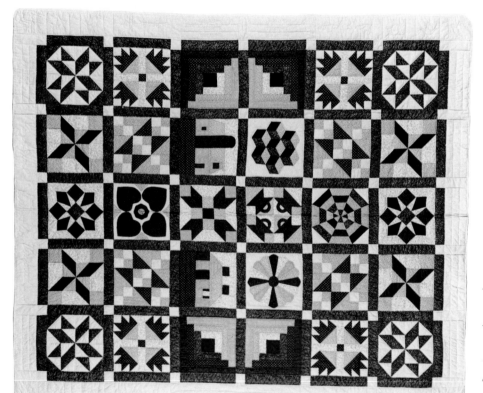

55. Family History Quilt,
1980–81
Lena Homme, b. 1916
Willmar, Minnesota
Cotton; Machine piecing, hand
quilting; 96 in. x 82 in.
Lent by Marjorie Sunvold

57. Jewish Prayer Shawl (Tallit)
Bag, 1986
Canvas, perle cotton;
Needlepointing; 9½ in. x
11½ in.
Jewish Girl's and Boy's Head
Coverings (Kepot), *1984, 1986*
Canvas, perle cotton;
Needlepointing; 3 in. x 7½ in.
(diameter); 3½ in. x 8½ in.
(diameter)
Ardis Wexler, b. 1942
Edina, Minnesota
Lent by Ardis Wexler

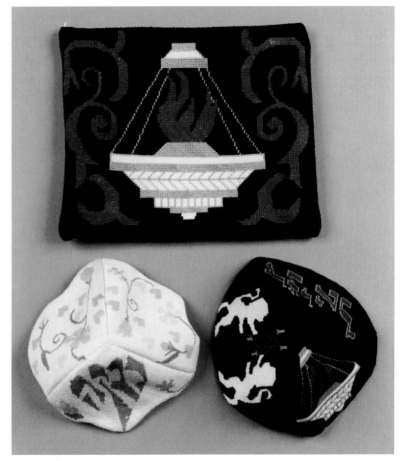

58. Chair, ca. 1900
Almon Whiting, 1821–1908
Otter Tail County, Minnesota
Oak; Lathe, hand tool (woven
seat not original); 32¼ in. x
16¾ in. x 15½ in.
Lent by the Otter Tail County
Historical Society

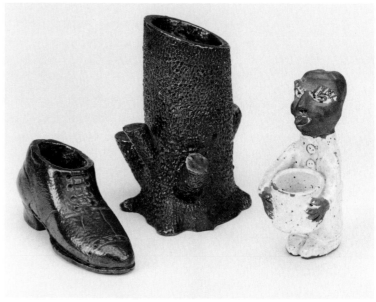

60. Lunch-Time Pottery, ca. 1900
Unknown
Minnesota
Clay; Shoe, 2½ in. x 1¾ in. x
5¼ in.; Tree Trunk Vase, 5¾ in.
x 4½ in. x 3¾ in.; Pullman
Porter, 5 in. x 3½ in. x 2½ in.
Lent by Wad and Caroline Miller

59. Woven Rag Rug, 1975
Rora Strom, b. 1898
Two Harbors, Minnesota
Cotton student nurse uniforms
cut in strips; Weaving on four-
harness loom; 42 in. x 27⅝ in.
Lent by Julia Widen

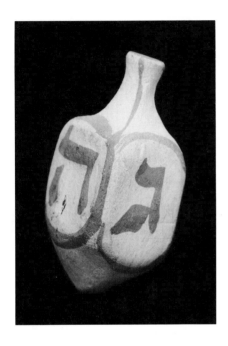

61. *Jewish* Dreidel
Unknown
Minnesota
Ceramic; Molding; 1 ½ in. x ⅝
in. x ⅝ in.
Lent by W. B. Moore

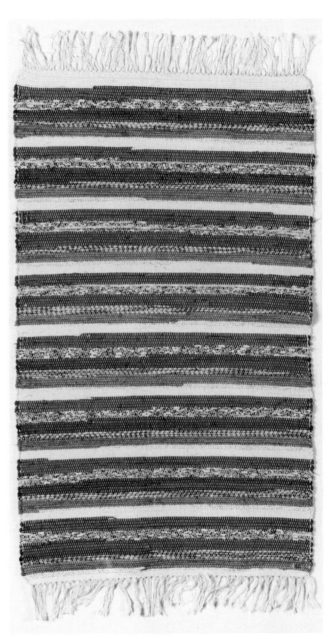

62. *Woven Rag Rug, 1986*
Julia Widen, b. 1954
Two Harbors, Minnesota
Scraps cut into strips; Weaving
on four-harness loom; 42 ¼ in. x
29 in.
Lent by Julia Widen

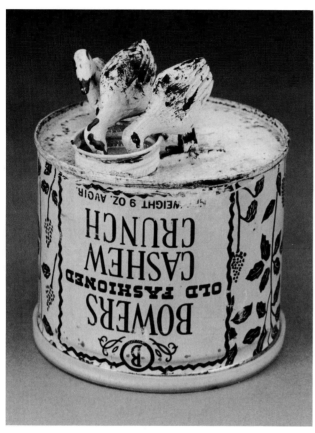

63. *Pecking Geese*
Melvin A. Hall, 1893–1988
Lanesboro, Minnesota
Metal, magnet, can; Welding; 5
in. x 4 in. (diameter)
Lent by W. B. Moore

64. *Computer Cover, 1985*
Bloua Vang, b. 1910
Minneapolis, Minnesota
Cotton; Appliqué, cross-
stitching; 12¾ in. x 13½ in.; 21
in. x 18¹/₁₆ in.
Lent by Vu Yang

124 INTEGRATED TRADITIONS

Perceived Traditions

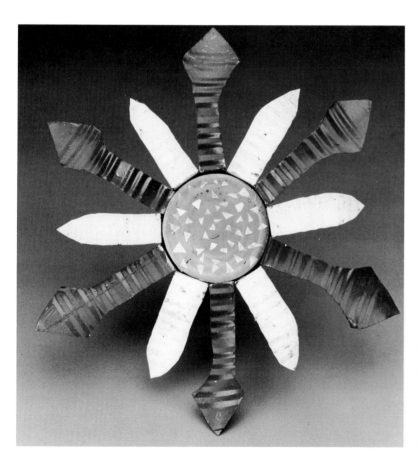

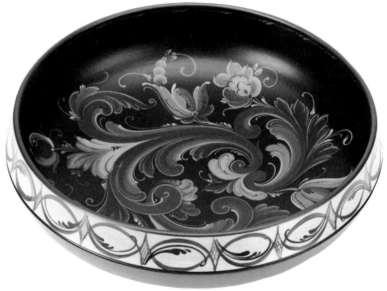

65. North Star, *1983*
Melvin A. Hall, 1893–1988
Lanesboro, Minnesota
Metal; Welding; 15 in. x 15 in. x
1 ¼ in.
Lent by Melvin A. Hall

66. Rosemaled Bowl, *1988*
Judith Nelson, b. 1949
Minneapolis, Minnesota
Hand-turned basswood, acrylic
and oil paint; Rosemaling; 4 in.
x 11 ½ in. (diameter)
Lent by Judith Nelson

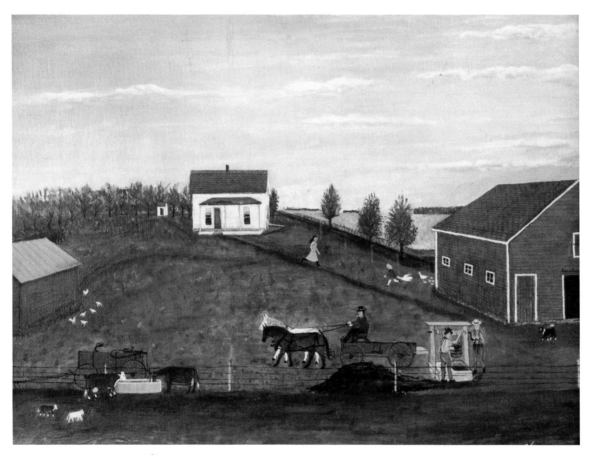

67. Well Digging, 1891, *1963*
Arnold Kramer, 1882–1976
Wabasso, Minnesota
Oil on masonite; 16¾ in. x
22¾ in.
Lent by Southwest State
University, Marshall

68. Wood Puzzle, ca. 1980
Severt Rasmuson, 1884–1987
Detroit Lakes, Minnesota
Wood; Carving; 2¾ in. x 2⁵⁄₁₆ in.
x 12 in.
Lent by Karen Jenson

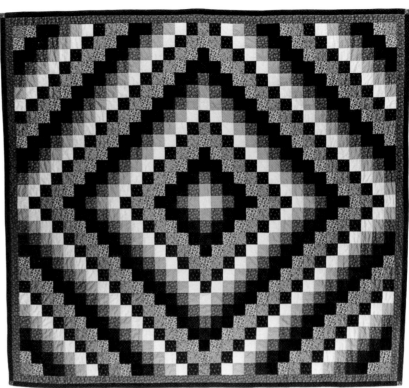

70. *Trip Around the World Quilt,*
1984
Sharlene Jorgenson, b. 1946
Montevideo, Minnesota
Cotton; Quilting; 90½ in. x
99½ in.
Lent by Sharlene Jorgenson

69. *Basket, ca. 1984*
Karen Hawk
Warroad, Minnesota
Willow, dogwood; Weaving; 13
in. x 13½ in. x 13 in.
Lent by Minnesota Historical
Society

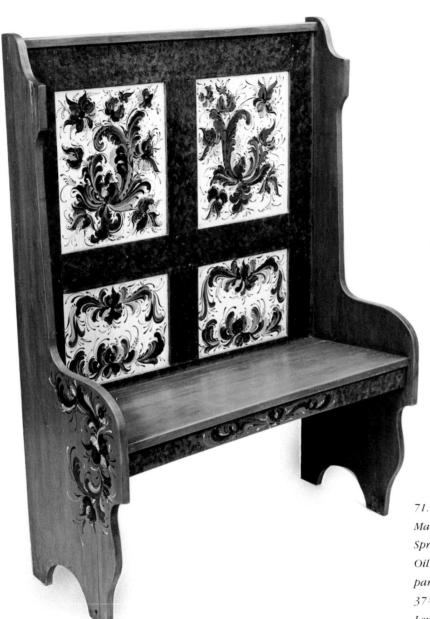

71. Rosemaled Bench, 1984
Mary Hanson, b. 1950
Spring Grove, Minnesota
Oil paint, pine bench with
panels; Rosemaling; 50⅝ in. x
37¾ in. x 16½ in.
Lent by Mary Hanson

72. Norwegian-Style Cedar Fan,
1985
Walter Torfin, b. 1904
Duluth, Minnesota
White cedar; Woodworking; 14½
in. x 18 in. x 4½ in. (includes
base)
Lent by Walter Torfin, "The
Fanman"

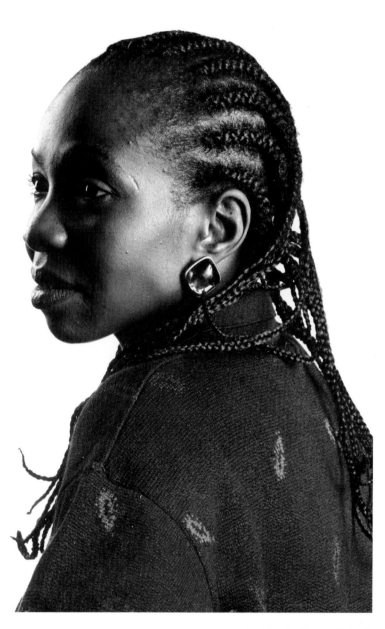

73. *Swedish Toothbrush Rug*
(Nålbinding), *1988*
Diane Holcomb Fields, b. 1957
Minneapolis, Minnesota
Cotton; Braiding; 45 in.
(diameter)
Lent by Diane Holcomb Fields

74. *Corn Row Hair Braids, 1987*
Jewelean Jackson
Minneapolis, Minnesota

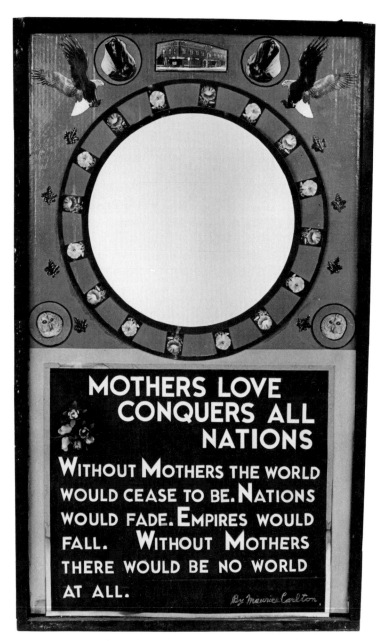

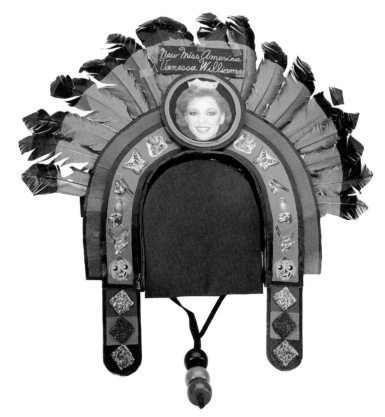

75. Mothers Love Conquers All
Nations, *ca. 1975–85*
Maurice Carlton, 1909–85
St. Paul, Minnesota
Cardboard, paper, paint, glue,
wood, plastic flower, stickers;
Cutting, gluing; 39½ in. x 23 in.
Lent by the Minnesota Historical
Society

76. *Headdress Commemorating*
Vanessa Williams, ca. 1984
Maurice Carlton, 1909–85
St. Paul, Minnesota
Cardboard, feathers, paper,
stickers, glitter, foam rubber,
aluminum foil, plastic tape, glue;
Cutting, painting, gluing; 20 in.
x 20 in.
Lent by the Minnesota Historical
Society

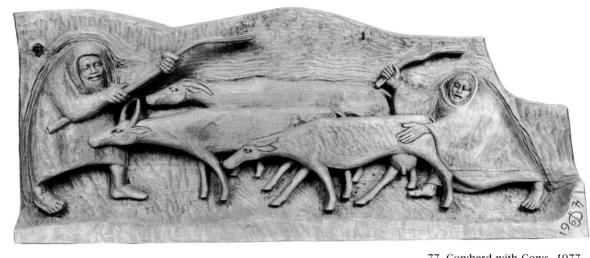

77. Cowherd with Cows, *1977*
Eduard Dietmaier, b. 1919
La Crescent, Minnesota
Basswood; Carving; 17 in. x
43 ½ in. x 3 ½ in.
Lent by Eduard Dietmaier

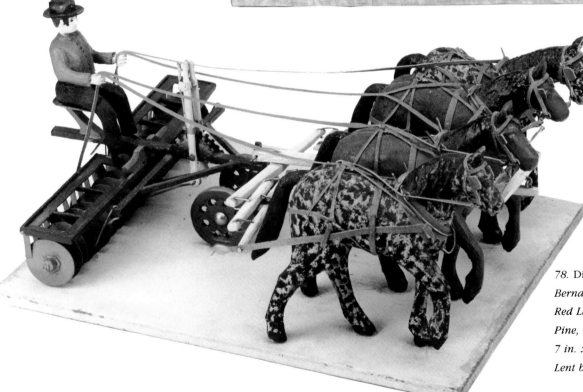

78. Disc with Horses, *1981*
Bernard Schmitz, Sr., b. 1899
Red Lake Falls, Minnesota
Pine, leather; Jackknife carving;
7 in. x 12 in. x 8 in.
Lent by Bernard Schmitz, Sr.

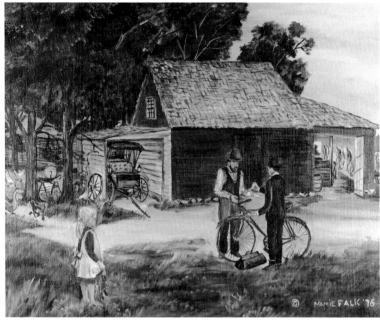

79. The Early Merchant, *1976*
Mamie Falk, b. 1896
Murdock, Minnesota
Oil on canvas; 16 in. x 20 in.
Lent by Jeanne Falk Johnson

80. *Wood Chopper and Wood Carrier*
Carl Dahlman
Minneapolis, Minnesota,
Wood; Carving; 8¾ in. x 3½ in. x 5 in.; 8½ in. x 3½ in. x 3⅝ in.
Lent by Steven Ohrn

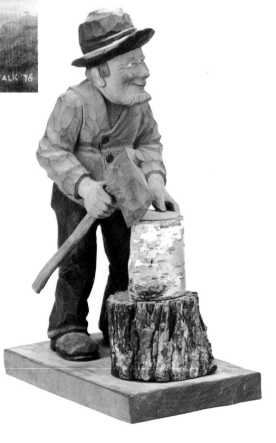

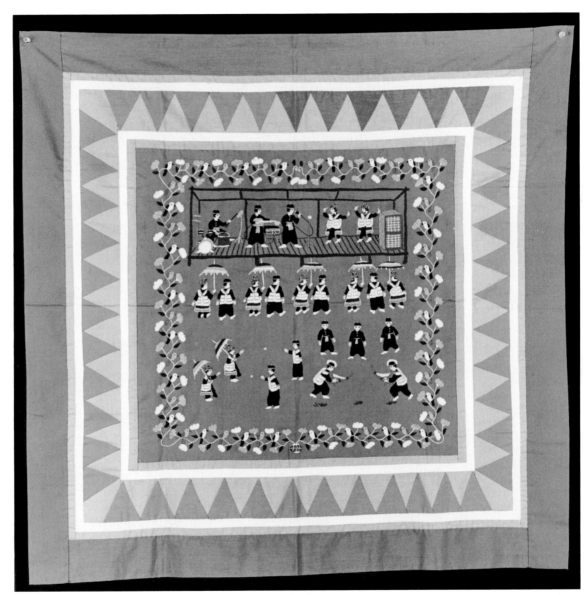

81. Story Cloth: New Year's
Celebration, *1987*
Mai Vang
Minneapolis, Minnesota
Cotton; Appliqué, cross-stitching;
35 in. x 36 in.
Lent by Carol and Pierce Smith

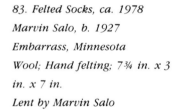

83. *Felted Socks, ca. 1978*
Marvin Salo, b. 1927
Embarrass, Minnesota
Wool; Hand felting; 7¾ in. x 3
in. x 7 in.
Lent by Marvin Salo

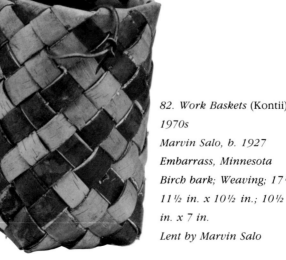

82. *Work Baskets* (Kontii), *early*
1970s
Marvin Salo, b. 1927
Embarrass, Minnesota
Birch bark; Weaving; 17½ in. x
11½ in. x 10½ in.; 10½ in. x 8
in. x 7 in.
Lent by Marvin Salo

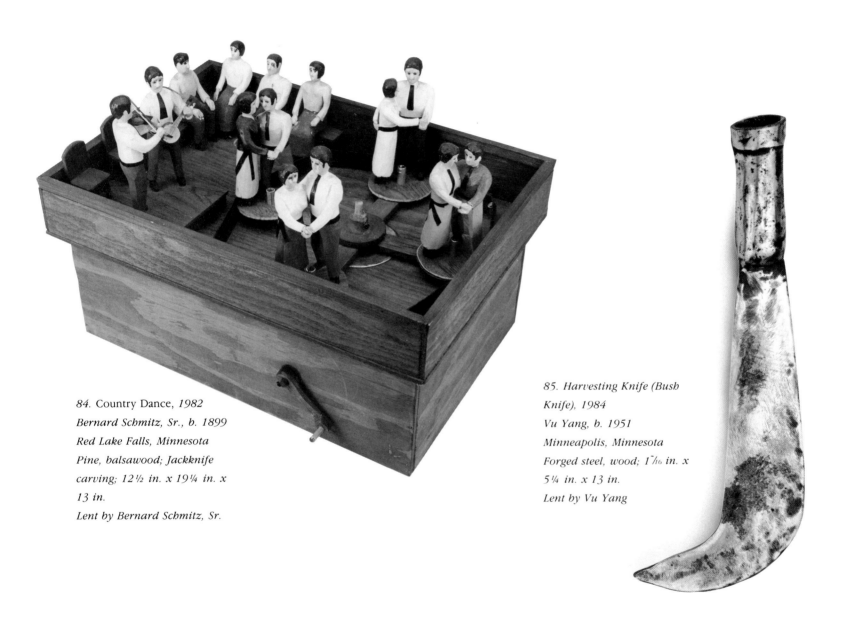

84. Country Dance, *1982*
Bernard Schmitz, Sr., b. 1899
Red Lake Falls, Minnesota
Pine, balsawood; Jackknife
carving; 12½ in. x 19¼ in. x
13 in.
Lent by Bernard Schmitz, Sr.

85. Harvesting Knife (Bush
Knife), 1984
Vu Yang, b. 1951
Minneapolis, Minnesota
Forged steel, wood; 1⁷⁄₁₆ in. x
5¼ in. x 13 in.
Lent by Vu Yang

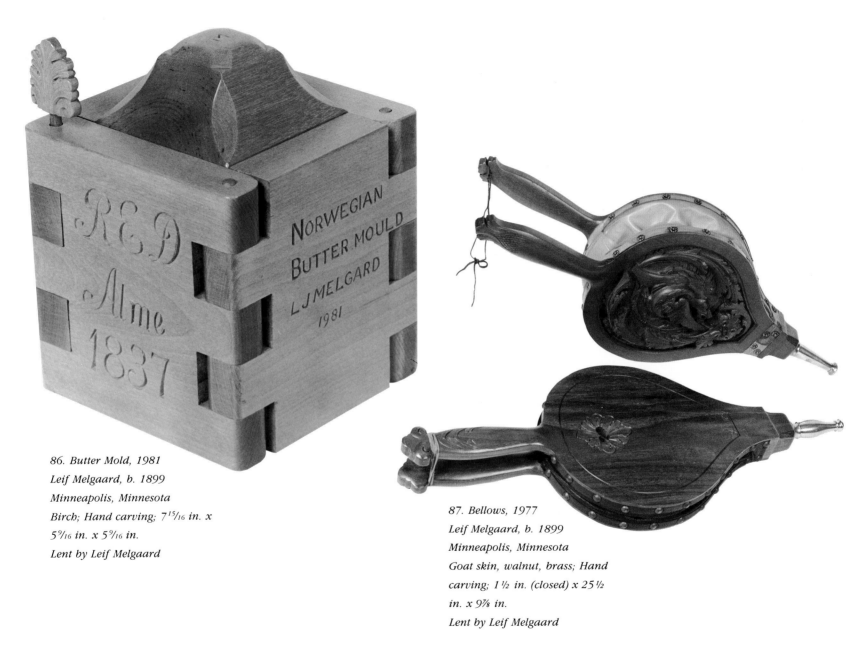

86. Butter Mold, 1981
Leif Melgaard, b. 1899
Minneapolis, Minnesota
Birch; Hand carving; 7^{15}/$_{16}$ in. x
5^{9}/$_{16}$ in. x 5^{9}/$_{16}$ in.
Lent by Leif Melgaard

87. Bellows, 1977
Leif Melgaard, b. 1899
Minneapolis, Minnesota
Goat skin, walnut, brass; Hand
carving; 1 ½ in. (closed) x 25 ½
in. x 9⅞ in.
Lent by Leif Melgaard

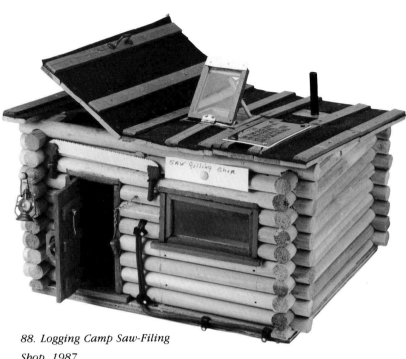

88. *Logging Camp Saw-Filing
Shop, 1987*
Milo Stillwell, b. 1901
Cloquet County, Minnesota
*Wood, metal; 8½ in. x 14½ in.
x 13 in.*
*Lent by Carlton County
Historical Society*

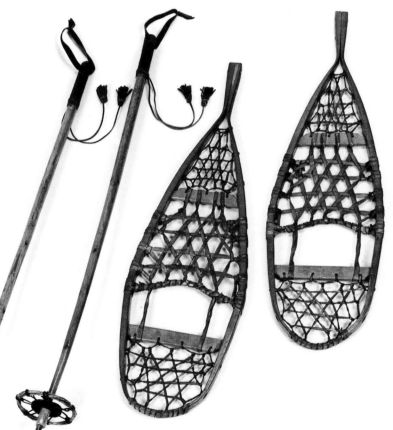

89. *Snow Shoes and Ski Poles,
ca. 1950*
Marvin Salo, b. 1927
Embarrass, Minnesota
*Birch, rawhide; 1 in. x 11 in. x
39¼ in.; 47½ in. x 1½ in.
(diameter, pole) x 5½ in.
(diameter, basket)*
Lent by Marvin Salo

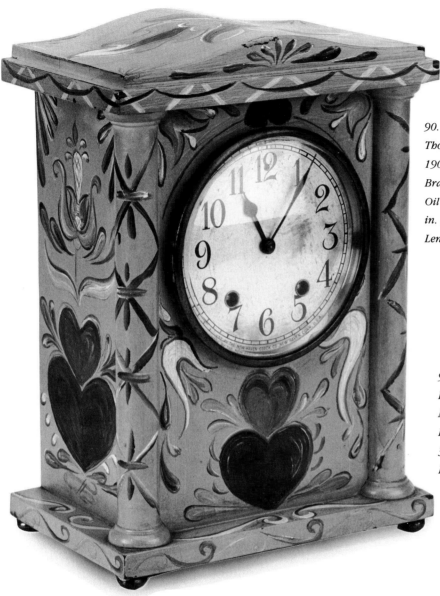

90. *Swedish Clock, ca. 1951*
Thora Ohrn Dobberstein, ca.
1902–86
Braham, Minnesota
Oil paint on wood; 12 ¼ in. x 8⅞
in. x 5 ¾ in.
Lent by Steven Ohrn

91. *Danish Table Runner, 1965*
Karen M. Muller, b. 1907
Minneapolis, Minnesota
Linen; Counted cross-stitching;
35 ½ in. x 14 ½ in.
Lent by Karen M. Muller

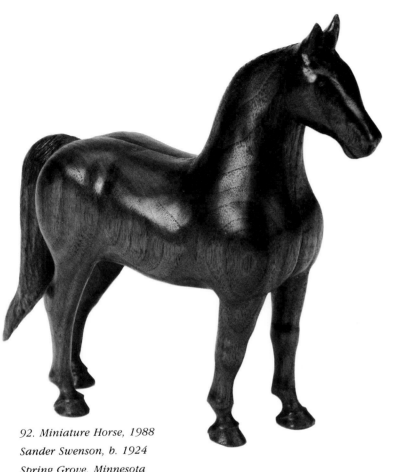

92. Miniature Horse, 1988
Sander Swenson, b. 1924
Spring Grove, Minnesota
Walnut; Outline sawing, gluing,
carving; 6¾ in. x 2 in. x 7¾ in.
Lent by Sander Swenson

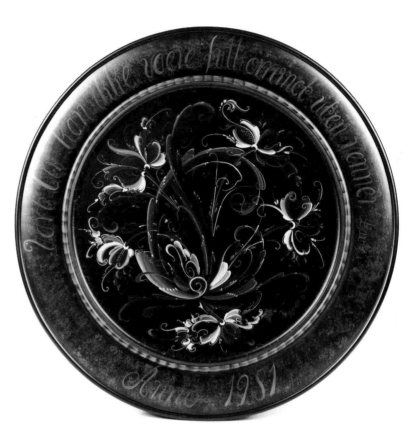

93. Rosemaled Nordic Rimmed
Plate, 1981
Ina Huggenvik, b. 1933
Preston, Minnesota
Turned basswood, oil paint;
Rosemaling; ¾ in. x 23⅞ in.
(diameter)
Lent by Ina Huggenvik

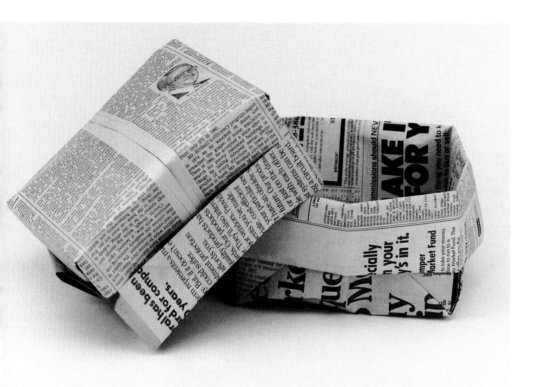

94. *Printers' Caps, 1988*
Richard Cooney
William James Davis
Minneapolis, Minnesota
Newspaper; Folding; 3 in. x 6 in.
x 6 in.
Donated to exhibit by Star
Tribune

95. *Polish Paper Cutting*
(Wycinanki), 1987
Emeline Dziabas Cook, b. 1927
Akeley, Minnesota
Paper; Paper cutting; 18 in. x
18 in.
Lent by Emeline Dziabas Cook

Celebrated Traditions

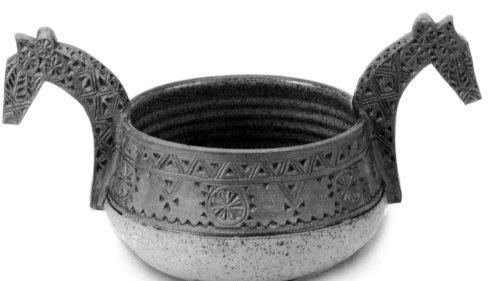

96. Ceramic Ale Bowl, 1988
Gene Tokheim, b. 1947
Lucy Tokheim, b. 1951
Dawson, Minnesota
Clay; Wheel thrown and applied;
6¾ in. x 12¾ in. x 7¾ in.
Lent by Gene and Lucy Tokheim

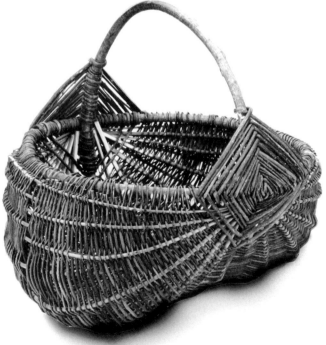

97. Hoop Basket, Appalachian
Style, 1984
Richard D. Harris, b. 1951
Belgrade, Minnesota
Black cherry, willow shoots,
green ash; Binding, weaving;
16½ in. x 17 in. x 18½ in.
Lent by Richard D. Harris

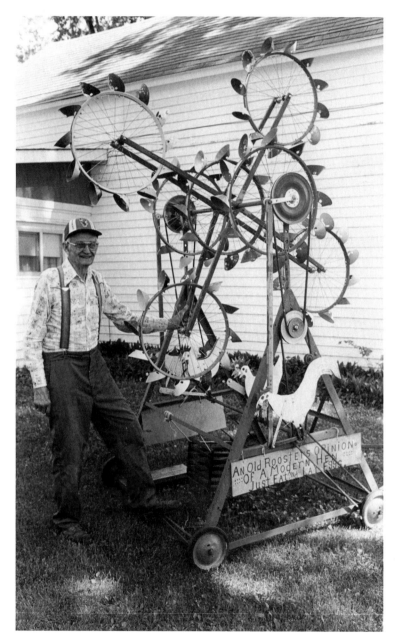

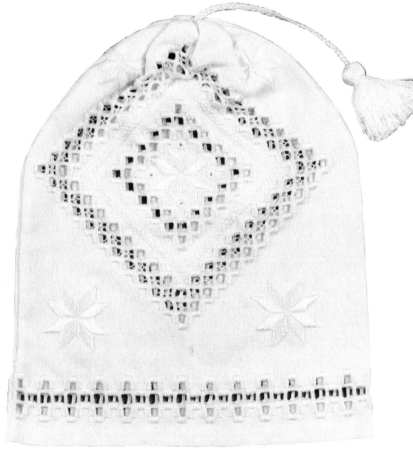

98. Mobile Yard Ornament, 1971
William Malwitz, b. 1899
Red Lake Falls, Minnesota
Painted wood, steel; Welding;
123 in. x 56 in.

99. Hardanger Lace Man's
Wedding Cap, 1986
Susan Clark, b. 1955
Clearwater, Minnesota
Hardanger fabric, thread;
Hardanger stitching; 10⅞ in. x 9
in. (diameter)
Lent by Susan Clark

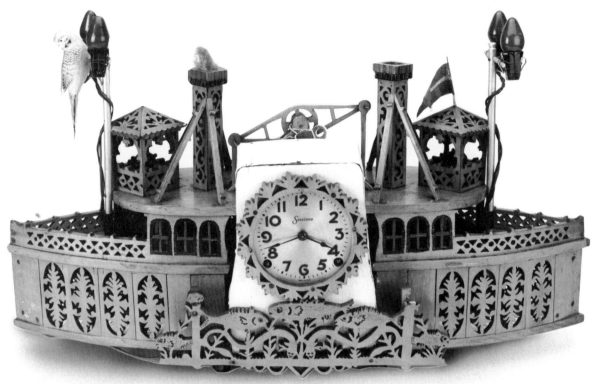

100. *Mississippi River Clock,*
1932–34
Hans Olson, b. 1889
Lanesboro, Minnesota
Wood; Carving, sawing; 14½ in.
x 25½ in. x 8 in.
Lent by Lanesboro Historical
Museum

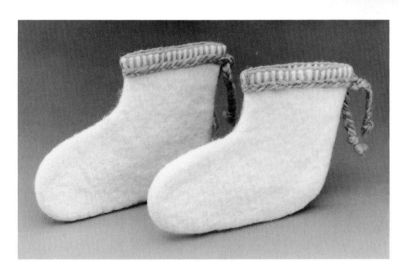

101. *Felted Socks, 1988*
Carol Sperling, b. 1932
Eveleth, Minnesota
Wool; Hand felting; 8¼ in. x ½
in. x 6½ in.
Lent by Carol Sperling

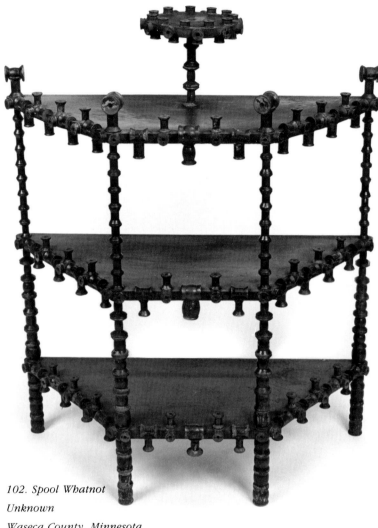

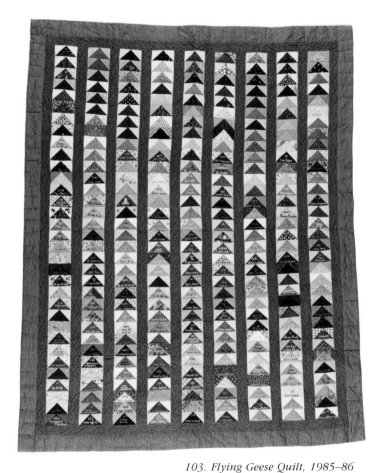

102. Spool Whatnot
Unknown
Waseca County, Minnesota
Wood, spools; 41 in. x 34 in. x
14¾ in.
Lent by the Waseca County
Historical Society

103. Flying Geese Quilt, 1985–86
Members of Minnesota Quilters
Inc.
Bloomington, Minnesota
Cotton; Hand and machine
quilting, hand embroidering; 74
in. x 60 in.
Lent by Minnesota Quilters Inc.

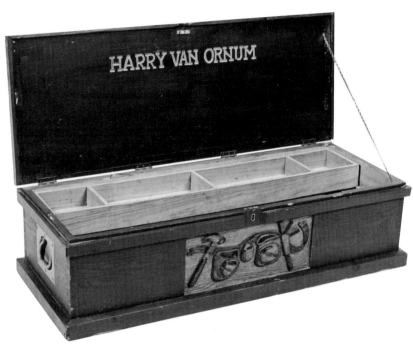

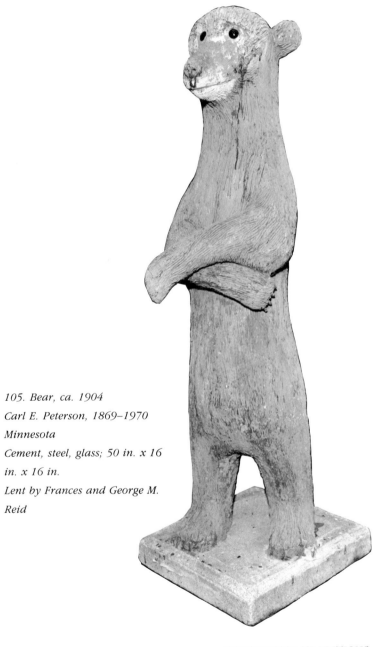

104. Tool Box, 1979
Harry Van Ornum, b. 1948
Cook, Minnesota
White pine; Carving, dovetail
box construction; 10¼ in. x 39½
in. x 15½ in.
Lent by Harry Van Ornum

105. Bear, ca. 1904
Carl E. Peterson, 1869–1970
Minnesota
Cement, steel, glass; 50 in. x 16
in. x 16 in.
Lent by Frances and George M.
Reid

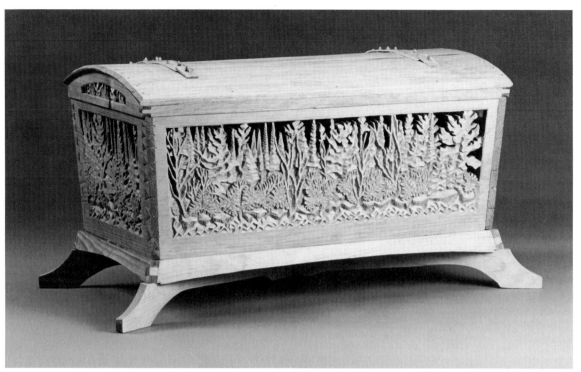

106. Trunk, 1988
Harry Dodge, b. 1937
Duluth, Minnesota
White pine; Hand carving,
planing; 19 in. x 38½ in. x
19½ in.
Lent by Harry Dodge

107. Rosemaled Bowl, 1947
Karen Jenson, b. 1935
Milan, Minnesota
Oil paint on wood; Rosemaling;
3 in. x 11 in. (diameter)
Lent by Karen Jenson

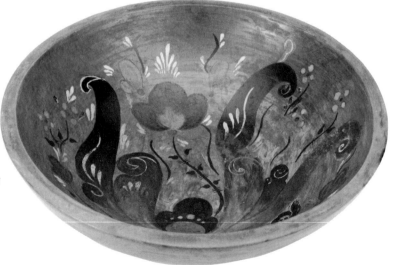

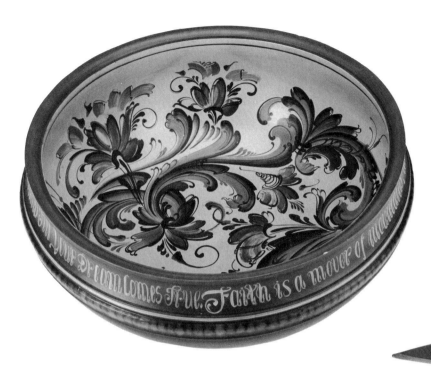

108. Rosemaled Bowl, 1985
Karen Jenson, b.1935
Milan, Minnesota
Oil paint on wood; Rosemaling;
5⅞ in. x 13¾ in. (diameter)
Lent by Karen Jenson

109. Whirligig in Loon Form
Arthur Lensegraz
Minnesota
Wood; Carving, painting; 7 in. x
23½ in. x 4¾ in. x 23½ in.
(propellers)
Lent by Steven Ohrn

The Minnesota Folk Arts Survey

FROM October 1984 through November 1988 Bill Moore conducted a comprehensive survey of the traditional arts in Minnesota. He traveled about fifteen thousand miles and followed up hundreds of leads. He personally visited eighty-one of the eighty-seven counties in the state. This book and the exhibition that accompanies it cannot possibly present in detail all of the artists and collections Bill studied. In order to make this volume a truly useful tool for future researchers or folk art enthusiasts, the following list gives the names of the people documented in the survey. It includes living artists who were interviewed and artists of the past whose works are in museum collections or owned by their relatives and friends. Those works that are featured in the exhibition or the book are indicated by an asterisk next to the artist's name. Listings for those artists who were not interviewed personally but whose work was documented in a collection include the name of the individual collector or the institutional collection. It undoubtedly does not include all the people who are making or have made folk art in Minnesota, but it is the most comprehensive list we know of to date and indicates the breadth and complexity of the traditional arts in our state.

Architecture

Barns and Outbuildings

Roman Landwehr
St. Cloud

Orrin Lovelace
Bertha

*Axel Maki
Angora

*Joseph Mannausau
Loman

J. Roosjala
New York Mills

Saunas

*Axel Maki
Angora

*Martin Mattson
Esko

Les Ristinen
Fergus Falls

Silos

Roy Tresco
St. Cloud

Baskets

Bentwood

Severt Rasmuson
Detroit Lakes
Rasmussen Family Collection,
Moorhead

*Marvin Salo
Embarrass

*Richard Wildgrube
Preston

Birch Bark

Arlene King
Nett Lake

Mae Pelkie
Tower

Woven

*Hannah Beedle
Otter Tail County
Otter Tail County Historical
Society

Tuula Bessy
Bloomington

*William Damer
Long Prairie

*Richard D. Harris
Belgrade

*Jerry and Karen Hawk
Warroad
Minnesota Historical Society

Mae Pelkie
Tower

Carrie Plamann
Brooten

Ellen Mae Robinson
Nay-Tah-Waush

William Robinson
Bagley

*Marvin Salo
Embarrass

*Ray Schabel
Long Prairie

*Unknown Artist
Carlton County Historical
Society

*Peg Warren
Afton

Beadwork

Terri Brightnose
Minneapolis

Roberta Drift
Nett Lake

Jess Goggleeye
Nett Lake

Linda Isham
Nett Lake

Maude Kegg
Mille Lacs

Mae Pelkie
Tower

Mary Porter
Nett Lake

*Unknown Artist
Cokato County Museum and
Historical Society

Unknown Artists
Science Museum of Minnesota

Edna Whiteman
Nett Lake

*Women of the Chippewa Band
of Mille Lacs Reservation
Vineland

Ceramics

Figures
*Franz Allbert Richter
Clarkfield

Jewish top (Dreidel)
*Unknown Artist
Minneapolis

Lunch-Time Pottery
*Albert H. Olson
Red Wing Arts Association

*Julius Risch
Red Wing
Goodhue County Historical
Society

*Unknown Artists
Wad and Caroline Miller
Collection, Willmar

Revivals
*Gene and Lucy Tokheim
Dawson

Seder Plates and Goblets
*Lia Lynn Rosen
Minneapolis

Clothing and Costume

Tuula Bessy
Bloomington

Terri Brightnose
Minneapolis

*Bounxou Chanthraphone
Minneapolis

*Richard Cooney
Minneapolis

*William James Davis
Minneapolis

*Susie Gingerich
Utica

Edna Gonske
Minneapolis

Fanny Hershberger
Harmony

Linda Isham
Nett Lake

Arlene King
Nett Lake

*Lao Lee
St. Paul

Mary Mast
Wadena

*Anna Mizens
Minneapolis

*Xaiv Muas
St. Paul

*Katri Saari
Angora
Saari Family Collection, Angora

*Marvin Salo
Embarrass

*Carol Sperling
Eveleth

Tesfai Tekle
Minneapolis

*Lizbeth Upitis
Minneapolis

*Ardis Wexler
Edina

Environments

Lois Gruhlke
Mazeppa

Mel Johnson
Red Wing

Franklin Olson
Henning

*Dennis Ueke
Vesta

Food

Helen Picek Arola
Angora

Florence Cyr
Red Lake Falls

*Dennis Gelpe
Minneapolis

Florence Gilbertson
Milan

Larry Goga
Minneapolis

*Rose Hanna
St. Paul

Eva Harder
Mountain Lake

Lena Homme
Willmar

Ann Kmit
Minneapolis

Ilie Motu
South St. Paul

Pauline Mueller
South St. Paul

*Lar Mundstock
Eagan

*Thomas O'Keefe
St. Paul

Banlang Phommasouvanh
Eagan

*Maria Silva
West St. Paul

Hanna Solheim
Minneapolis

Magdalena Swiderska
Minneapolis

*Katherny Zastawny
Minneapolis

Hairstyles

*Michael Chaney
Minneapolis

*Edyth McCloud
Edina

*Larkspur Morton
St. Paul

*Jewelean Jackson
Minneapolis

Knotting and Netting

Cheung Bik Yin
St. Paul

*John Harmala, Sr.
Cloquet

Jalmar Kuha
Sebeka

Looms

*Bounxou Chanthraphone
Minneapolis

Marcus Lind
Castle Danger

Mike Niemala
Carlton County Historical
Society

*Unknown Artist
Mary Carlson Collection,
Minneapolis

Unknown Artist
Carlton County Historical
Society

Metalworking and Blacksmithing

*Truman Austin
Lanesboro

Victor Bromley
Askov

*Friends of Albert Stimac
Hoyt Lakes

*Melvin A. Hall
Lanesboro
Curtis Hall Collection,
Lanesboro

Marvin Shave
Sebeka

*David Schebe
Litchfield
Steven Ohrn Collection, Des
Moines

*Nhia Yer Yang
Minneapolis

*Vu Yang
Minneapolis

Miniatures

Bernard Ange
Eveleth

*Carl Good
Cokato County
Cokato County Museum and
Historical Society

*Bernard Schmitz, Sr.
Red Lake Falls

*Milo Stillwell
Cloquet

Betty Storlie
Spring Grove

*Peter Trygg
Cloquet

Mixed Media

Collage
*Maurice Carlton
St. Paul
Minnesota Historical Society

Wesley Glewwe
Minneapolis

*Marty Roth
Minneapolis

Mailboxes

Dan Banitt
Zumbrota

*Ben Ricke
Cottonwood

Ed Schriock
Mountain Lake

Yard Ornaments

*William Malwitz
Red Lake Falls

Musical Instruments

Accordions

*Christy Hengel
New Ulm

Hmong Pipes (Qeej)

Song Ger Thao
St. Paul

Ojibway Game Drum

*Unknown Artist
Minnesota Historical Society

Violin and Fiddle

John Koskie
Angora
Gladys Holmes Collection,
Angora

Allan Kroshus
Spring Grove

Needlework

Berlin Work

*Unknown Artist
Otter Tail County Historical
Society

Crewel

*Magdolna Fulop
Minneapolis

Cross-Stitch

Elsie Hansen
Tyler

Ruth Kleven
Milan

*Elisabeth Lomen
Zumbrota

Blenda Lund
Dawson

*Karen Muller
Minneapolis

Cut Work

*Mrs. McMahan
Waseca County Historical
Society

Hardanger

Marjorie Berge
Milan

Selma Brustven
Appleton

*Susan Clark
Clearwater

Agnes Clausen
Fergus Falls

*Florence Gilbertson
Milan

Alicia Kittleson
Milan

Riet Kramer
Milan

Mrs. Roy Pederson
Battle Lake

Rutti Strand
Montevideo

Leona Thompson
Milan

Margaret Thompson
Milan

*Hmong Appliqué and
Needlework* (Paj ntaub)

Plia Her
St. Paul

Pang Kou
Duluth

Der Lee
St. Paul

Pa Lee
St. Paul

Xia Lee
St. Paul

Xaiv Muas
St. Paul

Yee Muas
St. Paul

*Bloua Vang
Minneapolis

Dia Vang
Rochester

Khang Vang
Minneapolis

*Mai Vang
Minneapolis

Yua Yao Xiong
St. Paul

Blia Yang
St. Paul

Chon Yang
St. Paul

Needlepoint

*Pat Mertes
Winona

Alice Nussbaum
St. Louis Park

Tatting

*Ruth V. Esping
Waseca

*Susan E. Mansfield
Golden Valley

Painting

Dalmålning

*Karen Jenson
Milan

Fireboards

Gayle Dahl
Byron

Furniture Decoration

*Thora Ohrn Dobberstein
Braham
Steven Ohrn Collection, Des
Moines

Pal Fulop
Minneapolis

*Oils or Acrylics on Canvas,
Wood, or Masonite*

*Mamie Falk
Murdock
Falk Associates, Inc.

Beulah Gemmill
Fairmont

*Olaf Gunvalson
Minnesota Historical Society

*Arnold Kramer
Wabasso
Southwest State University
Collection

John Lucius
Minnesota Historical Society

Dion Porter
Nett Lake

*John Rein
Hendrum
Roseau County Historical
Museum and Interpretive
Center

Ivadell Schmidt
Lake Crystal

Irene Siebring
Brewster

Rosemaling

Helen E. Blanck
Blaine

John H. Gundersen
Minneapolis

*Mary Hanson
Spring Grove

Lois Heglen
Bemidji

Alta J. Hemmingson
Fergus Falls

*Ina Huggenvik
Preston

*Karen Jenson
Milan

*Judith Nelson
Minneapolis

Addie Pittelkow
St. Paul

Wall Decoration

Bernard Ange
Eveleth

Paper

Calligraphy

*Peggy H. Davis
Minneapolis

Paper Cutting

*Emeline Dziabas Cook
Akeley

*Barbara Davis
Minneapolis

*Senja Jokinen
Angora

Gloria Kurkowski
St. Paul

*Earle Swain
Elysian
Le Sueur County Historical
Society Museum

*Magdalena Swiderska
Minneapolis

Piñatas

Nancy Muñoz Bernier
St. Paul

Performance

Dance

Sokah Chan
Richfield

Banlang Phommasouvanh
Eagan

Ron Wallace
St. Paul

Instrumental

Arnold Hanson
Spring Grove

*Christy Hengel
New Ulm

Lawrence House
Spring Valley

Viola Kjeldahl Lee
Minneapolis

*William Sherburne
Spring Grove

Henry Storhof
Lanesboro

Norwegian-American Mumming
(Julebukking)

Carsten Bregenhoj
Nordic Institute of Folklore
Turku, Finland

Karen Gray
Spring Grove

Jean Hall
Spring Grove

Rolf G. Hanson
St. Anthony Park

Ida Haukos
Madison

Georgia Rosendahl
Spring Grove

Oral/Verbal

Henry Abramowicz
St. Paul

*Michael Cotter
Austin

*Al Jedlicke
Underwood

Puppetry

*Heart of the Beast Mask and
Puppet Theater
Minneapolis

Song

*Nicolás Castillo
St. Paul

Eclectic Company
St. Paul

Larry Long
St. Paul

Sister Anita Smisek
New Prague

Pipe Carving

*Amos Owen
Welch

*Robert Rosebear
Minneapolis
Science Museum of Minnesota

Quilting

Carolyn Abbott
Brainerd

Myrtle E. Anderson
Aitkin

Mary Barvels
Montevideo

Marguerite Benoit
Red Lake Falls

Helen E. Blanck
Blaine

Stella Borstad
Dawson

Nelle A. Bredeson
New Brighton

Barbara Clarine
Brainerd

*Wilma Crawford
Brainerd

Thelma Dalen
Milan

Joan Deumeules
Plymouth

Eleanor Elmstrom
Forest Lake

Arlene Fitzgerald
Brainerd

Eva Harder
Mountain Lake

Fanny Hershberger
Harmony

Lydia Hershberger
Preston

*Lena Homme
Willmar

*Immanuel Lutheran Church and
Day School
Minneapolis

*Marlys Johnson
Dawson

*Sharlene Jorgenson
Montevideo

Helen Kelley
Minneapolis

Ruth Kleven
Milan

Emma Jean Kydd
Roseville

*Lovina Miller
Canton

Rachel Miller
Lanesboro

*Minnesota Quilters, Inc.
Bloomington

Ruby Olson
Wadena

Mrs. Jacob Petersheim
Preston

Lois Peterson
Bloomington

*Mathilda Quaal
Appleton

Mrs. Sam Quiring
Mountain Lake

Gladys Raschka
Minneapolis

Pauline Ritter
Aitkin

Mary Lou Schmitz
Roseville

Dagne Sylling
Spring Grove

Margaret Thompson
Milan

*Three Hundred and Twenty-
Four Artists
Waseca
Waseca County Historical
Society

*Selma Torstenson
Appleton

*Angela Tostenson
Montevideo

Leona Wilkins
Crookston

Catherine Yoder
Bertha

Rugs

Braided

*David and Joyce Bucklin
Mountain Lake

*Mabel Lyson
Battle Lake

Woven

*Diane Holcomb Fields
Brainerd

*Mary MacDonald Fleming
Little Canada

Verne Gjerset
Milan

*Lyli S. Holcomb
Kelly Lake

*Helga Johnson
Two Harbors

Emma Kaufman
Sauk Center

*Elisabeth Lomen
Zumbrota

Lois Peterson
Bloomington

*Katri Saari
Angora
Saari Family Collection, Angora

*Rora Strom
Two Harbors

*Julia Widen
Two Harbors

Seasonal Expressions

Halloween Pumpkins

*Jennifer J. Moore
Minneapolis

*Joshua E. B. Moore
Minneapolis

*Gillian R. Ross
Minneapolis

*Owen A. Ross
Minneapolis

Polish Easter Eggs

Malgorzata Cieslak
Westbrook

*Magdalena Swiderska
Minneapolis

Snowman

*Bradon Kessel

Ukrainian Easter Eggs

*Luba Perchyshyn
Minneapolis
Ukrainian Gift Shop, Inc.

Shrines

*Edgar Amiot
Red Lake Falls

*Virgil Benoit
Red Lake Falls

*Mrs. Karl Knettel
St. Stephen

*Del Philippi
St. Joseph

*Casper Schwartz
Wadena

*Mary Redick
Brandon

*Anna Slevnik
St. Stephen

*Laurence Trudeau
Red Lake Falls

*Edward Winczewski
St. Cloud

Stone and Cement Sculpture

*Carl E. Peterson
St. James
Gerald Czulewicz Collection,
Isanti

*Alexander Rennie
Minneapolis

Straw Ornaments

*Virginia Hammel
St. Paul

Martha Kortesmaki
St. Paul

Irene Swenson
Underwood

Toys

*Truman Austin
Lanesboro

*Max A. Bayers
Minneapolis

*Yee Chang
Minneapolis

*Carl Good
Cokato County
Cokato Museum and Historical
Society

*Melvin A. Hall
Lanesboro
Curtis Hall Collection,
Lanesboro

*Severt Rasmuson
Detroit Lakes
Rasmussen Family Collection,
Moorhead

Irene Swenson
Underwood

*Unknown
Cokato County
Cokato County Museum and
Historical Society

Transportation

Buggies and Wagons

Amos Yoder
Bertha

Ervin Yoder
Bertha

Martin Yoder
Hewitt

*Andrew Shetler
Utica

Saddles

*Emil Schatzlein
Gerald Schatzlein
Minneapolis
Schatzlein Family Collection,
Minneapolis

Skis

*Peder O. Sjoli
Otter Tail County
Otter Tail County Historical
Society

Sleds

John Juhala
Makinen

*Victor Juslin
Brimson

Snowshoes

Mae Pelkie
Tower

*Marvin Salo
Embarrass

Watercraft

Carl Madsen
Fergus Falls

Weaving

*Mack Davis
St. Paul

*Katri Saari
Angora
Saari Family Collection, Angora

Whirligigs

*Melvin A. Hall
Lanesboro
Curtis Hall Collection,
Lanesboro

*Arthur Lensegraz
Park Rapids
Steven Ohrn Collection, Des
Moines

*Dean Lucker and Ann Wood
Minneapolis

John Redick
Brandon
Redick Family Collection,
Brandon

Woodworking

Chain-Saw Carving

*Terry Boquist
Park Rapids

Patrick Falling
Cloquet

*Larry Jensen
Brainerd

Furniture

*Unknown
Cokato County
Cokato County Museum and
Historical Society

*Unknown
Clay County
Marion and Lila Nelson
Collection, Minneapolis

*Unknown
Waseca County
Waseca County Historical
Society

*Almon Whiting
Clitherall
Otter Tail County Historical
Society

Hand Carving

Edgar Amiot
Red Lake Falls

*Lawrence Bethel
Minnesota
Steven Ohrn Collection, Des
Moines

Lars Christenson
Benson
Vesterheim, Norwegian-
American Museum, Decorah

*Carl Dahlman
Minneapolis

*Eduard Dietmaier
La Crescent

*Harry Dodge
Duluth

Oscar Farnell
Chisago County
Helen White Collection, Taylors
Falls

*Mietek Glowka
St. Paul

John H. Gundersen
Minneapolis

Melvin A. Hall
Lanesboro
Curtis Hall Collection,
Lanesboro

*John Harmala, Sr.
Cloquet
Bruce and Cheryl Iverson
Collection, Willmar

Karl Hendrickson
Bloomington

Rollie Johnson
St. Paul

*Senja Jokinen
Angora

Bill Klinger
Wadena

Halvor Landsverk
Whalan

Ole Langos
Brandon

Gustaf Larson
Crosby

*Lester Lowell
Minnesota
Steven Ohrn Collection, Des
 Moines

Ole Lundberg
Butterfield

*August Mankinen
Minnesota

*Leif Melgaard
Minneapolis

*Hans Olson
Lanesboro

*Carl E. Peterson
St. James
Minnesota Historical Society

*Severt Rasmuson
Detroit Lakes
Rasmussen Family Collection,
 Moorhead

*Marvin Salo
Embarrass

*Bernard Schmitz, Sr.
Red Lake Falls

*Sander Swenson
Spring Grove

*Walter Torfin
Duluth

*Unknown Artist
Minnesota
Bruce and Cheryl Iverson
 Collection, Willmar

*Harry Van Ornum
Cook

Selected Bibliography

General References

Ames, Kenneth L. *Beyond Necessity: Art in the Folk Tradition.* Winterthur, Del.: Winterthur Museum, 1977.

Anderson, E. N., Jr. "On the Folk Art of Landscaping." *Western Folklore* 31 (July 1972): 179–88.

Becker, Arthur S. *Art Worlds.* Berkeley: University of California Press, 1982.

Blatti, Jo, ed. *Past Meets Present: Essays about Historic Interpretation and Public Audiences.* Washington, D.C.: Smithsonian Institution Press, 1987.

Bronner, Simon J. "Investigating Identity and Expression in Folk Art." *Winterthur Portfolio* 16 (1981): 65–83.

_____ . *American Folk Art: A Guide To Sources.* New York: Garland Publishing, 1984.

_____ . *American Material Culture and Folklife: A Prologue and Dialogue.* Ann Arbor: UMI Research Press, 1985.

_____ . *Grasping Things: Folk Material Culture and Mass Society in America.* Lexington: University Press of Kentucky, 1986.

Christensen, Erwin O. *The Index of American Design.* New York: Macmillan Co., 1950.

Dewhurst, C. Kurt, et al. *Religious Folk Art in America: Reflections of Faith.* New York: E. P. Dutton, Inc., 1983.

Dorson, Richard M., ed. *Folklore and Folklife: An Introduction.* Chicago: University of Chicago Press, 1972.

_____ . *Handbook of American Folklore.* Bloomington: Indiana University Press, 1983.

Gilbertson, Donald E., and James F. Richards, Jr. *A Treasury of Norwegian Folk Art in America.* Osseo, Wis.: Tin Chicken Antiques, 1975.

Glassie, Henry H. *Pattern in the Material Folk Culture of the Eastern United States.* Philadelphia: University of Pennsylvania Press, 1969.

_____ . *Passing the Time in Balleymenone.* Philadelphia: University of Pennsylvania Press, 1982.

Hall, Patricia, and Charles Seemann. *Folklife and Museums: Selected Readings.* Nashville: American Association for State and Local History, 1987.

Hobbs, Jack A. *Art in Context.* New York: Harcourt Brace Jovanovich, 1975.

Hufford, Mary. *A Tree Smells Like Peanut Butter: Folk Artists in a City School.* Trenton: New Jersey State Council on the Arts, 1979.

Jansen, William Hugh. "The Esoteric-Exoteric Factor in Folklore." In *The Study of Folklore,* ed. Alan Dundes, 43–51. Englewood Cliffs, N.J.: Prentice-Hall, 1965.

Jones, Michael Owen. *The Hand Made Object and Its Maker.* Berkeley: University of California Press, 1975.

_____ . *Exploring Folk Art: Twenty Years of Thought on Craft, Work, and Aesthetics.* Ann Arbor: UMI Research Press, 1987.

Kubler, George. *The Shape of Time: Remarks on the History of Things.* New Haven: Yale University Press, 1962.

Marshall, Howard, et al. *American Folk Architecture: A Selected Bibliography.* Washington, D.C.: American Folklife Center, 1981.

Quimby, Ian M. G., ed. *Material Culture and the Study of American Life.* New York: W. W. Norton, 1978.

_____ , and Scott Swank, eds. *Perspectives on American Folk Art.* New York: W. W. Norton, 1980.

Schlereth, Thomas J. *Material Culture Studies in America.* Nashville: American Association for State and Local History, 1982.

Teske, Robert T. "What is Folk Art?" *El Palacio: Magazine of the Museum of New Mexico* 88 (Winter 1982–83): 34–38.

Toelken, Barre. *The Dynamics of Folklore*. Boston: Houghton Mifflin, 1979.

Vlach, John Michael. *Plain Painters: Making Sense of American Folk Art*. Washington, D.C.: Smithsonian Institution Press, 1988.

Indian Sources

Coe, Ralph T. *Sacred Circles: Two Thousand Years of North American Indian Art*. Kansas City, Mo.: Nelson Gallery of the Atkins Museum of Fine Arts, 1977.

Garte, Edna. *Circle of Life: Cultural Continuity in Ojibwe Crafts*. Duluth: St. Louis County Heritage and Arts Center, 1984.

Lyford, Carrie A. *The Crafts of the Ojibwa*. Indian Handcrafts Series no. 5. [Washington, D.C.]: Office of Indian Affairs, 1943.

Vennum, Thomas Jr. *The Ojibwa Dance Drum: Its History and Construction*. Smithsonian Folklife Studies 2. Washington, D.C.: Smithsonian Institution Press, 1982.

Minnesota History Sources

Blegen, Theodore C. *Grass Roots History*. Minneapolis: University of Minnesota Press, 1947.

_____ . *Minnesota: A History of the State*. 2d ed. Minneapolis: University of Minnesota Press, 1975.

Folwell, William W. *History of Minnesota*. 4 vols. Rev. ed. St. Paul: Minnesota Historical Society Press, 1956.

Minnesota Folk Art Sources

Coen, Rena Neumann. *Painting and Sculpture in Minnesota, 1820–1914*. Minneapolis: University of Minnesota Press, 1976.

Henning, Darrell D., et al. *Norwegian-American Wood Carving of the Upper Midwest*. Decorah, Ia.: Norwegian-American Museum, 1978.

Kaplan, Anne R. "The Folk Arts Foundation of America: A History." *Journal of the Folklore Institute* 17 (Jan.–April 1980): 56–75.

Marling, Karal Ann. *The Colossus of Roads: Myth and Symbol Along the American Highway*. Minneapolis: University of Minnesota Press, 1984.

Sickels, Alice L. "The International Institute in the Field of Folk Art." Paper presented at the National Institute Conference of International Institutes Councils and League for Foreign-born, Grand Rapids, Mich., May 25, 1940. Copy in Immigration History Research Center, St. Paul.

[Spraker, Jean E]. "Abstracts of Papers Delivered at a Midwestern Conference on Folk Arts and Museums." St. Paul: Minnesota Historical Society Education Division, 1980.

Minnesota Folk Architecture and Material Culture Sources

Andersson-Palmqvist, Lena. *Building Traditions among Swedish Settlers in Rural Minnesota*. Stockholm: Nordiska Museet, 1983.

Brinkman, Marilyn S., and William T. Morgan. *Light from the Hearth: Central Minnesota Pioneers and Early Architecture*. St. Cloud: North Star Press, 1982.

Karni, Michael, and Robert Levin. "Northwoods Vernacular Architecture: Finnish Log Building in America." *Northwest Architecture* 36 (May–June 1973): 92–99.

Kaups, Matti. "Finnish Log Houses in the Upper Middle West: 1890–1920." *Journal of Cultural Geography* 3 (Spring/Summer 1983): 2–26.

_____ . "A Finnish Savusauna in Minnesota." *Minnesota History* 45 (Spring 1976): 11–20.

Nelson, Marion J. "The Material Culture and Folk Arts of the Norwegians in America." In *Perspectives on American Folk Art,* ed. Quimby and Swank, 79–133. New York: W. W. Norton, 1980.

Peterson, Fred. *Traditional American Crafts: American Industrial and Vernacular Arts*. Morris: The Gallery, Fine Arts Center, University of Minnesota, 1975.

Minnesota Folk Music and Folklife Sources

Fleishhauer, Carl, et al., comps. "Minnesota Logging Camp, September 1937: A Photographic Series by Russell Lee." In *Folklife Annual 1986,* ed. Alan Jabbour and James Hardin, 109–31. Washington, D.C.: Library of Congress, 1986.

Fowke, Edith. "The Red River Valley Re-examined." *Western Folklore* 23 (July 1964): 163–71.

Jordan, Philip D. "Toward a New Folklore." *Minnesota History* 27 (Dec. 1946): 273–80.

Kaplan, Anne R., Marjorie A. Hoover, and Willard B. Moore. *The Minnesota Ethnic Food Book.* St. Paul: Minnesota Historical Society Press, 1986.

Karni, Michael G. "Otto Walta: Finnish Folk Hero of the Iron Range." *Minnesota History* 48 (Winter 1967): 391–402.

Mittlefeldt, Pamela J., comp. *Minnesota Folklife: An Annotated Bibliography.* St. Paul: Center for the Study of Minnesota Folklife and Minnesota Historical Society, 1979.

Moore, Willard B. "Ritual and Remembrance in Minnesota Folk Celebrations." *Humanities Education* 3 (September 1986): 43–52.

Stanchfield, Bessie M. "'The Beauty of the West': A Minnesota Ballad." *Minnesota History* 27 (Sept. 1946): 179–89.

Swanson, Roy. "A Swedish Immigrant Folk Figure: Ola Värmlänning." *Minnesota History* 29 (June 1948): 105–13.

Comparative Sources from Other States

Dewhurst, C. Kurt, and Marsha MacDowell, eds. *Michigan Hmong Arts: Textiles in Transition.* Publications of the Museum, Michigan State University, Folk Culture Series, vol. 3, no. 2. East Lansing: The Museum, 1984.

Dewhurst, C. Kurt, and Marsha MacDowell. "Expanding Frontiers: The Michigan Folk Art Project." In *Perspectives On American Folk Art,* ed. Quimby and Swank, 54–78. New York: W. W. Norton, 1980.

———. *Rainbows in the Sky: The Folk Art of Michigan in the Twentieth Century.* East Lansing: Michigan State University Press, 1978.

Jones, Suzi. *Oregon Folklore.* Eugene: University of Oregon and Oregon Arts Commission, 1977.

Leary, James, and Janet Gilmore. *From Hardanger to Harleys: A Survey of Wisconsin Folk Art.* Sheboygan: John M. Kohler Arts Center, 1987.

Ohrn, Steven G., ed. *Passing Time and Traditions: Contemporary Iowa Folk Artists.* Des Moines: Iowa State University Press, 1984.

Siporin, Steve, ed. *Folk Art of Idaho.* Boise: Idaho Commission on the Arts, 1984.

Index

Algonquian Indians, drums, 60
Altarpieces, carved, 31; painted, 93
Altars, decorated, 12; painted, 32
Altmanis, Ilze, 82, 83
Altmanis, Janis, 82, 83
Amish, sense of tradition, 3; religion, 12; culture, 13; quilt, 102; caps, 107
Anderson, Wendell, governor, 49
Austin, Truman, artist, 9
Ayer, Harry D., 67
Ayer, Jeannette O., 67

Baker, William Bineshi, Sr., drum maker, 60
Bandolier bag, 103
Bands, dance, 71, 77
Baskets, potato, 106, 107; willow, 127; birch bark, 134; Appalachian, 141
Beadwork, decorative, 61, 62, 63, 65, 103
Beaver, Jim, drum owner, 64
Berg, Hans, artist, 38
Bernier, Nancy Muñoz, piñata maker, 7
Berquist, John, 36
Birch bark, baskets, 134
Blacks, hairstyles, 17, 129
Blacksmithing, tools made, 9
Blessing, Fred K., Jr., 63, 65
Blue Earth County Historical Museum, collections, 28
Budak, Mike, site manager, 47
Buddhists, religion, 12; festival, 14

Buggy, design, 13
Bullard's Jewelry Store, Minneapolis, 38
Byrne, Thomas R., mayor, 53

Calligraphy, 109
Cambodians, games, 10
Carlton, Maurice, artist, 130
Castillo, Michael, musician, 77
Castillo, Nicolás, career, 71; composes corridos, 73–78; honored, 77; death, 78
Castillo, Paul, musician, 77
Castillo, Tomasa Perez, 71, 75
Castillo family, 71, 78
Catholics, create grottoes, 4, 14, 55; celebrations, 77–78
Ceramics, dreidel, 123. See also Pottery
Chang, Yee, toymaker, 119
Chanthraphone, Bounxou, Laotian, 93, 96; weaver, 106
Chato, Mexican American, 75
Chavez, Cesar, honored, 71
Chicano, culture, 77. See also Mexican Americans
Children, toys, 7; games, 10
Christenson, Lars, woodworker, 26, 30–32, 40
Christmas, celebrated, 14
"Christmas Fools," customs, 10
Clark, Susan, needleworker, 142
Clocks, Swedish, 138; Mississippi River, 143
Clothing, Ojibway, 4, 65; caps, 12,

13, 14, 96, 107, 121, 140, 142; dresses, 13; as part of culture, 25–26; shoes, 28; mittens, 80–86, 101, 116; socks, 134, 143. See also Costumes
Colors, in quilts, 28; as symbols, 52, 53, 55, 63, 65, 67
Cook, Emeline Dziabas, paper cutter, 140
Cooney, Richard, capmaker, 140
Corridos, ballads, 71–78
Costumes, Hmong, 4; funeral, 13; for women, 15; Norwegian, 25; for festivals, 51–53, 130; Latvian, 84; Laotian, 93. See also Clothing
Cothran, Kay L., folklorist, 2
Crafts, Norwegian, 27–41; ethnic revival, 35–41
Cubbs, Joanne, curator, 13
Culture, concept discussed, 1, 2; relation to tradition, 4; values, 12; relation to folk art, 15, 24, 25, 46, 52; Mexican American, 77; Latvian, 84, 86
Curl, Hulda, 36
Czechs, songs, 84

Dahlman, Carl, woodworker, 132
Dakota Indians, drums, 61, 62, 63, 64, 65, 66, 68; pipes, 115
Dalmålning, 16, 100
Damer, William, basketmaker, 106, 107
Dance, social, 62; bands, 71, 77
Danes, needlework, 138

Davis, Barbara R., paper cutter, 109
Davis, Henry, drum, 64, 68
Davis, Peggy H., calligrapher, 109
Davis, William James, capmaker, 140
Decoys, carved, 120
Dietmaier, Eduard, woodworker, 131
Discrimination, racial, 76
Dobberstein, Thora Ohrn, painter, 138
Dodge, Harry, woodworker, 146
Drake family, barn, 108
Dreams, symbols, 63, 67; impact, 66, 67
Dreidels, 4, 11, 123
Drift, Walter, drum owner, 64, 66
Drum-rattle, 67
Drums, dance drum, 60, 65; construction, 61, 62, 66; decorations, 63, 64; dream drum, 64, 68; relation to religion, 65; powers, 66; symbols, 68
Durable Goods, Minneapolis, store display, 56

Eagles, feathers used, 63, 65
Easter, celebrated, 4, 5, 14, 90, 92, 103, 111
Education, gender specific, 82
Eelpout, fish, 48–51
Eggs, decorated, 92, 103
Elderly, as artists, 5, 18
Engen, Hans, woodworker, 40
Engseth, Martin, rosemaler, 44
Ericson, Edward, 38
Ericson, Eleanor, rosemaler, 38

Estrella, Armando, honored, 77
Ethnicity, impact on crafts revival, 35–41; and festivals, 51–53

Face paint, used, 65
Falk, Mamie, painter, 132
Farms, models of machines, 18; scenes, 89, 99, 126, 132; barn 108
Festival of Nations, 84, 85
Festivals, food, 14; and folk art, 48, 49, 51; ethnic, 51–53. *See also* specific occasions
Fields, Diane Holcomb, rugmaker, 129
Finns, sleds, 11, 113; furniture, 119
Fish, subject of festival, 48, 50–51; folklore, 49
Flamingos, as yard ornaments, 54–57
Flatgard, Thor, needleworker, 28
Folk art, concept discussed, 1, 2–3, 21, 24–27; analyzed, 4–6, 55; and religion, 12–15; and culture, 15; and continuity, 19; Norwegian, 27–41; impact of ethnicity, 35–41; defined, 45, 46, 48; of festivals, 48, 49, 51; and tradition, 52, 53, 56, 63, 80, 84–86; and photographs, 54
Food, 7; for festivals, 14; Mexican American, 75; customs, 111; canned, 90; Ukrainian, 90; Laotian, 96
Fourth of July, celebrated, 73–75
Fox Indians, drums, 63
French Canadians, customs, 14
Fulop, Magdolna K., needleworker, 101
Funerals, costumes, 13; customs, 15
Furniture, made, 27; Norwegian, 28–34; chairs, 39, 121; chest, 105; bed, 119; rosemaled, 94, 128; whatnot, 144

Gahgaydjeewun, drum owner, 68
Games, relation to folklore, 9, 10; Ojibway, 66
Germans, customs, 14; festival, 53

Gifts, of food, 14; of drums, 61, 63, 68; of mittens, 80, 83
Gilbertson, Florence, needleworker, 110
Gingerich, Susie, capmaker, 107
Glassie, Henry, folklorist, 15, 19, 25, 29, 30
Gonzalez, Corky, honored, 71
Goose decoy, carved, 120
Grand Mound, historic site, 47
Grass Dance, origins, 60; society, 61; drums, 61, 62
Grottoes, religious shrines, 4, 14, 55; family shrine, 102
Gunvalson, Olaf, painter, 33, 89

Hall, Melvin A., yard-ornament maker, 9, 33; metalworker, 124, 125
Halloween, customs, 10
Halvorson, Nettie Bergland, textile artist, 34–35, 36
Hand drum, 66, 67
Hanna, Rose, pastrymaker, 14, 111
Hanson, Mary, artist, 128
Hanukkah, celebrated, 11
Hardanger, altar cloth, 12, 21; revival, 36; towel, 110; cap, 142
Harris, Richard D., basketmaker, 141
Harvest figure, 49
Hawk, Karen, basketmaker, 127
Heart of the Beast Mask and Puppet Theater, 16
Hmong, costumes, 4; tools, 9; artwork, 13, 16; needlework, 15, 96, 124, 133; knives, 119, 135; toys, 119
Holcomb, Lyli S., rugmaker, 105
Homme, Lena, quiltmaker, 18, 120
Hovland, Synnove, promotes rosemaling, 44
Huggenvik, Ina, rosemaler, 139
Humor, jokes, 47–48; and tradition, 50, 51; relation to folk art, 55, 56
Hungarians, needlework, 101

Iconostasis, restored, 104
Indians, religion, 12. *See also* specific tribal groups

International Eelpout Festival, Walker, 48–51
International Falls, winters, 48
Ireland, John, archbishop, 53
Irish, festival, 51–53
Iron ranges, folklore, 8
Isham, Linda, artist, 14
Ishquayaush, Ojibway Indian, 68

Jackson, Jewelean, dancer, 17; hairstyle, 129
Jensen, Larry, woodworker, 117
Jenson, Karen, dalmålner, 16, 100; rosemaler, 39, 94, 146, 147
Jews, *dreidels*, 4, 11, 123; religious art, 12, 109, 112, 121, 123; food, 14
Johnson, Helga, rugmaker, 20, 115
Johnson, Marlys, quiltmaker, 98
Jokinen, Senja, woodworker, 110
Jones, Louis C., folklorist, 45
Jones, Michael Owen, folklorist, 1, 45
Jorgenson, Sharlene, quiltmaker, 127
Juhala, John, reminiscences, 11
Julebukking, customs, 10, 11
Jumis, mythical figure, 81
Juslin, Victor, woodworker, 113

Kemewan, drum owner, 64
Kennedy, John F., honored, 72–73
Kickapoo Indians, drums, 63
Knitting, 27; Norwegian, 28; Latvian, 80–86, 101, 116
Knives, Hmong, 9, 119, 135
Kouwenhoven, John, art historian, 24, 41
Kramer, Arnold, painter, 99, 126
Kramer, Reit, needleworker, 21, 36
Kubbestol, log chair, 29, 32, 34
Kundera, Milan, author, 84

Landes, Ruth, anthropologist, 61, 63
Landsverk, Halvor, woodworker, 19, 33, 39, 40; sculptor, 35
Landsverk, Tarkjil, woodworker, 32–34, 35
Laotians, customs, 14; costumes, 93; food, 96; loom, 106

Latvians, mittens, 80–86, 101, 116
Lensegraz, Arthur, whirligigmaker, 147
Lillevik, –, woodworker, 39
Lincoln, Abraham, statue, 33, 35
Littlewolf, James, informant, 61, 62
Lomen, Elisabeth, weaver, 39; needleworker, 114
Looms, Norwegian, 27; Laotian, 106; wood, 118. *See also* Weaving
Lucker, Dean, whirligigmaker, 5
Lumbering, camp model, 9, 137
Lunch-time pieces, pottery, 8, 122
Lysne, Per, rosemaler, 38
Lyson, Mabel, rugmaker, 98

McMahan, Mrs. –, needleworker, 116
Madison Lutheran Church, 12
Mahzoomahnay, Ojibway leader, 61, 65
Maingans, Ojibway singer, 70
Malwitz, William, yard-ornament maker, 16, 142
Mankinen, August, woodworker, 118
Mansfield, Susan E., tatter, 17
Mara, mythical figure, 81
Matchokamow, Johnny, drum owner, 61, 64
Medicine, Albert, drum owner, 68
Melgaard, Leif, woodworker, 27, 39, 136
Melheim, Hermund, woodworker, 32, 33
Men, tools used, 7, 9
Menominee Indians, drums, 63
Mertes, Pat, needleworker, 111
Metalwork, 117, 124, 125
Mexican Americans, murals, 17; community, 71; music, 72, 73, 75; culture, 77
Midewiwin, 62, 63, 65, 66
Miller, Lovina, quiltmaker, 102
Minnesota Historical Society, collections, 67
Minnesota Peace Ribbon, project, 17
Minnesota State Fair, exhibits, 12, 36
Mittens, Latvian, 80–86, 101, 116
Mizens, Anna, career, 81–83; mittenmaker, 84–86, 116
Mizens, Karlis, marriage, 83, 86

Moccasin game, 66
Morton, Shirley, teacher, 10
Mosquitoes, statue, 46–47; in folklore, 48
Muas, Xaiv, needleworker, 96
Muller, Karen M., needleworker, 138
Murals, public, 17
Museum of Industrial Arts, Oslo, Norway, 35
Music, Ojibway, 68, 70; Mexican American, 72, 73, 75; folk, 77. *See also* Songs
Myths, symbols, 81

Needlework, needlepoint, 12, 13, 111, 121; Hmong, 13, 15, 96, 124, 133; tatting, 17; embroidery, 34, 101, 114; cut-and-tie work, 116; Danish, 138. *See also* Hardanger, Knitting
Nelson, Judith, artist, 125
Neraason, Aletrice, quiltmaker, 6
Newspapers, workers' caps, 8, 140
Norwegians, customs, 10, 14; folk art, 19, 27; settlement, 24, 27; costumes, 25; crafts, 27–41; furniture, 28–33; folk art revival, 35–41; mittens, 80; skis, 112; wood carving, 128
Novak, Michael, author, 37

Odden, Gunnar, woodworker, 39, 40
Odjibwe, Ojibway singer, 70
Ojibway Indians, clothing, 4, 13, 14, 65; art, 15; drums, 60–66, 68; dreams, 66; music, 68, 70; bandolier bag, 103
O'Keefe, Thomas, canner, 7, 90
Olson, Hans, woodworker, 143
Olson, King, woodworker, 30, 32
Ordos, Joseph, 36
Otter Tail County Historical Society, collections, 28
Owen, Amos, pipe carver, 115
Paintings, naivist, 34; farm scene, 89, 99, 126, 132
Paj ntaub, symbolism, 13; created, 15

Palestinians, Easter pastries, 4; customs, 14
Paper cutting, Polish, 5, 97, 140; Jewish, 109
Parades, May Day, 16; St. Patrick's Day, 51–53
Peach, Trudy, rosemaler, 39
Perchyshyn, Luba, egg decorator, 92
Peterson, Carl E., sculptor, 5, 145
Photographs, of fish, 49–50; of families, 53, 54
Pindegagash, George, drum owner, 64
Pipes, carved, 115
Plains Indians, drums, 60
Poetry, Norwegian, 33
Poles, paper cutting, 5, 97, 140; decorate eggs, 103
Potawatomi Indians, drums, 61, 63, 67
Pottery, lunch-time, 8, 122; *dreidel*, 11; plate, 112; bowl, 141. *See also* Ceramics
Purim, celebrated, 14

Quaal, Mathilda, quiltmaker, 28, 91
Quilts, discussed, 6; made, 18–19, 25, 28, 91, 95, 98, 102, 120, 127, 144; used, 61

Raschka, Gladys, quiltmaker, 19
Raschka-Reeves, Nancy, quiltmaker, 19
Rasmuson, Severt, woodworker, 40, 126
Redick, Mary, creates grotto, 102
Rein, John, painter, 12, 31, 32, 93
Religion, and folk art, 12–15. *See also* specific groups
Rennie, Alexander, stone carver, 7–8, 113
Ricke, Ben, artist, 114
Riegl, Alois, scholar, 24
Rituals, Indian, 60; for drumming, 61–63
Roberts, Warren E., folklorist, 2
Rose Lutheran Church, Roseau County, 31
Rosemaling, 6, 25; created, 16;

revived, 38, 39, 44; bowl, 125, 146, 147; on furniture, 94, 128; plate, 139
Rosen, Lia Lynn, potter, 112
Roth, Marty, professor, 4
Rugs, woven, 20, 115, 122, 123; braided, 98; Swedish, 105, 129
Russian Orthodox Church of St. Peter and St. Paul, Bramble, 104

Saari, Katri, weaver, 20
St. Constantine's Ukrainian Catholic Church, Minneapolis, 14
St. Louis County Historical Society, collections, 32
St. Patrick's Day, celebrated, 51–53
St. Paul, neighborhood, 18, 71, 73; parades, 51–53; park, 78
St. Paul's Episcopal Church, Winona, 12, 111
Salo, Marvin, basketmaker, 134; sockmaker, 134; snow-shoe maker, 137
Sam, Pete, drum owner, 64
Sauk Indians, drums, 63
Schabel, Ray, basketmaker, 107
Schack, Ann, 46
Schack, Mike, sculptor, 46–47, 48
Schatzlein, Gerald, saddlemaker, 7
Schlereth, Thomas, scholar, 54
Schmitz, Bernard, Sr., woodworker, 94, 131, 135
Schroeder, Fred E. H., scholar, 9
Sculpture, concrete, 5, 33, 35, 145; yard ornaments, 46–47; chain saw, 117
Sioux Indians, drums, 61, 62, 63, 64, 65, 66, 68; pipes, 115
Sjoli, Peder O., makes skis, 112
Skare, John, weaver, 39
Skis, decorated, 8; made, 28; Norwegian, 112; poles, 137
Sleds, Finnish, 11, 113
Sletten, Ingebritt, woodworker, 30, 32
Smith, M. Estellie, anthropologist, 2
Snow shoes, made, 137
Songs, used with drums, 60, 68; Mexican American, 71–78; Czech, 84. *See also* Music

Southeast Asians, religion, 12
Sperling, Carol, sockmaker, 143
Spoons, wooden, 28
Stillwell, Milo, woodworker, 9, 137
Stone, carved, 7–8, 113
Stories, in pictures, 15; story cloths, 16; folklore, 47; told in song, 73, 75, 77
Storvik, Mari, knitter, 28
Straka, William J., priest, 15
Strom, Rora, rugmaker, 122
Sundt, Eilert, sociologist, 35
Swedes, painting, 16, 100; festival, 53; rugs, 105, 129; barn, 108; clock, 138
Swenson, Sander, woodworker, 40, 139
Swiderska, Magdalena, paper cutter, 97; egg decorator, 103

Tailfeather Woman, Dakota, 60, 61, 62, 65, 67
Tarabenez, Alex, makes iconostasis, 104
Textiles, made, 34–35, 36; Latvian, 85
Thunderbird Drum, 68, 69
Toftey, Suzanne, rosemaler, 39
Tokheim, Gene, potter, 141
Tokheim, Lucy, potter, 141
Tools, 7; blacksmithing, 9; used in art, 19; box, 145
Torfin, Walter, woodworker, 128
Torstenson, Ruth, quiltmaker, 6
Torstenson, Selma, quiltmaker, 6
Tostenson, Angela, quiltmaker, 95
Tourneau, Irena, historian, 80
Toys, 7; *dreidels*, 4, 11, 123; doll 10; hobby horse, 110; top, 119; puzzles, 126
Tradition, concept discussed, 1–4, 21; contexts, 7; and religion, 12–15; impact of change, 15–19; and variety, 19–21; relation to folk art, 24–27, 45, 52, 53, 56, 63, 80, 84–86; in Norwegian folk art, 28–41; relation to ethnic revival, 38–41; and humor, 50, 51; in songs, 73; Mexican American, 77

Trelstad, Thora, quiltmaker, 6
Trujillo, Marcella, honored, 76
Trygg, Pete, logger, 9

Ukrainians, customs, 14, 90, 92
United Food and Commercial
 Workers Union, strike, 17
United Methodist Church,
 Kabetogama, 32
Universities, faculty folk art, 3, 4
University of Minnesota, Chicano
 Studies, 71, 76
Upitis, Lizbeth, mittenmaker, 84, 85,
 101

Van Ornum, Harry, woodworker,
 145
Vang, Bloua, needleworker, 124
Vang, Mai, needleworker, 133
Vesterheim, Norwegian-American
 Museum, Decorah, Iowa, 33, 37,
 38, 39

Walker, festival, 48–51
Warfare, symbols, 63, 65
Water, John, filmmaker, 55
Weaving, rugs, 20, 115, 122, 123;
 Norwegian, 28, 39. *See also*
 Looms
Weberg, Emil, woodworker, 18
Wedding, gifts, 80
Weenanggay, drum owner, 68
Wexler, Ardis, needleworker, 12, 121
Whirligigs, 5, 33, 147
Whiting, Almon, chairmaker, 121
Widen, Julia, rugmaker, 123
Wilson, Maggie, drum owner, 68
Winczewski, Edward, artist, 14
Winnebago Indians, drums, 63
Wiskino, drum owner, 64
Women, tools used, 7; clothing, 13,
 15, 93, 107; quiltmakers, 28;
 preserve traditions, 34;
 beadworkers, 61; knitters, 80, 84,
 85; education, 82
Wong, George, woodworker, 41
Wood, Ann, whirligigmaker, 5
Wood, figures, 19, 94, 131, 132, 135,
 139; traditional carving, 21, 39,
 40; skis, 28; decorative plaque,
 40; toys, 110, 119, 126; loom,

118; rake, 118; decoy, 120; fan,
 128; mold, 136; clock, 143; box,
 145; trunk, 146
Workers, folklore, 8

Yang, Nhia Yer, blacksmith, 119
Yang, Vu, blacksmith, 9, 15, 135
Yard, ornaments, 5, 9, 16, 33, 46–47,
 54–57, 142
Yarn, for mittens, 81

Zastawny, Katherny, Ukrainian, 90
Zoo, displays, 54